ALSO BY TOBY LESTER

The Fourth Part of the World

DA VINCI'S GHOST

Genius, Obsession, and How Leonardo
Created the World in His Own Image

TOBY LESTER

Free Press

New York London Toronto Sydney New Delhi

Free Press
A Division of Simon & Schuster, Inc.
1230 Avenue of the Americas
New York, NY 10020

First Free Press hardcover edition February 2012

FREE PRESS and colophon are trademarks of Simon & Schuster, Inc.

For information about special discounts for bulk purchases, please contact Simon &
Schuster Special Sales at 1-866-506-1949 or business@simonandschuster.com.

The Simon & Schuster Speakers Bureau can bring authors to
your live event. For more information or to book an event contact the
Simon & Schuster Speakers Bureau at 1-866-248-3049 or
visit our website at www.simonspeakers.com.

Book design by Ellen R. Sasahara

Manufactured in the United States of America

1 3 5 7 9 10 8 6 4 2

Library of Congress Cataloging-in-Publication Data

Lester, Toby.
Da Vinci's ghost : genius, obsession, and how Leonardo
created the world in his own image / Toby Lester. — 1st ed.
p. cm.
Includes bibliographical references and index.
1. Leonardo da Vinci, 1452–1519. Vitruvian man. I. Leonardo da Vinci, 1452–1519—
Criticism and interpretation. II. Leonardo da Vinci, 1452–1519. III. Title.
IV. Title: Genius, obsession, and how Leonardo
created the world in his own image.
NC257.L4A78 2012
741.092—dc23
2011027966

ISBN 978-1-4391-8923-8
ISBN 978-1-4391-8925-2 (ebook)

For Jim Lester
(1927–2010),
too marvelous for words

CONTENTS

Preface ix

Prologue: 1490 1
1: Body of Empire 13
2: Microcosm 42
3: Master Leonardo 63
4: Milan 92
5: The Artist-Engineer 108
6: Master Builders 126
7: Body and Soul 159
8: Portrait of the Artist 190
 Epilogue: Afterlife 218

 Further Reading 227
 Notes 231
 Works Cited 247
 Acknowledgments 255
 Permissions and Credits 259
 Index 265

PREFACE

THIS IS THE story of the world's most famous drawing: Leonardo da Vinci's man in a circle and a square.

Art historians call it Vitruvian Man, because it's based on a description of human proportions written some two thousand years ago by the Roman architect Vitruvius. But not everybody knows that name. When I mention it to people, they often react with a blank stare—until I start to describe the picture. Then, invariably, their eyes light up with the spark of recognition. "Wait," one person said to me, "the guy doing naked jumping jacks?"

Call it whatever you like, but you know the picture. It's everywhere, deployed variously to celebrate all sorts of ideas: the grandeur of art, the nature of well-being, the power of geometry and mathematics, the ideals of the Renaissance, the beauty of the human body, the creative potential of the human mind, the universality of the human spirit, and more. It figures prominently in the symbology of *The Da Vinci Code* and has been spoofed gloriously on *The Simpsons*. It shows up

on coffee cups and T-shirts, on book covers and billboards, in movies and online, on corporate and scientific logos, on international spacecraft. It even appears on the Italian one-euro coin, guaranteeing that each day millions of people will hold it in their hands. In short, it's a worldwide icon of undeniable reach and appeal—but almost nobody knows its story.

I first began to get interested in that story while at work on my previous book, *The Fourth Part of the World* (2009), which tells the story of the remarkable map that in 1507 gave America its name. In writing that book I delved deep into the weird and wonderful world of early maps, geographical ideas, and visions of the cosmos—and one day I stumbled across a medieval world map that immediately grabbed my attention. What struck me about it was what strikes everybody when they first see it: its uncanny resemblance to Vitruvian Man (**Figure 1**).

The more I studied medieval manuscripts, the more I came across similar images—in maps of the world, diagrams of the cosmos, guides to the constellations, astrological charts, medical illustrations, and more. Leonardo, I began to realize, hadn't conjured up Vitruvian Man out of the blue. The figure had a long line of predecessors.

I discussed Vitruvian Man briefly in *The Fourth Part of the World,* in the context of medieval and Renaissance mapping. The picture occupied only a peripheral place in the story I was telling, and soon I had to leave it behind. But as I moved forward, I found myself glancing back in my mental rearview mirror at the receding form of Vitruvian Man. What else might be embedded in that picture? What forgotten worlds might it contain? What sort of a window on Leonardo

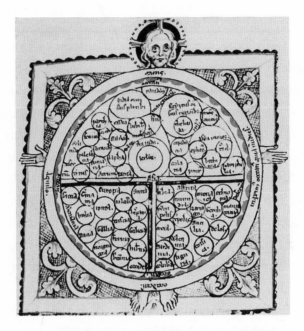

Figure 1. The Lambeth Palace world map (c. 1300). Inscribed in a circle and a square, Christ embodies and embraces the world.

and his times might it provide? Why had nobody ever tried to tell the picture's story? Soon enough I was hooked, and the result, some two years later, was this book.

ON THE SURFACE, the story seems straightforward enough. Writing at the dawn of the Roman imperial age, Vitruvius proposed that a man can be made to fit inside a circle and a square, and some fifteen hundred years later Leonardo gave that idea memorable visual form. But there's much more to the story than that. Vitruvius had described his figure in an

architectural context, insisting that the proportions of sacred temples should conform to the proportions of the ideal human body—the design of which, he believed, conformed to the hidden geometry of the universe. Hence the importance of the circle and the square. Ancient philosophers, mathematicians, and mystics had long invested those two shapes with special symbolic powers. The circle represented the cosmic and the divine; the square represented the earthly and the secular. Anybody proposing that a man could be made to fit inside both shapes was therefore making an age-old metaphysical statement. The human body wasn't just designed according to the principles that governed the world. It *was* the world, in miniature.

To an almost astonishing degree, this idea, known as the theory of the microcosm, was the engine that had powered European religious, scientific, and artistic thought for centuries, and in the late fifteenth century Leonardo hitched himself to it in no uncertain terms. If the design of the human body really did reflect that of the cosmos, he reasoned, then by studying it more carefully than had ever been done before—by using his unparalleled powers of observation to peer deep into his own nature—he might expand the scope of his art to include the broadest of metaphysical horizons. By examining himself in minute detail, he might see and understand the world as a whole.

Vitruvian Man sums up that dream in powerful visual form. At a superficial level, the picture is simply a study of individual proportions. But it's also something far more subtle and complex. It's a profound act of philosophical speculation. It's an idealized self-portrait in which Leonardo, stripped down to his essence, takes his own measure, and in doing so embodies a

timeless human hope: that we just might have the power of mind to figure out how we fit into the grand scheme of things.

THE STORY OF Vitruvian Man is actually two stories: one individual and one collective. The individual story, of course, is Leonardo's own. Set in the years immediately leading up to 1490, it's the story, as best I've been able to reconstruct it, of how Leonardo came to draw his famous picture—and it's a surprisingly unfamiliar tale. Like Vitruvian Man, Leonardo himself has become such a popular icon, deployed for so many different purposes, that he's rarely encountered as an actual person. Instead, he's almost entirely a creature of myth: a prophetic, maguslike figure invested with almost superhuman traits who completely transcended his age. As one modern historian has put it, echoing the words of countless others, "Leonardo, the complete man of the Renaissance, paces forth, as far removed from medieval man as imagination can conceive." But that's not the figure you'll encounter in this book. The Leonardo who drew Vitruvian Man turns out to be every bit as medieval and derivative as he is modern and visionary—and he's all the more complex, fascinating, and mysterious for that.

The second story unfolds on a much broader scale. It's the story of how Vitruvian Man first came into being as an idea more than two thousand years ago and then slowly made its way across the centuries toward its fateful encounter with Leonardo. It's a saga of grand proportions, spanning centuries, continents, and disciplines, in which people and events and ideas tumble into and out of view: the architect Vitruvius, age-old theories of the cosmos, ancient Greek sculptors, the emperor Augustus,

Roman land-surveying techniques, the idea of empire, early Christian geometrical symbolism, the mystical visions of Hildegard of Bingen, Europe's great cathedrals, Islamic ideas of the microcosm, art workshops in Florence, Brunelleschi's dome, the humanists of Italy, court life in Milan, human dissections, Renaissance architectural theory, and much more. At times the story ranges far afield, but never, I hope, without good reason: each new episode, and each new chapter, is designed to help put Leonardo and his picture into deeper perspective.

By definition, the two stories start out at a considerable remove from each other. I've constructed them in very different ways, one as a personal story, told at the ground level, and the other as a story of ideas, surveyed from a considerable altitude. But as the book progresses, the two slowly wrap themselves around each other until, in the final chapter, they become one and the same. Both are strongly visual, which is why this book includes so many period drawings and diagrams. Flip through the pages quickly from front to back, and you should be able to see those images flickering to life, almost like movie stills being sped up, as they gradually evolve into Leonardo's Vitruvian Man.

"THIS WAY, PLEASE."

One damp, cold morning in March, a security guard at the Gallerie dell'Accademia, in Venice, asked me to follow her through the museum's grand exhibit halls. For almost two hundred years the Accademia has owned Vitruvian Man, and I had come to see it in person.

Off we went. Without once looking back, the guard strode purposefully through room after room, weaving her way through

packs of museum visitors gazing at some of the most celebrated paintings in the history of Italian art. I scurried to keep up. Eventually we reached the back of the museum, where we were met by another guard. He asked us to wait while he radioed ahead for clearance, then directed us into a cordoned-off stairwell and waved us upward.

Vitruvian Man only very rarely appears on display at the Accademia. Most of the time the picture is kept out of harm's way, in a climate-controlled archive not accessible to the general public. To see it you have to request special permission from the director of the museum's Office of Drawings and Prints, Dr. Annalisa Perissa Torrini, who, if she deems your request worthy, will guardedly schedule a private viewing.

When at last I was ushered into the archive, I found her waiting for me. We greeted each other and made pleasant small talk for a short while. Then, moving to a nearby display table, we got down to business. Dr. Perissa Torrini donned a pair of slightly tattered white cotton gloves and asked me to do the same. She walked over to a bank of flat file drawers, slid one open, and lifted out a manila conservation folder, which she carried back and gingerly placed on the table. Straightening up, she looked over at me.

"Okay," she said, a smile creeping onto her face. "Are you ready?"

Man is a model of the world.

—Leonardo da Vinci (c. 1480)

DA VINCI'S GHOST

PROLOGUE

1490

*O*N JUNE 18, 1490, a small group of travelers set out from Milan for the university town of Pavia, some twenty-five miles to the south. A well-worn road connected the two cities, and the journey promised to be a pleasant one—a late-spring saunter across the verdant Lombard Plain. The trip lasted several hours. Riding past clover-strewn meadows, shady stands of poplars, and farmland crisscrossed with irrigation canals, the travelers had plenty of time to take in the scenery, soak up the country air, and make easy conversation.

When at last they reached Pavia, they brought their horses to a clattering halt in front of an inn called Il Saracino. The innkeeper, Giovanni Agostino Berneri, must have rushed out to greet his new guests. Two of them, after all, had been summoned to Pavia by none other than Ludovico Sforza, the self-proclaimed duke of Milan, whose dominion extended to Pavia and far beyond. The duke had visited Pavia not long before,

1

and on June 8, after surveying the construction of the town's new cathedral, which he had commissioned just two years earlier, he had relayed a request to his personal secretary in Milan. "The building supervisors of this city's cathedral have asked, and made pressing requests," he wrote, "that we agree to provide them with that Sienese engineer employed by the building supervisors of the cathedral in Milan. . . . You must talk to this engineer and arrange that he come here to see this building."

The engineer in question was Francesco di Giorgio Martini, one of the most famous architects of his day, who at the time was in Milan, studying plans for the design of the *tiburio,* or domed crossing tower, soon to be built in the city's unfinished cathedral. But in a postscript to his letter the duke asked that two experts of his own choosing also be sent. One was Giovanni Antonio Amadeo, a well-known local architect who was working on the *tiburio* with Francesco and had received other commissions from the duke. The other was a much less obvious choice: a thirty-eight-year-old Florentine painter and sculptor, based in Milan, who had no experience as a practicing architect. In his letter the duke called him "Master Leonardo of Florence," but he's known today by a different name: Leonardo da Vinci.

The duke's secretary dutifully looked into the matter and responded two days later. Francesco, he reported, had more work to do but would be able to leave Milan in eight days. Amadeo couldn't join him, because he was involved in an important project on Lake Como—but Leonardo, he said, had expressed great interest in accompanying Francesco to Pavia. "Master Leonardo the Florentine," he wrote, "is always ready, whenever he is asked. If you send the Sienese engineer, he will come too."

Not long afterward, Francesco of Siena and Leonardo of Florence set out for Pavia, accompanied by a small group of colleagues and attendants. Had anybody traveling with the group that day been asked which of the two men would still be remembered five hundred years later, the answer would have seemed obvious: the great Francesco. Even by the middle of the sixteenth century he was already being said to have contributed more to the development of Italian architecture than anybody since the legendary Filippo Brunelleschi. Francesco's reputation stemmed from his accomplishments not only as a prolific master builder but also as an author and a graphic artist; his illustrated treatises were copied more often during the fifteenth and sixteenth centuries than those of any other artist. By the time he came to Milan in 1490, he was perhaps the most sought after architectural consultant in all of Italy. That year alone he traveled from Siena to Bologna, Bracciano, Milan, and Urbino to discuss building projects. And to Pavia, of course, in the company of Leonardo—whose legacy as an artist and engineer would soon eclipse his own.

ONE OF THE earliest surviving descriptions of Leonardo, based on the recollections of a painter who knew him personally in Milan, provides an idea of what he looked like when he and Francesco set out for Pavia. "He was very attractive," the description reads, "well-proportioned, graceful, and good-looking. He wore a short, rose-pink tunic, knee-length at a time when most people wore long gowns. He had beautiful curling hair, carefully styled, which came down to the middle of his chest." This already is a largely forgotten Leonardo—not the

pensive, bearded elder of legend but a much younger man, still busy fashioning his own image.

If any of this provoked doubts in Francesco about his traveling companion, they can't have lasted long. According to another artist who knew him, Leonardo was "by nature very courteous, cultivated, and generous"—a genial person to spend time with. "He was so pleasing in conversation," one of his earliest biographers records, "that he won all hearts." Leonardo may well have revealed another side of his personality to Francesco as the two men settled into their journey: his passion for jokes. In his private notebooks he recorded scores of them, many of which involve a kind of inside humor that might have worked to break the ice with a fellow artist. "It was asked of a painter why," one of them went, "since he made such beautiful figures, which were but dead things, his children were so ugly. To which the painter replied that he made his pictures by day and his children by night."

Francesco would quickly have recognized that Leonardo was no court dandy. He would have noticed, for one thing, how Leonardo never stopped scanning his surroundings for scenes of artistic interest. "From the dawning of the day," Leonardo later wrote, "the air is filled with countless images for which the eye acts as magnet." Whenever something caught his eye he would compulsively open a small notebook that he wore hanging from his belt and begin sketching furiously, with almost mind-boggling virtuosity. He loved his tiny sketchbook and recommended that all serious artists carry one. "As you go about," he wrote, "constantly observe, note, and consider the circumstances and behavior of men as they talk and quarrel, or laugh, or come to blows; the actions of the men them-

selves, and the bystanders who intervene or look on. And take note of them with rapid strokes thus, in a little book that you should always carry with you. . . . These things should not be rubbed out but preserved with great care, for the forms and positions of objects are so infinite that the memory is incapable of retaining them." One can imagine Leonardo en route to Pavia, explaining the function of his notebook to Francesco in similar terms, and suggesting that he, too, consider wearing one on his belt.

Francesco would also soon have noticed that Leonardo's mind roved every bit as much as his eye. At court in Milan, Leonardo was both renowned and mocked for the all-consuming gyre of his interests—and for the doggedness with which, whenever his thoughts fastened temporarily on a subject, he sought out experts and texts that might help him understand it. The year before he traveled to Pavia with Francesco, for example, he jotted down a collection of notes to himself that, like a nighttime flash of lightning in a jungle, momentarily illuminate a mental landscape absolutely teeming with life.

> The measurement of Milan and suburbs. A book that treats of Milan and its churches, which is to be had at the stationer's on the way to Cordusio. The measurement of the Corte Vecchio [a courtyard in the duke's palace]. The measurement of the Castello [the duke's palace itself]. Get the master of arithmetic [probably an accountant] to show you how to square a triangle. Get Messer Fazio [a professor of medicine and law in Pavia] to show you about proportion. Get the Brera friar [at a Benedictine monastery in Milan] to show you *De ponderibus* [a medieval text on mechanics] . . .

Giannino, the bombardier, regarding the means by which the tower of Ferrara is walled without loopholes. Ask Maestro Antonio how mortars are positioned on bastions by day or night. Ask Benedetto Portinari [a Florentine merchant] by what means they go on ice in Flanders. . . . The measurement of the sun, promised me by Maestro Giovanni Francese [probably the French diplomat and art theorist Jean Pèlerin]. The crossbow of Maestro Gianetto. The book by Giovanni Taverna that Messer Fazio has. Draw Milan. Find a master of hydraulics and get him to tell you how to repair a lock, canal, and mill in the Lombard manner. . . . Try to get Vitolone [the medieval author of a text on optics], which is in the library at Pavia, and which deals with mathematics. . . . Pagolino Scarpellino, called Assiolo, has great knowledge of waterworks.

These notes reveal Leonardo in his perpetually ravenous information-gathering mode. Benedictine monks, obscure medieval treatises, university professors, popular guidebooks, accountants, itinerant merchants, doctors, foreign diplomats, artillerymen, military engineers, waterworks experts: all are fair game to him as he hunts for information about subjects that interest him.

The notes also help explain why Leonardo so eagerly agreed to travel with Francesco to Pavia in 1490: he clearly considered the town itself a valuable source of experts and books that he needed to consult. And what better person to ply with questions about the many subjects he had ranged over in his notes than Francesco, one of Italy's greatest architects, military engineers, and hydraulics experts? Leonardo's mind must have raced at the thought of having the eminent man

almost to himself for several days. The two could even discuss plans for the cathedral *tiburio* that Francesco had come to Milan to work on. Leonardo himself had recently proposed to the overseers that he be the one to build the structure, and had submitted to them a model of how he proposed to do it. Small wonder, then, that after receiving his summons to Pavia he made it clear he would be happy to go—if Francesco would be going, too. He had a lot he wanted to discuss with the Sienese engineer.

TODAY JUST ONE book survives that is known to have belonged to Leonardo: a lavishly illustrated manuscript titled *Treatise on Architecture, Engineering, and the Art of War*, by none other than Francesco di Giorgio Martini. Leonardo's copy of the work, which contains illustrations by Francesco himself, dates from the early 1480s. He probably acquired the work only after Francesco's death in 1502, but Francesco was actively working on revisions to the text in 1490 and may well have taken it with him to Milan and Pavia.

The *Treatise* is a rambling summary of Francesco's early thoughts on architectural theory and practice. As such, it's the best available guide to the ideas that he and Leonardo probably discussed during their time together. Written in an unpolished vernacular Italian that suggests its audience was builders, engineers, and military officers rather than literary men, the work ranges over a number of the subjects that were preoccupying Leonardo in 1490: geometry and surveying; the design of cities, fortresses, and harbors; hydraulics; building styles for temples, palaces, theaters, and homes; and a variety of

ingenious pumps, hoists, cranks, military machines, and other mechanical devices.

It's easy to imagine the scene. After much discussion en route from Milan to Pavia, Leonardo and Francesco sit down together in their quarters at Il Saracino and begin poring over the *Treatise*. Or perhaps Francesco, badgered to exhaustion by Leonardo's relentless questioning, announces after dinner that he will be retiring for the evening—and, in lieu of answering any more questions, digs the manuscript out of his travel bag, hands it over to Leonardo, and politely suggests that he spend some time combing it for answers. In either scenario one of Francesco's favorite ideas would have leapt out at Leonardo as soon as he began studying the work, as, indeed, it probably already had during their conversations. "Basilicas," Francesco explained at one point in the text, "[have] the proportions and shape of the human body."

But Francesco didn't just state his church-body analogy and move on. He *drew* it, too. That's because, uncommonly for his time but in complete sympathy with Leonardo, he believed in the explanatory power of images. "Without a drawing," he explained in the epilogue of his *Treatise,* "one cannot express and clarify one's idea." Such thinking led him to toy with his analogy visually—and to produce a phantasmagoric sequence of sketches in the margins of his manuscript in which architectural forms are inhabited by ghostly visions of the human body (**Figures 2** and **3**).

In his *Treatise,* Francesco applied this human analogy to everything from individual columns to entire cities. The human body, after all, had been created in God's own image, which meant that it could, and should, be considered to contain a

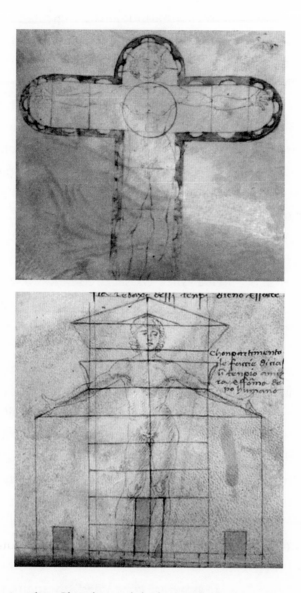

Figures 2 and 3. Churches and the human body. From Francesco di Giorgio Martini's *Treatise on Architecture, Engineering, and the Art of War* (c. 1481–84), owned by Leonardo.

kind of source code for *all* harmonious design. "Man, called a little world," he explained, "contains in himself all the general perfections of the entire cosmos."

Such ideas would have appealed enormously to Leonardo, who since at least 1487 had been rigorously pursuing the study of the human body and human proportions, and investigating the relationship between anatomy and architecture. His investigations, he was coming to believe, would allow him to move beyond surface questions of function and design and ultimately arrive at an understanding of first principles—at which point he would be able to resolve all sorts of artistic problems, scholarly misapprehensions, engineering challenges, and even philosophical mysteries. So what Francesco declared in the opening paragraph of his *Treatise* was music to Leonardo's ears. "All the arts and all rules," he wrote, "are derived from a well-composed and proportioned human body."

This was an idea much discussed in the Middle Ages and the Renaissance, for both its practical applications and symbolic resonances. Famously, it derived from an obscure treatise on the art of building, an ancient Latin work much more talked about than read. Highly technical, inexpertly written, and bristling with ancient Greek architectural terminology, the treatise had reached the fifteenth century corrupted by centuries of scribal errors and omissions, which made it inaccessible to all but a few scholars and architectural theorists—and even *they* tended to throw up their hands when asked to make sense of the treatise and its author. "As far as we are concerned," despaired the great Florentine humanist Leon Battista Alberti, one of the first to comb methodically through the text, in the mid-fifteenth century, "he might just as well not have written at all."

A fourteenth-century copy of the work survived in the magnificent Visconti library, in Pavia, which Leonardo planned to visit while in town on his consulting trip. In the confused mangling of a scribe the manuscript was identified there simply as "Virturbius de architretis." But Leonardo and Francesco both knew better. The work's real title was *De architectura libri decem,* or *Ten Books on Architecture,* and its author was a Roman architect and military engineer who had written it some twenty years before the birth of Christ. His name was Vitruvius.

1

BODY OF EMPIRE

*I have gathered what I observed to be useful,
and brought it together as a single body.*

—Vitruvius, *Ten Books on Architecture* (c. 25 B.C.)

ARCUS VITRUVIUS POLLIO was an army man, a cog in the great lumbering Roman war machine. For years, assigned to the staff of Julius Caesar and other generals, he rumbled around Italy and the provinces, transporting equipment, fording rivers, pitching camps, digging ditches, sinking wells, constructing catapults, fighting battles, repairing siege engines, surveying captured land, laying out towns, founding colonies. Toiling away behind the scenes, he saw to it that everything *worked*. His efforts helped ensure victory and prosperity for Rome, and allowed his superiors to bask in fame and glory.

That seems to have struck him as not quite fair. In the mid-20s B.C., having retired from active duty, he looked back on his

career and found he had almost nothing to show for the labors of a lifetime. "Little fame has resulted," he lamented. "I am unknown to most people."

But his working life wasn't yet over. He still had time to make a name for himself and had even decided how he would do it. He would write a book—a how-to guide to the building of empire.

VITRUVIUS DIDN'T MAKE that decision in a vacuum. In the early 20s B.C., he and other Romans had watched with a mix of apprehension and pride as a canny new consul named Gaius Octavius Thurinus had asserted his grip on their capital city. In the previous decade Octavius, not yet forty, had avenged the murder of his uncle Julius Caesar and defeated his own archrival, Mark Antony, in Egypt, at last bringing to an end years of devastating civil war. Not long after returning home he had assumed a grand new name, Caesar Augustus, and had dedicated himself to the restoration of Rome. And then, as Vitruvius no doubt observed with delight, he had proceeded to launch the greatest building campaign the world had ever known, one that would fundamentally remake the city of Rome, transform the nature of Roman power and government, and redefine the very idea of empire. It was a campaign that in many ways gave lasting shape to what is today often described as the Western world.

Alive with resonances, the name Augustus inspired confidence. It meant "stately," "dignified," and "holy": in a word, "august." It implied an association with *augurium* ("augury"), the art of interpreting divine omens, which had long formed

the bedrock on which Roman political, civic, and religious life was built. It also broadcast connections with *augere* ("to increase," "to grow," "to prosper"), the meanings of which were embedded in *auctor* ("originator," "founder," "author") and *auctoritas* ("authority," "power," "the one in charge"). Augustus was Rome's new augur, founder, and chief authority—and he would use his powers to bring a new age of prosperity to his people.

Augustus loved order. But what he found when he returned to Rome from Egypt in 29 B.C. was just the opposite: a decrepit megalopolis ravaged by years of war, political chaos, and administrative neglect. The city that Augustus came home to, wrote Suetonius, one of his first biographers, was "not adorned as the dignity of the empire demanded."

That was putting it mildly. Most of Rome was a sprawling warren of precariously built multistory houses that pressed in along the sides of small, unpaved roads, creating suffocatingly close quarters where shopkeepers, street vendors, beggars, day laborers, prostitutes, unemployed soldiers, immigrants, foreign slaves, and beasts of burden all jostled together. Wheeled carts were banned during the day to reduce congestion, which meant a constant clatter at night. Public spaces were few and far between; temples and monuments revealed shocking signs of neglect; and the city's once vaunted sewer system had fallen into disrepair. From the upper stories of their houses, home owners routinely dumped the contents of their chamber pots into the streets—and pedestrians routinely found themselves on the receiving end of this practice. To walk through much of Rome was to pick one's way through a morass of garbage, animal refuse, human waste, and even the occasional corpse.

Holding his fingers to his nose, one Roman chronicler of the period described the city as a giant "disease-ridden body."

Rome was sick—but Augustus had the cure. He turned his attention first to the city's physical infrastructure, launching a major effort to restore its public buildings, renovate its roads, repair and expand its aqueducts, and clean out its sewers. He also organized the citywide distribution of free goods and services: salt, olive oil, theater tickets, and even, at festival times, haircuts. The point of all this was clear: the hard times were over. Romans now could—and should—clean themselves up, rebuild their city, and enjoy a new era of peace and prosperity.

Augustus and his followers attributed the decline of Rome to one cause above all others: the neglect of the gods and their temples. Direct communication with the gods, the Romans believed, was what had allowed them to amass wealth, political power, and military might over the years, but now, with the temples falling into disrepair, and religious traditions with them, this hotline to the heavens, as one scholar has called it, had been severed. Right relations with the gods had to be reestablished if Rome was to thrive and rule the world. "Roman, you will remain sullied with the guilt of your fathers," the poet Horace had written not long before, "until you have rebuilt the temples and restored all the ruined sanctuaries."

So down they came, countless dilapidated structures of timber, mud, and brick. In their place, up rose magnificent new temples and monuments of gleaming, expensive marble, built in a style that deliberately harked back to the classic temple designs of the Etruscans and Greeks: a classical Renaissance

that took place in Italy some fifteen hundred years before the one so often discussed today. Augustus devoted himself with astonishing energy to the task, setting into motion a flurry of construction the likes of which no city had ever experienced, and earning himself a reputation, according to the Roman historian Livy, as "the founder and restorer of all sanctuaries." At the end of his life Augustus himself blandly but proudly catalogued the remarkable fruits of his labors.

> I built the Senate House; and the Chalcidicum adjacent to it; the temple of Apollo on the Palatine with its porticoes; the temple of the divine Julius, the Lupercal, the portico at the Flaminian circus . . . a pulvinar at the Circus Maximus; the temples on the Capitol of Jupiter Feretrius and Jupiter the Thunderer; the temple of Quirinus; the temples of Minerva and Queen Juno and Jupiter Libertas on the Aventine; the temple of the Lares at the top of the Sacred Way; the temple of the Di Penates in the Velia; the temple of Youth; and the temple of the Great Mother on the Palatine. I restored the Capitol and the theatre of Pompey. . . . In my sixth consulship I restored eighty-two temples. . . . In my seventh consulship . . . I built the temple of Mars the Avenger and the Forum Augustum. . . . I built the theater adjacent to the temple of Apollo.

And that was just Rome. He also set his sights farther afield. Armies of Roman soldiers, engineers, and bureaucrats now began marching out in all directions into the provinces, making war, "pacifying" rebellious tribes, annexing territory, building

roads, founding colonies, establishing new cities, and erecting monuments, all in Augustus's name. "In cities old and new," one observer wrote, "they build temples, monumental gateways, sacred precincts, and colonnades for him." It was happening even in the distant eastern provinces, at the edges of the Roman world. "The whole of humanity, filled with reverence, turns to the Sebastos," wrote one Syrian citizen of Rome, referring to Augustus by his Greek name. "Cities and provincial councils honor him with temples and sacrifices, for this is his due."

Romans now encountered the name and image of Augustus everywhere in his growing sphere of influence: on coins and statues, on milestones and monuments and temples, in the names of roads and towns and colonies. In the middle of Rome—at the center of the world—he placed the *milliarium aureum* ("golden milestone"), the starting point for all roads leading out of the city. Naturally, it bore his name. Similarly, the place where a road reached its end at the outer limits of Roman territory sometimes bore his name: the *terminus Augusti*.

Something remarkable was taking place. At its center and circumference, and everywhere in between, Augustus was beginning to embody Rome—a metamorphosis that the Roman historian Florus, writing in the following century, claimed was his defining achievement. "By his wisdom and skill," Florus wrote, "he set in order the body of empire, which was all overturned and thrown into confusion, and would certainly never have been able to attain coherence and harmony unless it were ruled by the nod of a single protector: its soul, as it were, and its mind."

The body of empire. The very concept was an Augustan innovation. Before Augustus the Latin word *imperium* ("empire")

had signified an abstract power—a right of command held temporarily by an elected official or military commander. Many people had been able to possess this power at once, much as today many people can be said to possess media "empires." The related term *imperator* ("emperor") described nothing more than a commander's fleeting status as a victor and could be used only between the time of a great victory and a return home in triumph. To claim it after that, he had to return to the battlefield and earn it again.

Augustus changed all that. By the time he took power Romans had already begun to imagine that their *imperium,* won year after year on the battlefield with the help of the gods, might allow them to become masters of the world. But they hadn't thought of this *imperium* as something innately geographical or physical—as a world body, that is, made up of different member provinces, all set permanently in their rightful place and controlled by a single head of state. But that's exactly what Augustus wanted Rome to become: a perfect body—his perfect body—of empire.

As a physical specimen, Augustus fell considerably short of anybody's ideal.

Small and lame, with bad teeth, a crooked nose, and eyebrows that had grown together, he suffered from kidney stones and bladder trouble. Spots, birthmarks, and ringworm scars covered his body. Coins struck early in his career, when he still called himself Octavius, probably preserve the best surviving image of what he actually looked like—and they appear to depict a real

person, imperfections and all (**Figure 4**). But coins struck after he renamed himself Augustus, in 27 B.C., present him with a bold new look (**Figure 5**).

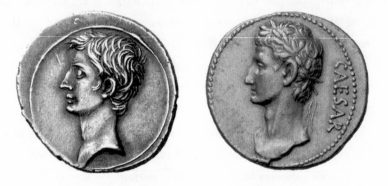

Figures 4 and 5. Left: Octavius, the individual, before 27 B.C.
Right: Caesar Augustus, the ideal, after 27 B.C.

It was all part of his larger campaign of transformation. He had succeeded in bringing an end to civil war because, the story went, he was *divi filius:* the son of a god. The title derived from his uncle Julius Caesar, who, two years after having been murdered in 44 B.C., had been the only Roman other than Romulus ever to be officially deified by the Roman Senate. Not long before his death, Caesar had secretly adopted Octavius as his rightful heir, which in the eyes of the law did indeed make him the son of a god—and after consolidating power Augustus seems to have decided he should look the part.

Coins offered Augustus a way of introducing himself to Romans all over the world, literally by putting his new image into the hands of the people. A mint, it's easy to forget, was an early version of the printing press, and it made possible for Augustus a feat that Johannes Gutenberg often is mistakenly

given credit for: the cheap and easy distribution of the exactly repeatable image. Coins, Augustus and his supporters realized, were a powerful means of broadcasting his new look and all that it symbolized. As citizens carried his likeness all over the Roman world, they would spread the message that prosperity and increase derived from one source alone: Caesar Augustus. No longer would the forces of ugliness, imperfection, disease, and disorder tear Rome apart. Just as Octavius had remade his own body in an august new form, he would now remake his body of empire. And its coherence and harmony would derive from one source above all: the ideal human form.

Augustus turned to the art of ancient Greece to find models of that ideal. "He was interested in Greek studies," his biographer Suetonius wrote, "and in these he excelled greatly. . . . There was nothing for which he looked so carefully as precepts and examples instructive to the public or to individuals." The most celebrated model appeared in the work of the sculptor Polykleitos, revered by the Greeks and Romans alike as one of the greatest artists ever to have lived. Some four centuries earlier, Polykleitos had written a book titled the *Canon,* now lost, in which he laid out the mathematical—that is, "canonical" —proportions of the perfect human figure. Needless to say, it was male.

Polykleitos had done more than codify those proportions in writing. He had embodied them in a statue. Also called the *Canon,* the statue took the form of a nude athlete holding a spear and resting his weight on one foot, in a position of perfect equipoise: a pose designed to suggest a combination of tranquillity and strength, motion and rest (**Figure 6**).

The *Spear Bearer* of Polykleitos, copied again and again in

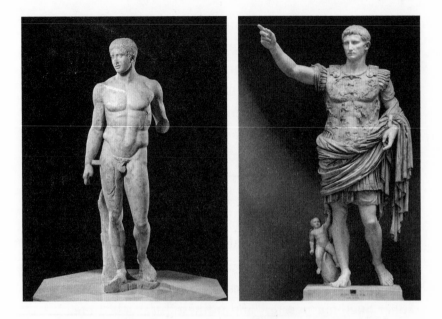

Figures 6 and 7. Left: Roman copy of Polykleitos's *Spear Bearer,*
embodying the ideal proportions of the human form. *Right:* The
Prima Porta statue of Augustus, based on the model of
the *Spear Bearer* (c. 19 B.C.).

antiquity, was a timeless classical ideal. Romans knew it well.
Cicero described it as an exemplar of the beautiful, to be emu-
lated and learned from. The first-century authority Quintilian
described it as "full of dignity and holiness"—the very traits
embedded in the name Augustus. The great Roman encyclo-
pedist Pliny the Elder weighed in, too. "Polyclitus," he wrote,
"made a statue that artists call the Canon, and from which they
derive the principles of their art, as if from a law of some kind.
And he alone of men is deemed to have rendered art itself in
a work of art."

Few people outside elite circles in Rome ever had a chance

to see Augustus in person. So somebody—perhaps Augustus himself, or perhaps a sculptor commissioned to make a statue of him—had a brilliant idea. The familiarity of the *Spear Bearer* as an icon made it a potentially powerful propaganda tool. Why not make the bodies of the *Spear Bearer* and Augustus one and the same? Why not, with the help of sculptors throughout the empire, erase Augustus's imperfections and instead demonstrate to the Roman world that he incorporated a timeless ideal?

Statues of Augustus cast in this new mold began to proliferate all over the Roman world after 27 B.C. Along with the coins minted after that date, they defined him visually to a degree that's hard to appreciate today, when political leaders are on constant public display in the media, warts and all. And nothing defined him more fully than the statue known as *Augustus of Prima Porta,* a work often copied in Roman times that is well worth pondering as an expression of the Augustan ideal (**Figure 7**).

In the statue Augustus poses as an emperor in triumph, clad in military regalia. With his right arm raised in the pose of an orator, he addresses the world, a pose that, in the language of classical sculpture, suggests an aura of divinity. Superficially, the statue looks quite different from the *Spear Bearer*—but in fact the resemblances are numerous and would have been obvious to educated Romans. The two statues correspond very closely in size and proportion; both have hair cropped symmetrically, in the classical Greek style; both have soft, idealized facial features; both possess a peaceful, remote look that conveys a sense of power calmly restrained; and both are cast in that characteristic one-footed stance. The message would have been hard to miss: Augustus embodies the Polykleitan ideal.

There's more. Unlike the Spear Bearer, Augustus wears clothes, including a glorious breastplate depicting an event that justifies his pose as temporary emperor: his recent victory of the Romans over the Parthians, in modern-day Iran. The breastplate shows not only the Parthians in the east but also other peoples and provinces in the south, west, and north. It's an allegorical world map, in other words, made an official part of the Roman body of empire.

The statue also has cosmic dimensions. A number of classical deities appear on the breastplate, among them, at the top, the twins Apollo and Diana, the gods of the sun and the moon. Romans looking at the statue would have understood the symbolism: Augustus and his body of empire mirror the divine perfection of the cosmic order.

Based on the ideal human form, reaching out in all directions to encompass the known world, and aligned with the cosmic order, Augustus in the *Prima Porta* statue sets in stone a powerful new Roman ideology of empire. His perfect form embodies Rome—and Rome's perfect form, in turn, embodies the world. This was an idea that would animate Roman political thought for generations. Seneca would capture it best, in an address to the emperor Nero. "Your spirit will spread little by little through the whole great body of empire," he declared, "joining all things in the shape of your likeness."

AUGUSTUS, SOME SCHOLARS claim, had a special fondness for style guides and rule books, works that wove disparate strands of information into a *corpus,* or complete body of knowledge. This was precisely what Cicero had just done for the art of

oratory, in *On Rhetoric,* and what Varro had just done for Latin grammar, in *On the Latin Language.* But when Augustus took power and began rebuilding Rome, no such guide existed for architecture. Even the idea of the field as a theoretical discipline, rather than as just a manual craft, had only begun to emerge. The term *architectura* itself—a Latin coinage probably derived from Greek roots—dates only to the 40s B.C. or so.

Observing from the sidelines as Augustus began to create his empire, Vitruvius must have sensed a once-in-a-lifetime opportunity. He could fill this void. If at the outset of the greatest building campaign the world had ever known no comprehensive guide to architecture existed—well, then, why shouldn't *he* be the one to write it? How better to help set the empire in order, curry favor with the world's most powerful ruler, and make a lasting name for himself? Why not, as he would soon put it, "bring the whole body of this great discipline to complete order"?

Even during his active career, Vitruvius seems to have stolen time from his official duties to study architectural theory. He found it a fascinating but frustrating pursuit. Over the years—especially late in his career, after Augustus, for reasons unknown, granted him a stipend that allowed him some leisure in his retirement—he managed to locate a number of specialized treatises, primarily by Greek authors: commentaries on individual buildings, discussions of specific technical problems, guides to systems of proportions. But they were "incomplete drafts," he complained, "scattered like fragments." He felt he could do better—and so he set to work. By the mid-20s B.C. he had produced *De architectura libri decem,* or *Ten Books on Architecture*—which, naturally, he dedicated to Augustus.

The *Ten Books* is a curious hybrid. At one level, it's a rich repository of technical information for practitioners, divided, as its title suggests, into ten discrete books, each of which addresses a different subject. Vitruvius provides advice on just about everything he can think of: how to determine sites for new buildings and new cities; what kind of sand to use in mixing concrete; where to find different kinds of timber; how to construct arches, retaining walls, courtyards, villas, bathhouses, theaters, and temples; what to consider when installing floors and ceilings; ways to find water and build aqueducts; and how to make different kinds of machines—odometers, cranes, hoists, water pumps, catapults, siege engines, and more. The book is much studied in architecture programs today because it was also the first to codify the famous architectural orders used by the Greeks: Doric, Ionic, and Corinthian.

But all of this practical information had limited uses. A true architect can't just be a master of his trade, Vitruvius insisted. He had to be the kind of well-rounded person who, centuries later, would come to be known as a Renaissance man. "He ought to be both naturally gifted and amenable to instruction," he wrote, and then continued, "Let him be educated, skillful with the pencil, instructed in geometry, know much history, have followed the philosophers with attention, understand music, have some knowledge of medicine, know the opinions of the jurists, and be acquainted with astronomy and the theory of the heavens."

Why such a broad definition of the architect—and, by extension, architecture? Because, according to Vitruvius, architecture is *the* defining human art. It creates civilization. It constructs homes and lays out cities, bringing people together. It designs

temples, revealing the will of the gods and aligning the man-
made with the divine. It produces machines, guaranteeing vic-
tory in times of war and prosperity in times of peace. In sum—as
Vitruvius described it and as Augustus was practicing it—it
builds empire.

MUCH OF WHAT Vitruvius has to say in the *Ten Books* involves
some very basic principles. Again and again, whether the mat-
ter at hand is the assembly of a retaining wall or the layout of a
city, everything comes down to the manipulation of squares and
circles—or, as Vitruvius put it, "the use of the rule and com-
passes." But in writing about circles and squares he was writing
about more than just geometry, as his readers knew full well.

Philosophers, mathematicians, and mystics in the ancient
world held the view that the circle possessed special symbolic
powers. It represented unity and wholeness, the cosmic and
the godly. Plato, for example, in one of his most influential
and widely read works, the *Timaeus,* had likened the cosmos
to a single world body animated by a world soul, the entirety
of which was contained within a sphere, which he described
as "a figure the most perfect and uniform of all." This idea
appealed to many Romans in the age of Julius Caesar and
Augustus, especially as they developed their twin obsessions
with order and empire. "I can see nothing more beautiful,"
Cicero wrote not long before Vitruvius produced the *Ten
Books,* "than that figure which contains all others, and which
has nothing rough in it, nothing offensive, nothing cut into
angles, nothing broken, nothing swelling, and nothing hol-
low." Only circles and spheres "have the property of absolute

uniformity in all their parts, of having every extremity equidistant from the center," he continued; "there can be nothing more tightly bound together."

Cicero had not just Plato but Aristotle in mind. Aristotle had described the cosmos as a concentric set of spheres, each of which spun at a different rate around a central axis. The word *cosmos,* meaning "order" in Greek, implied all of this—as does the word *universe,* with its suggestion of a giant single turning entity. The earth was the midpoint of the whole system. It didn't move, but around it rotated the spheres of the moon, the sun, the planets, and finally the stars, together creating the apparent motions of the heavens.

Vitruvius devoted considerable time to describing this system in the *Ten Books.* "The cosmos," he wrote, "is the all-encompassing system of everything in nature, and also the firmament, which is formed of the constellations and the courses of the stars. This revolves ceaselessly around the earth and sea." The shape of the cosmos would seem to have little to do with the practice of architecture, but in fact, according to Vitruvius, it had *everything* to do with it—in the design of the cosmos, as he put it, "the power of nature has acted as architect." And what the power of nature, or God, had done for the cosmos, he suggested, the human architect should for his creations—which is why some of the earliest surviving illustrations of the geocentric cosmos appear not in works of ancient astronomy or philosophy, as one might expect, but in the practical treatises of the very kinds of people Vitruvius worked closely with as an architect: Roman land surveyors (**Figure 8**).

God as the architect of the world: this was an idea that would echo down through the ages. Cicero himself had made a similar

point not long before. The geometrical perfection of the cosmos suggested to many the presence of "not only an inhabitant of this celestial and divine abode," he wrote, "but also a ruler and governor—the architect, as it were, of this mighty and monumental structure."

The analogy made perfect sense to Vitruvius, who, after all, had dedicated his book to Rome's divine ruler and governor, Augustus. The job of the architect, he proposed, was to survey the cosmic order of things, grasp its circular animating principles, and then bring them down to Earth. And the way to do *that,* he went on, was with the help of the set square.

In human affairs as in architecture, Romans in the Augustan era fixated on the idea of the square as a complement to the idea of the circle. A good citizen had to be not only well-rounded in the liberal arts but also a model of physical and moral

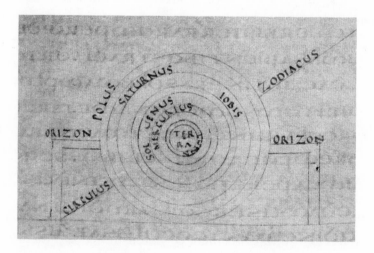

Figure 8. One of the earliest surviving depictions of the spherical cosmos, set square against the horizon with the earth (*terra*) at its center. From a sixth-century copy of a Roman land-surveying treatise.

rectitude: "foursquare in hands and feet and mind, and fashioned without a flaw," as one Greek writer had put it. Rome itself had supposedly been plowed in a circle at its founding, hence the relationship that Varro, for one, suggested between the words *urbs* (city) and *orbis* (circle)—but in founding the city, the story went, Romulus had divided the circular city into quarters for the purposes of augury, setting in order what future Romans would proudly call *Roma quadrata* (squared Rome).

So how would Romulus, in the mythical role of augur-surveyor, have squared his city? Imagine him on a hilltop late one evening, gazing out at the circular horizon. Looking up at the sky, he would have easily located the north celestial pole—"the pivot of the universe," as one Roman surveyor would later describe it. This would have allowed him to divide the sky into quadrants based on the four cardinal directions. A sense of how he might have worked survives in a description by the Roman historian Livy, who wrote in the age of Augustus. "The augur, with his head veiled," Livy recorded, "holding in his hand a crooked and knotless staff called *lituus* . . . prayed to the gods and fixed the regions from east to west, saying that the southern parts were to the right, and the northern to the left." The Romans called each quadrant a *templum:* a sacred space carved out of the sky, subject to the act of *contemplatio.* These four parts they would often then divide into twelve smaller sections, each associated with a god who corresponded to the celestial bodies contained in that part of the sky, as in the *templum* of Mars—which, by extension, led to the idea of a temple as we now understand it, and the original sense of religious *contemplation.*

Finding the four cardinal points in the heavens was a critical task. "These points are charged with exceptional powers," the Roman astronomer Marcus Manilius would explain during the reign of Augustus, "because the celestial circle is totally held in position by them, as by external supports. . . . If they did not clamp it with fetters at the two sides, and at the lowest and highest extremities of its compass, the heaven would fly apart."

As it was above, so it had to be below. For a city to endure, as one Roman surveyor would write, it had to have "its origin in the heavens." It had to be set square with the cardinal directions, just like the cosmos itself. So after dividing up the night sky an augur would have drawn a circle representing the horizon on the ground with his crooked staff and then traced two lines perpendicularly across it: one extending from north to south, the other from east to west. This plan he might later have confirmed with the help of a sundial, which would have allowed him, by revealing the specific path of the sun over the site, to draw with precision the two principal axes that would determine the layout of the rest of his city: the *decumanus maximus,* which ran from east to west, and the *cardo maximus,* which ran from north to south. The Romans also used the word *cardo*—meaning an axis or pole around which something turns—to describe what the earth and universe themselves revolved around, and it's a term we still allude to today whenever we refer to the *cardinal* directions.

All of this highlights an important idea. Properly laid out, in the fashion illustrated by land surveyors in their treatises (**Figures 9** and **10**), Roman towns provided citizens with the comforting sense that their lives were in proper alignment with

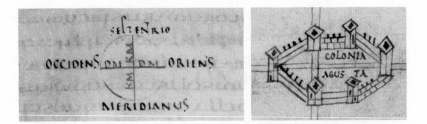

Figures 9 and 10. How to lay out a city, from Roman land-surveying treatises. *Left:* The horizon is divided into quadrants based on the cardinal directions. The *cardo [kardo] maximus* (KM) runs north-south, and the *decumanus maximus* (DM) runs east-west. *Right:* A generic Roman colony called *Colonia Augusta*.

the divine order. Making their way along the *cardo,* they followed the axis around which all of the cosmic spheres turned; making their way along the *decumanus,* they followed the sun's course.

Romulus and the early Romans had originally learned the arts of site selection and town planning from the Etruscans, and in the *Ten Books* Vitruvius argued for a return to these traditional methods. "I assert emphatically," he wrote, "that the old principles for selecting a site should be called back into service." Augustus's surveyors and architects set to work in precisely that way, relying on the ancient art of augury, with its emphasis on the circle and the square, and the idea of a direct connection to the gods. Gradually, inexorably, they began to construct what they hoped would become a perfect body of empire—one in which Rome the city and Rome the empire could be considered one and the same thing, encompassing all four corners of the earth.

* * *

THE IDEA OF the Roman world as a body was no randomly chosen metaphor. It relied on an age-old philosophical conceit: that the human body was a scaled-down version of the world or the cosmos as a whole. Plato and other Greek philosophers had made the analogy repeatedly, as had the Bible ("Let us make man in our image"). Vitruvius himself had alluded to the idea, noting that blood, milk, sweat, urine, and tears were all related to the "countless varieties of juices" found in the ducts and veins of the earth. Writing not long after the death of Augustus, Philo of Alexandria had taken the analogy further, explicitly likening human bones to stones and wood, human hairs and nails to plants, human blood to rivers and streams. Astrologers and doctors, often one and the same in antiquity, developed their own version of the idea, expounding in detail on the direct correspondences between celestial objects and the human body. In this scheme of things, the spots and birthmarks covering the body of Augustus became manifest signs of his divinity, corresponding, according to his biographer Suetonius, "in form, order, and number with the stars of the Bear in the heavens."

Nobody made the human analogy more consistently than the Stoic philosophers of Greece and Rome. The heavens, they argued, consisted of an invisible element called the *aether*, which had no material substance. The material world, on the other hand, was made up of four basic elements: earth, water, air, and fire. Holding all of the elements in a state of finely balanced tension and giving the cosmos its perfect form was the *pneuma* (Greek for "breath"): the all-pervasive divine spirit, or mind, of which the human mind was a small-scale model.

"Who can doubt that a link exists between heaven and man," Manilius would ask, adding, "Just as the world, composed of the elements of air and fire on high, and earth and water, houses an intelligence that, spread throughout it, directs the whole, so, too, with us the bodies of our earthly condition and our lifeblood house a mind that directs every part and animates the man."

In making this kind of analogy, which biographers of Augustus would borrow and apply directly to their subject, Manilius and the Stoics were drawing on ancient Greek theories of medicine. The Greeks had written at great length on what constituted a healthy person. In their view, the human body wasn't just subject to the laws of nature; it literally embodied them. The body was what the Romans called a *minor mundus*: a world in miniature, designed and held together according to the exact same principles as the cosmos itself. Like the world around it, the body consisted of the four material elements: flesh and bones (earth), blood (water), the invisible source of body heat (fire), and air. Keeping those elements in balance was the key to health; moisture had to be balanced against dryness, and heat against cold.

This led to some very strange but powerful ideas—which Vitruvius would lay out at length in the *Ten Books*. In southern climates, he explained, where Africans and Indians live, the excessive heat of the sun robs bodies of their moisture. This creates small people, darkens their skin, crinkles their hair, and raises the pitch of their voices. The heat quickens their minds, making them inventive and mentally agile, but it also dries out their blood, making them cowardly in battle. In northern climates, on the other hand, where the Germanic and Nordic tribes

live, cold temperatures give rise to an abundance of moisture. This creates large people, lightens their skin, straightens their hair, and lowers the pitch of their voices. The cold renders their minds sluggish, making them slow-witted, but it keeps their supply of blood ample, making them brave warriors.

If the peoples of the world were to become members of a healthy and whole body of empire, Vitruvius argued, their natural excesses needed balancing out. And the gods had placed the Romans in Italy, halfway between the north pole and the equator, for just that reason.

> The people of Italy are the most balanced with respect to both north and south, in terms of bodily form and the spiritual rigor required for decisive action. For exactly as the planet Jupiter is temperate, running in the middle between the sweltering planet Mars and the freezing planet Saturn, so, for the same reason, Italy has the unbeatable advantage of being balanced between the southern and northern regions, but with admixtures from both. And so she shatters the courage of [northern] barbarians by intelligent planning, and foils the plots of southerners by force of arms. Thus the divine mind allocated to the city of the Roman people a superb, temperate region in order that it could acquire governance of the whole world.

This is a remarkable passage. In effect, it provides the blueprint for a race-based ideology of empire that for two millennia would hold sway in Europe, and has yet to fully disappear. Geography and biology, Vitruvius was suggesting, are destiny. Placed at the center of the world by the gods, the Romans

would rule the world forever as part of the natural order—if, that is, they could assemble a coherent world body of empire. Which is exactly what Vitruvius set out to explain how to do in his *Ten Books*.

As an architect with plenty of hands-on experience, Vitruvius recognized that a singular challenge confronted the Romans if they wanted to build a body of empire based on the natural order. It would have to be assembled piece by piece, according to a set of standard measurements that could be understood and used by engineers and construction workers all over the world.

Earlier powers had encountered this challenge. Much head-scratching, for example, must have accompanied the construction of one fifth-century monument in Persia. "The stonecutters who wrought the stone," an inscription on the monument reads, "those were Ionians and Sardians. The goldsmiths who wrought the gold, those were Medes and Egyptians. The men who wrought the wood, those were Sardians and Egyptians. The men who baked the brick, those were Babylonians. The men who adorned the wall, those were Medes and Egyptians." The Greeks grappled with the problem in their own colonial building enterprises—and the only solution to it, they decided, was a system of measurement based on the human body.

This idea was nothing new. For as long as people have been measuring things, they've been using body parts to do it. Examples abound, among them the inch (the thumb), the foot, the cubit (the forearm), the Italian *braccio* (the full arm), and the fathom (both arms outstretched).

But all bodies are different. What the Greeks realized they needed was a system of measurements and proportional relationships that was based on a single body—an *ideal* body.

Fortunately, this was what Polykleitos and other Greek artists had tried to codify. As the Greek physician Galen would later record, Polykleitos in his books and statues had laid out "the proper proportion of the parts, such as, for example, that of finger to finger, and of all these to the palm and base of hand, of those to the forearm, of the forearm to the upper arm, and of everything to everything else." This gave Greek builders what they needed. Using that model, they produced carvings in stone known as metrological reliefs, which provided them with a uniform standard of measurement embodied in the form of an idealized human figure.

Two such reliefs survive, including one from about the fifth century B.C. that sets out in precise detail the exact size and relative proportions of the body parts most commonly used for measurement: the fingers, palm, hands, arms, head, chest, and feet (**Figure 11**). Vitruvius was well acquainted with this sort of relief, and with the canons of measurement proposed

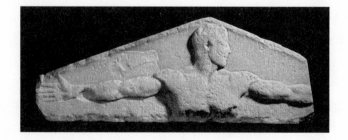

Figure 11. The Oxford metrological relief (Greek, fifth-century B.C.), laying out a uniform system of measurement based on the ideal human form.

by ancient Greek artists. He had them in mind, in fact, when he wrote what would become the most famous passage of the *Ten Books:* a brief description of the figure we know today as Vitruvian Man.

THE PASSAGE APPEARS at the beginning of the third of his ten books, where he lays out principles for the design and construction of temples. The context is critical. Vitruvius knew that temples were the central element of Augustus's building campaign. They, more than anything else, signified his desire to piece together a body of empire. They weren't just august places, carved out of the sky and aligned with the gods. They were Augustus *himself*—august embodiments of earthly power and authority, full of dignity and holiness, designed according to the principles of the natural order. As one modern scholar has observed, the poet Ovid memorably summed up the idea in a pun. *"Quis locus est templis augustior?"* he asked. "What place is more august [more Augustus] than temples?"

This is the context into which Vitruvian Man was born. "No temple can be put together coherently without symmetry and proportion," Vitruvius wrote, "unless it conforms exactly to the principle relating the members of a well-shaped man."

At a literal level this is a very basic proposition: a temple must be designed according to the set of natural laws embodied in the human form. But that very linkage, between the universal and the particular as they come together in architecture and anatomy, implies something much grander. The proper building of a temple starts with the contemplation of the cosmos—but

the only way to make sense of the cosmos, too vast an entity for the human mind to comprehend, is to study the scaled-down version on display in a well-shaped man.

Vitruvius then went on to lay out what the exact proportions of this figure should be. (In text only, it should be noted; no evidence survives that he ever illustrated his book.) The distance from his chin to the top of his forehead, he wrote, should be equal to the distance from his wrist to the tip of his middle finger—and both should be equal to one-tenth of his total body height. The distance from his chest to the crown of his head should be one-fourth of his total height, as should the width of his chest and his forearm. His foot should be one-sixth of his total height. His face itself should be divided into equal thirds: the first extending from the base of the chin to the bottom of the nostrils, the second from the nostrils to a point between the eyebrows, and the third from there to the top of the forehead. Similar relationships applied to other parts of the body, he continued, noting that readers could find details in the well-known works of "the famous painters and sculptors of antiquity"—a nod to Polykleitos and other Greeks.

But Vitruvius didn't limit himself to enumerating the proportions of his well-shaped man. In the passage that comes next, he placed him inside a circle and a square—and gave shape to Vitruvian Man as we know him today. "Likewise," he wrote,

> in sacred dwellings the symmetry of the members ought to correspond completely, in every detail and with perfect fitness, to the entire magnitude of the whole. By the same

token, the natural center of the body is the navel, for if a man were placed on his back with his hands and feet outspread, and the point of a compass put on his navel, both his fingers and his toes would be touched by the line of the circle going around him. You could also find a squared layout in the body in the same way that you made it produce the circular shape. For if you measured from the bottom of his feet to the top of his head and compared that measurement to his outspread hands, you would find the breadth the same as the height, just as in areas that have been squared with a set square.

The passage hums with resonances. Anatomy and architecture, art and aesthetics, the circle and the square, medicine and geography, religion and philosophy, politics and the ideology of empire—they're all there, rolled into one. Part divine and part human, the source of harmony and order, Vitruvian Man, as described in the *Ten Books,* represents the measure of all things. At one level he's a simple study in proportions, but at another he's the expression of an ideal: a human figure whose body is the world, whose mind is its spirit, and whose being represents the power and order of the heavens brought down to Earth. His spread-eagled figure haunts the circular layout of Roman temples and cities, the full span of the globe, even the cosmos itself.

Vitruvius didn't conjure up Vitruvian Man only as an abstraction. He also wanted his readers to associate the figure directly with a specific person: the august ruler who had just begun to build a body of empire in his own perfect image, and whose

ideal form was embodied in all temples. Vitruvian Man, in other words, was none other than the figure to whom Vitruvius dedicated his *Ten Books:* Caesar Augustus himself.

That's how Vitruvian Man came into the world, at least. But in the centuries that followed, he would take on a life of his own.

2

MICROCOSM

Behold the human creature! For man holds heaven and earth and other created things within himself. He is one form, and within him all things are concealed.

—Hildegard of Bingen (c. 1150)

*I*N THE YEAR 1100 or thereabouts, a young German girl living in the Rhineland witnessed an ethereal sight. "In the third year of my life," she would later recall, "I saw so great a brightness that my soul trembled."

So began the mystical life of St. Hildegard of Bingen, one of the most extraordinary figures in medieval history.

In the decades that followed, Hildegard would stun all of those who knew her with the range of her interests and activities. She would write at length about her visions and their mystical meanings. She would produce wide-ranging treatises on medicine and the natural world. She would correspond with popes, emperors, kings, and clerical authorities, and often

chide them fearlessly for their shortcomings. She would preach publicly throughout central Europe and found a monastery of her own. She would write the first known morality play, compose a large corpus of sacred music, and invent a secret language. And she would do it all while professing herself to be unschooled and unlearned—nothing but, as she put it, a "poor little womanly creature."

Hildegard regularly had visions as a girl. Each time they arrived they overwhelmed her—incapacitating her at their onset, terrifying her with their intensity, nauseating her as they played out before her eyes, and exhausting her in their aftermath. Sickly and bedridden as a child, she developed a paralyzing fear of these visions and resolved to keep them secret. But she couldn't help observing what was happening to her with a kind of detached fascination. "I grew amazed at myself," she wrote, "that whenever I saw these things deep in my soul I still retained outer sight, and that I heard this said of no other human being." The visions, moreover, didn't come to her in dreams. "I see them wide awake, day and night," she wrote. "And I am constantly fettered by sickness, and often in the grip of pain so intense that it threatens to kill me."

Based on the ways in which she described her visions and the symptoms that attended them, the medical consensus today is that Hildegard suffered from acute migraine headaches. But she didn't know that. Instead, as she grew older, she came to understand her affliction as a kind of gift. Recalling one episode, she wrote, "When I was twenty-four years and seven months old, I saw an extremely strong, sparkling, fiery light coming from the open heavens. It pierced my brain, my heart, and my breast through and through, like a flame. . . . And

suddenly I had an insight into the meaning and interpretation of the psalter, the Gospel, and the other Catholic writings of the Old Testaments."

Again and again she had similar experiences. Finally, at the age of forty, having lived for some thirty-two years as part of the religious order at the monastery of St. Disibod, she could keep her secret no longer. She confided in her superior—who, astonished at what she told him, hastened away for urgent consultations with the abbot. Soon the two returned to Hildegard with a diagnosis of her condition. Her visions, they said, descended directly from God.

Her condition now accepted and admired, Hildegard began to speak and write openly about what she saw, and this set into motion a rise to fame and influence almost unthinkable for a woman (or just about any man) in the Middle Ages. Word spread fast. "Crowds of people of both sexes came flocking to her," records one early account, "from every part of threefold Gaul and from Germany." Even Pope Eugenius III found himself smitten. Quoting the Song of Songs in a letter, he asked, "Who is this woman who rises out of the wilderness like a column of smoke from burning spices?"

Hildegard spent the final decades of her life near the town of Bingen, as the abbess of St. Rupert's monastery, which she herself had founded at the end of the 1140s. And it was there, unforgettably, that a dazzling sequence of visions arose before her. What appeared to her again and again were human incarnations of the microcosm, and they looked a lot like Vitruvian Man.

* * *

IT'S IMPOSSIBLE TO say what happened after Vitruvius finished his *Ten Books*. Did he present Augustus with a copy? Did the emperor read it? Did he like it and have it distributed? Nobody knows. One ancient source reports that late in his career Vitruvius worked on the aqueducts of Rome, standardizing the size of the water pipes under the direct command of Marcus Agrippa, Augustus's deputy; this suggests that his book did indeed manage to get the attention of the emperor and that it helped advance Vitruvius's career.

But one thing is certain: during his lifetime Vitruvius didn't win the fame he had hoped for. He seems to have died in obscurity; not one reference to him by a contemporary survives. The *Ten Books* itself disappears almost entirely from the historical record for centuries after his death—and when at last it reemerges, in the eighth century, in the form of a precious manuscript copy being lugged from Italy to England by an Anglo-Saxon abbot named Ceolfrith, the world that Vitruvius had known was long gone. The Augustan body of empire had now split in two. In the west was a Latin-speaking half, based in Italy, and in the east a Greek-speaking half, based in Constantinople.

Those changes alone would have struck Vitruvius as deeply unsettling. But he would have been stunned to learn that both halves of the empire now looked to a new man-god as their supreme authority: not an imperial heir of Augustus but an obscure Jew known to his followers as Jesus Christ. And it was this Christ, born not long before the death of Augustus, who now gave shape to the body of empire. Appealing to pagan sympathies, St. Paul had described Jesus in terms that deliberately echoed descriptions of Augustus and his imperial heirs.

"In him all things hold together," Paul wrote about Christ. "And he is the head of the body, the church."

By the time Ceolfrith carried the *Ten Books* to England—and with it the ghost of Vitruvian Man—much of the western half of the empire had been overrun by Germanic tribes from the north. Europe as a whole had devolved into a grimly feudal place, derided by the Byzantines and Arabs alike as geographically and culturally irrelevant. "As regards the peoples of the northern quadrant," one Arab observer would write in 947, "the warm humor is lacking among them; their bodies are large, their natures gross, their manners harsh, their understanding dull, and their tongues heavy."

Yet some Roman learning and culture did survive in early medieval Europe, thanks largely to bands of zealots who had begun to establish small communities across the continent: Christian monks. Without their efforts, hundreds of texts from antiquity would not have survived until the age of printing and mass reproduction. That's certainly true of the *Ten Books,* which monks in early medieval Europe copied and recopied for centuries in their scriptoria. One recent inventory records that 132 of those manuscripts survive—evidence of a powerful current of interest in Vitruvius that flowed right through the Middle Ages.

The copying of manuscripts was punishingly hard labor in the Middle Ages. Scribes hunched over their writing tables for days and weeks, painstakingly scratching line after line of text onto sheets of vellum, itself prepared laboriously by scraping clean the skins of sheep. "Let me tell you," one twelfth-century Irish scribe complained to his readers, "the work is heavy. It makes the eyes misty, it bows the back, crushes the ribs and

belly, brings pain to the kidneys, and makes the body ache all over. . . . As the sailor finds welcome in the final harbor, so does the scribe in the final line."

Given the grueling nature of this work, texts had to have an obvious value to be copied—and at first glance Vitruvius's *Ten Books* would not seem to have been worth the effort. The scribes assigned to copy it wouldn't even have been able to understand most of what they had in front of them; Vitruvius had strewn the work with ideas and terminology that came directly from Greek, a language almost completely forgotten in early medieval Europe. Moreover, the monks who *did* consult the work would have had little interest in, or ability to understand, its archaic discussions of building techniques and architectural history.

So why keep copying the book? The answer can be deduced from the way in which monks themselves described it. In the ninth century, for example, the librarian of one German monastery catalogued the book in the company of works by the Church Fathers, a choice that suggests he and his brethren valued the book not as a practical manual or historical survey but as a springboard for spiritual contemplation. What early medieval monks sought in ancient texts were passages that, despite the pagan context in which they had been written, provided new ways of conceptualizing the Christian God. And in the case of the *Ten Books* they found precisely what they were looking for in the description of Vitruvian Man.

Some of the earliest excerpts and summaries of the *Ten Books,* dating from the ninth and tenth centuries, include the passage on Vitruvian Man copied out in full. It's easy to understand why. In the form in which Vitruvius described him, as an

exemplar of Augustus, the figure bore an uncanny resemblance to Christ. Each was the son of a god; each represented a cosmic ideal; and each, in its spread-eagled pose, inhabited temples, held the empire together, and embodied the world.

Other early medieval librarians and writers placed the *Ten Books* in a different place: alongside treatises on geometry, land surveying, and astronomy. This would seem an entirely different way of thinking about the book—but, as was the case with the *Ten Books,* monks turned to these works not so much for practical information as for analogies for the divine. "We use whatever appropriate symbols we can for the things of God," one widely read sixth-century authority declared, adding elsewhere that God had created geometrical forms so that "he might lift us in spirit up through the perceptible to the conceptual, from sacred shapes and symbols to the simple peaks of the hierarchies of heaven."

The most popular geometrical treatise in Europe from the ninth to eleventh centuries, often known simply as *Geography I,* put this way of thinking into practice. The work brought together excerpts and summaries of all sorts of ancient astronomical and geometrical theories—and made it very clear to readers that their importance was metaphysical, not practical. Astronomy and geometry, the author explained, represented the perfect way "to approach the heavens with the mind, and to investigate the entire construction of the sky, and in some measure to deduce and to recognize, by sublime mental contemplation, the Creator of the world, who has concealed so many beautiful secrets."

This was the top-down approach. One dutifully contemplated the heavens in all of their vastness—the *macrocosm,* as

the Greeks had called it—and then tried to discern in them an image of God. But early in the Christian era some authorities began to propose another way. Did not the Bible itself declare that God had created man in his own image? In the fourth century, just after the Roman emperor Constantine the Great had officially embraced Christianity, the Latin astronomer Julius Firmicus Maternus seized on the idea and ran with it. "God," he wrote,

> the fabricator of man, created his form, his condition, and his entire material frame in the image and likeness of the cosmos. For he made the body of man just as of the world, from the mixing together of the four elements, namely of fire, water, air, and earth, in order that the harmonious union of all these might adorn the living being in the form of a divine imitation.

Writing in the seventh century, Isidore of Seville, the greatest encyclopedist of the so-called Dark Ages, reprised the theme. "All things are contained in man," he wrote. "And in him exists the nature of all things." In the following century the Venerable Bede, one of the most influential of all medieval Christian theologians, took the idea a step further. One way of gaining access to the secrets of the heavens, and thus of understanding the nature of God, he noted, was to study the nature of the human being—"whom the wise," he wrote, "call a *microcosm*, that is, a little world."

In time, this analogy would come to underlie much of medieval and Renaissance thought, occupying a position as central in any explanation of the natural order as evolution does for us

today. But Isidore and Bede alluded to it primarily as a kind of thought exercise, as the diagrams with which they illustrated it make clear (**Plates 1** and **2**). European theologians and artists wouldn't give these abstract schemes a specifically human form for a few centuries, but when at last they did, in the twelfth century, what they drew soon insinuated itself directly into the visions of Hildegard of Bingen.

HILDEGARD RECORDED HER visions of the microcosm in the *Book of Divine Works,* her most ambitious work. Describing one of her visions, she wrote, "A wheel of marvelous appearance became visible. . . . In the middle of the giant wheel appeared a human figure. The crown of its head projected upward, while the soles of its feet extended downward as far as the sphere of sheer white and luminous air. The fingertips of the right hand were stretched to the right, and those of the left hand were stretched to the left, forming a cross extending to the circumference of the circle." The wheel contained a human figure who at its center embodied Adam and Christ, and at its circumference embodied the Holy Spirit, whose arms enfolded the whole of the cosmos in an open embrace. Presiding over the scene outside the limits of both time and space was the Godhead.

Hildegard described the scene in great detail but in a convoluted mystical style that's often hard to follow. Fortunately, an illustration of what she saw, perhaps based on a drawing of her own, survives in a copy of the *Book of Divine Works.* It dates from a only few decades after her death and is astonishing to behold (**Plate 5**).

In the opening lines of her book, Hildegard explained the

miraculous origins of this vision. "In the year 1163," she wrote, "a voice from heaven resounded, saying to me: *O wretched creature and daughter of much toil, even though you have been thoroughly seared, so to speak, by countless grave sufferings of the body, the depth of the mysteries of God has completely permeated you. Transmit for the benefit of humanity an accurate account of what you see with your inner eye. . . . This vision has not been contrived by you, nor has it been conceived by any other human being.*"

That final remark is telling. For Hildegard to have admitted any human influence would have marred her status as a visionary, and in the *Book of Divine Works,* consequently, she made not a single reference to the ideas or writings of any other author. But there was much more to her visions than she let on. Although she described them as being of heavenly origin, they had some obviously earthly sources.

THE CURRENTS OF European thought changed course so dramatically during the twelfth century that historians often describe the period as a mini-Renaissance. Much ink has been spilled trying to define the nature of the movement, but there's a simple way of summing it up: after having focused for centuries on the renunciation of earthly things, Christian scholars in medieval Europe began to reengage with the world around them.

A technological revolution took place alongside this intellectual shift. It, too, involved a reengagement with the natural world, which Europeans began to harness with all sorts of new tools: windmills, waterwheels, and mills turned by animals; various systems of weights, cogs, and gears designed for use

in agriculture, architecture, and war; devices that permitted a growing mastery of the open ocean, such as the keel, the rudder, and the compass; and more. Some writers observing the shift began to imagine the whole of the natural world as a single animate being pulsing with a cosmic life force that was humanity's to tap.

Here's a useful way of thinking about the intellectual shift that took place. For centuries in Europe, from late antiquity into the Middle Ages, Christian scholars had merged their beliefs with a select group of ideas from Plato, whose emphasis on the ideal forms of things had suited an otherworldly approach to religion. Saint Augustine, in particular, had borrowed from Plato to advance his own theological agenda. But in the twelfth century scholars began to turn away from the abstractions of Plato and Augustine. Instead, they developed an interest in the empirical observations of Aristotle, who had focused on the makeup of the physical world and the causes of natural phenomena. Perhaps God could best be apprehended, they suggested, by focusing not on what the world should be but on what it actually *was*.

Many theologians viewed this idea with horror. Why on earth would one abandon the serene contemplation of divine ideals in order to wallow in the muck of reality? The whole idea seemed a giant distraction—the sort of thing, one theologian sermonized, that would draw "the scholar away from theology altogether, by making him too interested in the secular arts and in useless questions about the natural world." Human beings simply had no business, as another writer put it, trying to understand "the composition of the globe, the nature of the elements, the location of the stars, the nature of animals, the

violence of the wind, the life-processes of plants and of roots."
Heaven forbid!

Debate on the subject raged during the first half of the
century. One of the most vocal members in the Aristotle camp
was the philosopher William of Conches, who insisted that for
Christian theology to be true, it would have to be reconciled
with the realities of the physical world. Had not Plato him-
self suggested in the *Timaeus,* one of the only works of his
known to medieval Europeans, that the cosmos was a world
soul and body whose many parts all partook of the same uni-
versal principles of design? If so, there were logical conclu-
sions to draw. By definition, the natural order had to be in
complete sympathy with the heavenly order—which meant,
in turn, that all of creation had to be explored in detail. "To
slight the perfection of created things is to slight the perfection
of the divine power," William explained and went on to heap
contempt on those who felt otherwise. "Ignorant themselves
of the forces of nature," he wrote, "and wanting company in
their ignorance, they don't want people to look into anything.
They want us to believe like peasants and not ask the reason
behind things. . . . But we say the reason behind *everything*
should be sought out."

This, of course, was precisely what Aristotle had tried to do.
In works that explored everything from cosmology to biology,
he had sought out the causes of things. Today we call most of
what he was doing science, but in the ancient and medieval
world, and indeed until just a couple of centuries ago, it had a
different name: natural philosophy.

William was one of the first medieval European scholars to
find his way to the works of Aristotle, most of whose works

had been lost for centuries in the west. But scholars working in the Islamic world had preserved and written commentaries on many of them, and during William's lifetime Latin retranslations of those texts began to appear in Europe, thanks largely to contacts among Christians, Jews, and Muslims in Moorish Spain. It was while reading those works that William and other scholars in Europe began to recognize that the study of natural philosophy might provide them with a new way of exploring the relationship between the human being and the cosmos—and of harnessing the divine forces that animated them both.

The key to it all was the careful study of astrological influences, as many ancient and Islamic authorities had made clear. This highlights a development in the history of ideas that's not well appreciated today. Many of the disciplines we now consider the most scientific—astronomy, geography, geometry, mathematics, medicine, physics—first returned to medieval Europe, as one modern scholar has put it, "riding the magic carpet of astrology."

Astrology seemed to be the universal science. Didn't the daily and yearly travels of the sun profoundly affect changes in the seasons and the weather? Didn't its heat and movements make possible the generation of all earthly life? Likewise, didn't the moon possess immense powers, literally tugging vast bodies of water to and fro across the planet? It made sense, then, as the ancients themselves had argued, that the movements of the other planets and the constellations exerted similar powers over the world and human beings, and that only by studying them in meticulous detail could human affairs be brought into healthy alignment with the celestial order. One early Christian maxim,

repeated often during the Middle Ages, summed up the idea this way: "When man looks to the signs in the heavens, God is revealed. And when God is revealed, man is healed." The twelfth-century philosopher Bernardus Sylvestris, one of the most important sources of Hildegard's ideas about the microcosm, put it more expansively. "I would have you survey the heavens," he had God declare, "inscribed with their manifold array of symbols, which I have set forth for learned eyes, like a book with its pages spread open, containing things to come in secret characters."

The mini-Renaissance of the twelfth century returned this sort of ancient thinking to the fore. It's why William of Conches, in the first half of the century, felt so strongly about seeking out the reason behind everything—and it's why Hildegard, in the second half of the century, following his lead, would write an entire treatise on astrology and medicine titled *Causes and Cures.*

THE EARLIEST ILLUSTRATIONS of the human body as a microcosm, which date to the twelfth century, amount to little more than adaptations of the diagrams that had long appeared in manuscripts by such writers as Isidore of Seville and the Venerable Bede (**Plate 3**).

Soon, however, writers and illustrators began to describe a set of almost biological relationships between parts of the heavens and the human body. Hildegard herself clearly spent time poring over their work. "From the very top of our cranium," she wrote in the *Book of Divine Works,* "seven points are found, separated from one another by equal intervals. This symbolizes

the planets, which are also separated from one another in the firmament by like intervals." In *Causes and Cures* she expanded on this idea, writing, "The firmament, as it were, is man's head; sun, moon, and stars are as the eyes; air as the hearing; the winds are as smell; dew as taste; the sides of the world are as arms and as touch."

Hildegard didn't illustrate all of this herself, but plenty of her contemporaries did, in works that she could easily have consulted in monastery libraries—and their visions clearly underlie her own. One twelfth-century German manuscript, for example, contains an illustration (**Figure 12**) that corresponds almost exactly to Hildegard's description above. Christ appears as an embodiment of the microcosm; his halo is said to represent the celestial sphere; and the set of rays dividing it up into equal parts connects the seven planets to the seven openings of his head. The four material elements appear in the corners of the picture, where they are attached to lines that connect them to the different bodily senses. Many specific body parts and functions are themselves likened to aspects of the natural world, echoing ideas that date back to Philo of Alexandria and beyond: breath and coughing are wind and thunder; the stomach is the ocean, into which all waters flow; the feet hold up the body, just as the earth supports all things. At an even more microcosmic level, the hair is grass, bones are rock, and nails are trees.

What's particularly striking about this image is its newly anatomical emphasis. There's a close-up attention to body parts and bodily functions that would surely have made traditional Latin Christians squirm. The makeup of the body might well correspond to the makeup of the world, they would have admitted—but such things were for God's eyes only.

Figure 12. Christ as a microcosm, from a twelfth-century German manuscript produced during the lifetime of Hildegard of Bingen. The image illustrates many of the relationships between the human body and the heavens that Europeans began to explore with renewed vigor in the twelfth century: the openings of the head are linked to the planets, the human senses are connected to the four elements, and more.

The intellectual tide was turning, however. By the middle of the century translations of Arabic texts on human anatomy were beginning to appear in Latin. Some preserved the works of ancient medical and astrological authorities, others reproduced commentaries and treatises by Islamic sages, and all laid bare a wealth of detail about the human anatomy that most Christian thinkers had been turning their eyes away from for centuries. Many of these texts even contained illustrations: typically, a standard sequence of squatting anatomical figures that have been traced back to the Greek medical writers of Alexandria. Each of the figures laid bare a different aspect of the human anatomy, hence the names by which they're known today: Bone Man, Muscle Man, Nerve Man, Artery Man, and Vein Man. And, as it happens, some of the earliest European copies of these figures (**Figure 13**) appeared in the same German manuscript that contained the above illustration of Christ as a microcosm.

The arrival of these anatomical texts and illustrations in Europe had a profound effect on the continent's astrologers, doctors, mystics, and theologians. Here, after all, was a way of peering, however crudely, into the hidden nature of the microcosm—a sight that had already sent many Islamic sages into a rapture of analogy. "The body itself," declared one influential tenth-century Arabic encyclopedia called the *Epistles of the Brethren of Purity,*

is like the earth, the bones like mountains, the brain like mines, the belly like the sea, the intestine like rivers, the nerves like brooks, the flesh like dust and mud. The hair on the body is like plants; the places where hair grows, like

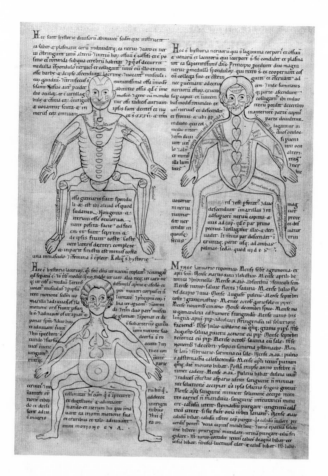

Figure 13. Some of the earliest medieval European anatomical illustrations, from the same twelfth-century manuscript as the illustration in Figure 12. *Clockwise from top left:* Bone Man, Nerve Man, and Muscle Man.

fertile land; and where there is no growth, like saline soil. From its face to its feet, the body is like a populated state, its back like desolate regions. Its top is like the east, its bottom the west, its right the south, its left the north. Its breath is like the wind, words like thunder, sounds like thunderbolts.

Its laughter is like the light of noon, its tears like rain, its sadness like the darkness of night, and its sleep is like death as its awakening is like life. The days of its childhood are like spring, youth like summer, maturity like autumn, and old age like winter. Its motions and acts are like the motions of stars and their rotation. Its birth and presence are like the rising of the stars, and its death and absence like their setting.

The idea that the body of the world could be envisioned in this way—at once anatomically, geographically, and cosmographically—intoxicated Hildegard and many of her contemporaries. "Nature's lineaments," the mystical theologian Alan of Lille enthused, could now be observed in miniature in the human body, "as in a mirror of the universe itself."

Only a few decades after Hildegard's death, this idea came together in one of the grandest visualizations of the microcosm ever drawn: the giant Ebstorf *mappamundi*, a circular world map produced in northern Germany sometime in the early 1200s, quite possibly by Benedictine nuns (**Plate 4**).

The map lays out a geographical scheme typical of medieval European world maps. Bounded by a single vast ocean, the world consists of three parts: Asia, Europe, and Africa. But the world itself is an embodiment of Christ, whose head appears at the top, in the east; whose feet appear at the bottom, in the west; and whose hands appear at the sides, in the north and south. Geography, in other words, has merged with not only cosmography but also anatomy. The world's waterways have become Christ's bloodstream and nervous system, its land formations have become his flesh and bones, and its center, Jerusalem, has

become his navel. Framed in a cosmic circle and an earthly square, the map depicts Christ's full body of empire, which, needless to say, brings Vitruvian Man to mind.

As does Hildegard's stunning vision of the microcosm. Did Hildegard somehow have Vitruvian Man in mind when she contemplated her famous vision? It's certainly possible. Many of the copies of the *Ten Books* that survive from her time were produced in German monasteries, and at several points in the *Book of Divine Works* Hildegard herself seems to be echoing Vitruvius. In describing the nature of the microcosm, for example, she repeatedly discussed the proportions present in the human form. "God created humanity with one limb fitted to another," she wrote at one point, "in such a way that no limb should exceed its proper proportion." She zeroed in several times on the relative distances among various parts of the body, too. "It is the same distance from one of our ears to the other," she observed, "as the distance from our ears down to the shoulders, or the distance from our shoulders to the base of the throat." But she echoed Vitruvius most closely when she described the ideal figure at the center of her visions and then generalized about his proportions.

"If we extend both our hands and arms out from the chest," she wrote, "the human form has the same length and width, just as the firmament is also as tall as it is wide."

INFLECTED WITH THE Vitruvian spirit, images of the microcosm proliferated in Europe in the centuries that followed. But Vitruvius's *Ten Books* itself remained a work rarely copied or understood. That began to change in about 1415, however, when the

early Italian humanist Gian Francesco Poggio Bracciolini visited the monastery of St. Gall, in Switzerland.

Poggio had recently embarked on a book-hunting tour: a quest to find copies of lost or long-forgotten ancient Roman texts, many of which sat moldering and worm-eaten in the great monastery libraries of central Europe, ignored in favor of newer Christian works. The effort paid off handsomely. During the course of his travels he discovered copies of works by, among others, Cicero, the poet Lucretius, the grammarians Quintilian and Priscian, the astronomer Manilius, and the land surveyor Frontinus—and one day, while making his way through the rich collection at St. Gall, he stumbled across a beautifully preserved eighth-century copy of the *Ten Books*.

As he was doing with many of the other works he discovered, Poggio had the manuscript sent back to Florence, the efflorescent hub of the newly emergent Italian Renaissance. Injected into this lively new social and intellectual environment, the work would take on new life in the decades that followed, gradually spawning copies that would be studied not just by theologians and philosophers but also by practicing architects and artists—among them Leonardo da Vinci.

3

MASTER LEONARDO

*I can carry out sculpture in marble, bronze, or clay; and in
painting I can do everything it is possible to do.*

—Leonardo da Vinci (c. 1484–85)

O N A SPRING DAY in 1452, in the Tuscan hill town of Vinci,
some thirty miles from Florence, on the final page of an
old journal in which he had already recorded the birth of his
own children, an elderly landowner named Antonio da Vinci
recorded the arrival of the newest member of his extended fam-
ily. "There was born to me a grandson," he noted, "the son of
Ser Piero, my son, on the 15th day of April, a Saturday, at the
3rd hour of the night." The boy was illegitimate, conceived out
of wedlock by Piero and a young local woman named Caterina,
but that doesn't seem to have bothered Antonio. With matter-
of-fact pride he went on to describe how, on the day after his
birth, the baby had been baptized by the local parish priest in

the presence of ten godparents and a number of other witnesses from Vinci. They christened him Leonardo.

No other reference to Leonardo da Vinci survives from his childhood, and one can only guess as to how he spent his youth. He probably lived like many other Tuscan country boys: rising with the sun, doing early-morning chores, tending to farm animals, plowing and planting and harvesting in the fields, helping to press grapes and olives into wine and oil. He surely whiled away plenty of hours making mischief with village kids, too, and wandering off on his own into the countryside, pausing to drink from streams, idly tracing pictures in the dirt, crouching down to study bugs, dozing under trees, gazing up at the clouds. The natural world was his classroom, and hands-on experience his teacher; they would remain so for the rest of his life. A lifelong lover of the view from above, he would have clambered to the tops of nearby hills to survey the full contours of his little Tuscan world: a sight captured in his earliest surviving drawing, from 1473 (**Figure 14**).

By his own account, Leonardo received only limited schooling as a child, little more than some rudimentary training in reading, writing, and mathematics. As a youth he probably taught himself how to write, developing the famously eccentric mirror script that he would use throughout his life, in which he formed his letters backward and ran his text from right to left. Much has been made of this script as a kind of secret code, but it probably has a very simple explanation: Leonardo was left-handed. Writing from right to left would have allowed him to avoid dragging his hand over wet ink. With no formal schoolmaster to correct the habit after he developed it, he would have persisted in it until it became second nature.

Figure 14. Leonardo's earliest surviving drawing,
of a Tuscan landscape (c. 1473).

The lack of schooling probably suited Leonardo just fine. Even at a young age he seems to have been a creature of passionate but fleeting enthusiasms, driven by a restless, inquisitive spirit that refused to be confined by traditional limits. That's the picture that emerges in the account of the art historian Giorgio Vasari, who in the sixteenth century gathered anecdotes about Leonardo's early life. "He would have been very proficient at his early lessons if he had not been so volatile and unstable," Vasari wrote. "He set himself to learn many things, only to abandon them almost immediately."

Leonardo's artistic talents emerged early. It's fun to imagine with what wide-eyed astonishment those around him began to take notice as he doodled portraits, sketched landscapes, and sculpted objects out of whatever material lay at hand. By the time he was in his early teens, the word around Vinci must have been that Piero and young Caterina had produced a prodigy. Piero, who lived and worked as a notary in Florence, even found himself wondering if the boy might possess enough talent to make a living as a big-city artist—and in about 1466, with Leonardo soon to be coming of age and in need of a career, he decided to find out. "One day," Vasari recalled, "Ser Piero took some of Leonardo's drawings along to [the well-known Florentine artist] Andrea del Verrocchio, who was a good friend of his, and asked if he thought it would be profitable for the boy to study drawing. Andrea was amazed to see what extraordinary beginnings Leonardo had made, and urged Piero to make him study the subject. So Piero arranged for Leonardo to enter Andrea's workshop."

And so, at about the age of fourteen, Leonardo left Vinci behind and set out for Florence.

HE PROBABLY MADE the trip in a day, on the back of a mule and in the company of his father. For hours they would have ridden through the Tuscan countryside, on well-worn dirt tracks, and then at last the great city would have come into view. It was a feast for the eyes—the kind of sight, as the Florentine poet Ugolino Verino would write not long after Leonardo arrived, that makes "every traveler arriving in the city swear that there is no place more beautiful in all the world" (**Figure 15**).

The city was indeed a marvel to behold. Home to 50,000 people, enclosed by a circular wall seven miles in diameter, it spread out along both sides of the Arno River, with 80 defensive watchtowers studding its walls: a reminder that in the fifteenth century the threat of war among Italian city-states loomed large. Spanning the Arno were four bridges, among them the famous Ponte Vecchio, then as now a tourist attraction lined with shops. But what dominated the cityscape from afar was the soaring, majestic dome of the cathedral of Florence, erected in the 1420s and 1430s by the legendary Filippo Brunelleschi. When Leonardo moved to Florence a generation later, the structure was still provoking wonder and pride in the city's inhabitants—among them Ugolino Verino. "Nothing is superior to this dome," he wrote, "not even the seven wonders of the world." Already there was talk of the *malattia del duomo,* or cathedral

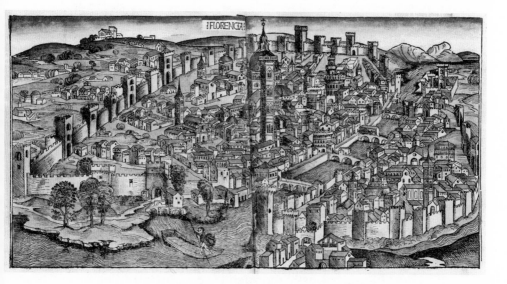

Figure 15. Florence in 1492, as Leonardo knew it.

sickness, a malaise akin to homesickness that had just one symp-
tom: an intense longing for the sight of the cathedral and its
great dome.

Scores of other churches also came into view as Leonardo
approached the city. A total of 108 of them lay inside the city
walls. They, too, were a source of great civic pride—"meticulously
maintained," the Florentine diplomat Benedetto Dei wrote in
1472, "and exquisitely furnished with cloisters, chapter houses,
refectories, infirmaries, sacristies, libraries, bell towers, relics,
crosses, chalices, silver items, gold and silver paramagnets, and
velvet and damask clothes."

The churches—and much of the rest of Florence, for that
matter—had all been built with something very specific to
prove. Once a provincial town known primarily for its cloth
makers and small-time moneylenders, the city had been over-
shadowed in previous centuries not only by Rome but also by
other regional powers: Venice, Milan, Genoa, Naples. These
were feudal cities, where birth defined one's class and profes-
sion, where wealth was inherited, and where political power
was the birthright of the nobility, which ruled absolutely. But
early in the thirteenth century the merchants and craftsmen of
Florence began to create a new kind of social order, by orga-
nizing themselves into loose trade associations, or guilds. The
move proved a spectacular success. "The barons," wrote one
thirteenth-century Florentine, bemoaning the loss of the old
order, "must sometimes give precedence to the merchants, for
they go on foot while the merchants have horses and carriages.
Nowadays his majesty Money is the most highly esteemed of
all." Soon Florence possessed such wealth, such trading power,

such a strong working class, and such an expansive administrative bureaucracy that its guild members began to chafe under the rule of the existing feudal elite. Why not rid their city of its useless hereditary nobility, they felt, and just run it themselves as a republic? The early Romans had done something similar two thousand years earlier—and *that* experiment had turned out pretty well.

To prove their superiority over their fellow Italian city-states, Florentines devoted themselves and their growing fortunes to making Florence a kind of theater of political and cultural power. Their city, they decided, had to have the best of everything: the biggest cathedral, the most lavishly adorned churches, the grandest piazzas, the biggest homes, the loveliest statues, the most expensive paintings, the finest silks, the most skillful engineers, the most educated scholars, the most eloquent poets. By the time Leonardo arrived, few could deny how successfully and completely the city, now a republic of wealthy merchants and bankers, had reinvented itself—as a financial center, a political power, a cultural haven, and, ultimately, a work of art. "Venetian, Milanese, Genoese, Neapolitan, Sienese," Benedetto Dei wrote tauntingly in 1472, "try to compare your cities with this one!"

Nothing better symbolized the nature of this transformation in the fifteenth century than the new streets of Florence: wide open spaces, all clean lines and smooth surfaces, that were gradually replacing the clutter and meandering disorder of the narrow medieval alleyways that had long wound through the city. "How can I properly describe the paved and spacious streets," Ugolino Verino wrote, "designed in such a way that

the traveler's journey is impeded neither by mud when it rains nor by dust during the summer, so that his shoes are never dirtied?"

Leonardo probably felt the same way as he entered the city. And he would have encountered some dazzling sights as he made his way along some of those streets toward his father's home, where he is likely to have lodged at first. According to one period inventory, the city contained a remarkable 50 piazzas, each with its own church and shops; 33 banks, which collectively represented the beating heart of the city's mercantile empire; and 23 *palazzi,* or mansions, which provided bases of operations for the sprawling administrative staffs of the city's 23 guilds. On display everywhere was a new architectural and artistic style, based on a clean, simple aesthetic that rejected centuries of medieval tradition and instead harked back (it was claimed, at least) to the classical ideals of Greece and Rome. And sitting at the center of it all, captivating everybody who saw it, was the city's cathedral, capped by Brunelleschi's magnificent dome.

But if the city was a work of art, it was also a work in progress. Riding through town, Leonardo would have been assaulted on all sides with the sights and sounds of construction—the kind of dirt and din that one Florentine apothecary of the time grumbled about in his diary when describing the building of a nearby mansion. "The streets round about," he wrote, "were full of mules and donkeys carrying away the rubbish and bringing gravel, which made it difficult for people to pass. All the dust and the crowds of onlookers were most inconvenient for us shopkeepers."

Everywhere Leonardo looked, he would have seen artisans

and craftspeople at work. According to figures gathered in the late 1470s, Florence was home to the studios of 270 woolworkers, 84 wood carvers, 83 silk workers, 54 master masons, 44 goldsmiths and silversmiths, and 30 master painters. Tellingly, more wood carvers and silk workers had set up shop in the city than butchers (70) and spice merchants (66)—a sign of just how hungry for the decorative arts Florence's increasingly wealthy and status-conscious middle class had become. There was no better place to begin a career as a promising young artist.

The sight of all this bustle no doubt turned Leonardo's thoughts to one of the city's busiest and most important artistic workshops, located in the parish of Sant'Ambrogio, a short walk from his father's office. It was a small factory of sorts, devoted to the production of paintings, sculptures, metalwork, tombstones, heraldic devices, suits of armor, theatrical sets, costumes, and more. Not long after Leonardo had settled in to his quarters, he sought the workshop out. It was his new place of employment: the studio of Andrea del Verrocchio.

NOTHING SURVIVES OF Verrocchio's studio today. In all likelihood, however, it resembled the studios often depicted in fifteenth-century miniatures and frescoes. These show a large, open ground-floor space separated from the street by a simple awning of some kind. Outside the doorway, samples of the studio's wares are on display to attract the attention of passersby. Inside, one can imagine a roomful of artisans engaged in all manner of tasks: hammering and welding metal, grinding and chiseling stone, carving wood, sculpting clay at turntables,

operating kilns, sketching and painting at easels, sitting as models. The environment is pungent, dirty, and noisy, more akin to what one encounters today in the shop of an auto mechanic than in an art studio. The master himself wanders about the studio, greeting clients, supervising apprentices and assistants, worrying about deadlines, devoting his attention to projects that need his special attention and expert touch. Tucked away in the back or upstairs are the living quarters, which he and his employees share.

When Verrocchio took Leonardo in, he would have assigned him the kinds of entry-level jobs he always gave his new assistants. Tables had to be cleaned, floors swept, errands run. Discovering that his new assistant was blessed with an alluring

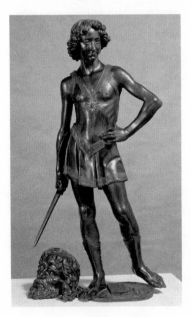

physique and extraordinary good looks, Verrocchio probably also put him to work almost immediately as a model. Some scholars have even proposed that he had Leonardo pose for the bronze statue of David he produced in 1466, the year Leonardo arrived. If this is true, the statue provides a sense of what Leonardo looked like as a fourteen-year-old (**Figure 16**).

Leonardo would also have spent time each day preparing materials for use in the studio, everything from paints and varnishes and glues—none of which

Figure 16. A possible likeness of the young Leonardo: Verrocchio's *David* (*c.* 1466).

came prepared in cans and tubes as they do today—to brushes and drawing tablets and canvases. Many of these jobs were described in detail in a how-to manual that Verrocchio may well have made Leonardo study carefully: *Il libro dell'arte,* or *The Craftsman's Handbook,* written in the late 1300s or early 1400s by the Florentine artisan Cennino Cennini. The following set of rather involved instructions, for example, appeared at the outset of the book, under the deceptively simple title "How You Begin Drawing on a Little Panel."

First, take a little boxwood panel, nine inches wide in each direction; all smooth and clean, that is, washed with clear water; rubbed and smoothed down with cuttle such as the goldsmiths use for casting. And when this little panel is thoroughly dry, take enough bone, ground diligently for two hours, to serve the purpose; and the finer it is, the better. Scrape it up afterward, take it and keep it wrapped up in a paper, dry. And when you need some for priming this little panel, take less than half a bean of this bone, or even less. And stir this bone up with saliva. Spread it all over the little panel with your fingers; and, before it gets dry, hold the little panel in your left hand, and tap over the panel with the finger tip of your right hand until you see that it is quite dry. And it will get coated with bone as evenly in one place as in another. . . . You must know what bone is good. Take bone from the second joints and wings of fowls, [and] just as you find them under the dining table, put them in the fire. When you see that they have turned whiter than ashes, draw them out and grind them well in the porphyry; and use it as I say above.

This sort of work, tedious, dusty, and messy, defined the life of a craftsman in fifteenth-century Florence—as does that delightfully casual reference to a dining-room floor strewn with chicken bones. But the work was critical, and the lesson that Verrocchio and other masters taught their assistants about it was this: to learn how to draw and paint, one had learn how to *prepare* to draw and paint.

The study of artistic technique was the next step. In Verrocchio's studio, this would have involved a gradual introduction, over the course of years, to such subjects as how to organize a composition, how to sketch its outlines, how to flesh out subjects, how to render them using perspective and foreshortening, how to play with light and shade, how to apply color, and more. *The Craftsman's Handbook* covered much of this, but Verrocchio would have also expected Leonardo to learn many of the basics by copying directly from a model book: a folio of drawings showcasing the kinds of generic figures and scenes that an artist might be asked to produce on demand for a client. And when it came to what was considered the most important element of any work of art, the depiction of the human form, Verrocchio would have insisted that Leonardo study and commit to memory what another Italian master described to his assistant in 1467 as the "system of the naked body"—that is, a standard set of ideal human proportions.

It was there, in the rote study of human proportions, that the young Leonardo probably had his first encounter with the ghost of Vitruvian Man—although neither he nor anybody else in Verrocchio's studio would have recognized it as such. Vestiges of the figure certainly inhabited *The Craftsman's Handbook,* in

the section titled "The Proportions Which a Perfectly Formed Man's Body Should Possess." After noting dismissively that the body of a woman wasn't even worth discussing ("for she does not have any set proportion"), the author went on to explain, just as Vitruvius had done some fifteen hundred years earlier, that an ideal man's face should be divided into three equal parts, and that his body, drawn in full, should be "as long as his arms crosswise."

These proportional relationships would have become very familiar to Leonardo during his apprenticeship. The Florentine masters that Verrocchio made him study, after all, had been working with them for generations, and the results of their efforts could be seen all over Florence. And they were on obvious display in one archetypal image that Verrocchio would have made Leonardo copy again and again: the figure of Christ on the cross.

LEONARDO LEARNED FAST. One anecdote recorded by Vasari, although probably apocryphal, suggests just how fast.

Like many apprentices, Leonardo eventually began to assist his master with paintings, filling in color, providing background detail, adding minor characters. In Leonardo's case this led to an awkward moment. According to Vasari, in 1472, while working on his famous *Baptism of Christ,* Verrocchio asked Leonardo to add in an angel to the scene. With a disconcertingly assured touch, Leonardo proceeded to produce a figure of such beauty, grace, and refinement that Verrocchio gave up painting altogether—"chagrined," as Vasari put it, "to be outdone by a mere child."

Whether the story is true or not, Leonardo did manage to complete his apprenticeship in six years, or only about half the time recommended by *The Craftsman's Handbook.* In the summer of 1472 he made it official, by registering in the Compagnia di San Luca, the Florentine painters' confraternity.

As a dues-paying member, Leonardo could have easily set up shop on his own. But he didn't. Instead, for the next four years he remained with Verrocchio, as a partner of sorts. The decision made good sense. It guaranteed Leonardo a steady flow of work and income, and it allowed him, under the watchful eye of one of Florence's best-known masters, to continue to hone his skills, develop his reputation, and pursue his ever-widening range of interests. It also meant, not insignificantly, that he could continue to live and work with the colleagues and friends in whose company he had come of age. The arrangement, in other words, made it possible for him not only to earn a living and continue to learn but also to have some fun.

The life of a young artist in Florence involved plenty of revelry. After the workday was over there were parties, with much music, and Leonardo no doubt took part. By all accounts he had a lovely singing voice, and entertained friends and colleagues by accompanying himself masterfully on the *lira da braccio,* or arm lyre: a small violinlike instrument with seven strings, played with a bow. All of his early biographers agree on the subject of his musical talents. "Full of the most graceful vivacity," Vasari wrote, "he sang and accompanied himself most divinely."

Horsing around at the studio, he also developed his lifelong taste for jokes, light verse, ribald banter, riddles, and fables—and, experimenting with the materials available to him in the studio, he began to develop the kinds of party tricks that later

in his career would serve him well as a producer of special effects for ceremonial pageants. It's easy to picture him some night at the studio stirring up some of the mischief he describes in one of his notebooks. "If you want to make a fire that will set a room ablaze without injury, do this. First, perfume the room with a dense smoke of incense, or some other odiferous substance: it is a good trick to play. Or boil ten pounds of brandy to evaporate, but see that the room is completely closed, and throw up some powdered varnish among the fumes. This varnish will be supported by the smoke. Then enter the room suddenly with a lighted torch, and at once it will be set ablaze."

All in all, it was an intoxicating time for the young man from Vinci. Preternaturally gifted as an artist, ravishing to look at, and only in his early twenties, he had risen with disconcerting rapidity to become a partner at one of the most important workshops in one of the world's most prosperous and artistically vibrant cities. Few certain traces of Leonardo survive from this phase of his life, but one that does—a note he scrawled to himself on the back of his earliest surviving drawing—at least fleetingly suggests a mood of contentment. Written in 1473, it reads simply, "I am happy."

THAT'S SURELY NOT the way he felt when, three years later, he was handed a court summons. An anonymous complaint against him and three other young men had been filed with the Florentine authorities in early 1476, and in response the city's moral police, known as the Officers of the Night and Monasteries, had opened a criminal investigation. The youths were

being summoned to face charges of having engaged in sodomy with a seventeen-year-old apprentice goldsmith named Jacopo Saltarelli—a notorious debauchee who, as the anonymous complaint put it, "pursues many immoral activities and consents to satisfy those persons who request such sinful things from him." Saltarelli, it seems, moonlighted as a prostitute.

Homosexuality was not uncommon in late-fifteenth-century Florence, especially not in the city's tight-knit art studios, with their all-male staffs, their intimate living quarters, and their perpetual focus on the beautiful male body. Several leading artists in Renaissance Florence are known to have been homosexual. By the 1470s a Renaissance cult of Plato had also taken hold among the city's political and scholarly elite, prompting a revival in upper-class society of the ancient Greek ideal of erotic love between men and boys. As a result of all this, not surprisingly, Florence acquired something of a reputation as a gay haven. The word *Florenzer,* or Florentine, even came to mean "sodomite" in German slang of the period.

Plenty of clues scattered throughout Leonardo's notebooks suggest that he was a homosexual. But, as with so many of his passions, his interest in sex ultimately transformed itself into a kind of detached curiosity about the mysterious workings of the body: an almost reverent fascination, not without its humorous side, that comes across clearly, for example, in an extended rumination on the penis that he would later record in one of his notebooks. "It has dealings with human intelligence," he wrote, "and sometimes displays an intelligence of its own; where a man may desire it to be stimulated, it remains obstinate and follows its own course; and sometimes

it moves on its own without permission or any thought by its owner. . . . This creature often has a life and an intelligence separate from that of the man, and it seems that man is wrong to be ashamed of giving it a name or showing it. That which he seeks to cover and hide, he ought to expose solemnly, like a priest at mass."

The priests of Florence wouldn't have appreciated that comparison. Most routinely railed against homosexuality from their pulpits, and their remonstrations fell on plenty of receptive ears. The city authorities themselves prosecuted more than a hundred accused "sodomites" annually, with punishments ranging from the mild (public humiliation, the payment of fines) to the extreme (branding, execution).

Prostitution, illicit sexual practices, backstabbing anonymous accusations, investigations by the morality police, a tawdry arrest, public humiliation: this was the seamy underbelly of big-city life, and Leonardo now had firsthand experience of it. He can't have taken the charges against him lightly. Fortunately, in the summer of 1476 he and the others were absolved of the charges against them—not necessarily because they were innocent but simply for lack of a witness willing to testify against them. Leonardo must have been greatly relieved, but by then his reputation had suffered a blow. In the aftermath of his arrest, even some of those closest to him seem to have shunned him. "As I have told you before," he wrote to a leader of the Florentine guilds in a petition for support, "I am without any of my friends."

Later in life Leonardo composed a fable that captures the turn his mood seems to have taken after the Saltarelli affair.

Written in a high-allegorical mode, the tale exudes nostalgia for the country life Leonardo had left behind in Vinci—and a powerful sense that he regretted ever leaving home at all.

> A stone of good size, washed bare by the rain, once stood in a high place, surrounded by flowers of many colors, at the edge of a grove overlooking a rock-strewn road. After looking for so long at the stones on the path, it was overcome with desire to let itself fall down among them. "What am I doing here among plants?" it asked itself. "I ought to be down there, with my own kind." So it rolled to the bottom of the slope and joined the others. But the wheels of carts, the hooves of horses, and the feet of passersby had before long reduced it to a state of perpetual distress. Everything seemed to roll over or kick it. Sometimes, when it was soiled with mud or the dung of animals, it would look up a little— in vain—at the place it had left: that place of solitude and peaceful happiness. That is what happens to anyone who seeks to abandon the solitary and contemplative life to come and live in town, among people of infinite wickedness.

By 1477 LEONARDO had struck out on his own.

The details are murky. Sometime that year—perhaps now out of favor with Verrocchio because of the Saltarelli affair—he seems to have set up an independent studio. According to one of his earliest biographers, sometime in the years immediately afterward he lived and worked in the service of Florence's de facto ruler, the wealthy and powerful art patron Lorenzo de' Medici. The claim is improbable: no other source mentions

this relationship, which would have provided Leonardo with considerable renown and income, and nothing, not even a passing mention, survives of any work that Leonardo ever did for Lorenzo. But there's little doubt that by the late 1470s, primarily because of his affiliation with Verrocchio, Leonardo had been exposed to the world of the Medici—the rarefied world of Florentine humanism, that is, in which art was beginning to be thought of as something far loftier than a mere craft.

One person above all others had created the first stirrings of this transformation: the remarkable Leon Battista Alberti, born in 1404. A figure of prodigious classical learning, wide-ranging practical talents, and apparently boundless energy, Alberti was one of the leading lights of the early Italian Renaissance. While working by turns as an architect, cartographer, civil engineer, cryptographer, grammarian, memoirist, satirist, and surveyor, he also wrote influentially on the theory of art—and by the time of his death, in 1472, several of his treatises had become virtually canonical in Florentine art circles.

The most influential of these was *On Painting,* a work he composed in the 1430s, hoping it would help bridge the gap that had long existed in art between theory and practice. No longer, he believed, should there be one class of people who worked only with their minds, and another only with their hands. To that end, unusually for his time, he produced two versions of the treatise. The first he wrote in Latin, for the edification of well-born patrons and scholars; the second he wrote in Italian, for practicing artists. Both were circulating widely in Florence by the 1460s. Leonardo would come to know it well—and would take many of its lessons profoundly to heart.

In many ways, *On Painting* represented the perfect supplement to the medieval *Craftsman's Handbook*. It introduced and explained, for example, one of the most important artistic developments of the early Italian Renaissance: linear perspective. The technique, which involved organizing the space of a picture into a mathematically consistent grid, enabled artists for the first time to render a three-dimensional subject realistically on a two-dimensional surface. It had been perfected earlier in the century by Brunelleschi, and in *On Painting* (the Italian edition of which was dedicated to Brunelleschi) Alberti codified it for the very first time, a move that would have profound consequences for Renaissance art and science.

But explaining artistic technique wasn't the point of *On Painting*. Whereas *The Craftsman's Handbook* had taught that proper materials and practices were the foundations of good art, *On Painting* put its emphasis elsewhere: on the cultivation of a painter's mind and character. Learning how to paint still meant learning how to prepare to paint—but now that preparation involved not grinding bone and mixing colors but educating oneself roundly in the liberal arts. Only then could one tap into the unified principles of harmony and proportion that governed the makeup of the world. As an art rather than a craft, painting as Alberti described it provided a powerful visual means of capturing truths about the natural world and human nature, and then conveying them to others in beautiful, instructive works of art. Hence the importance of linear perspective: it gave an artist of exceptional ability and great learning the almost godlike ability to re-create the world in miniature. "Painting," he wrote, "possesses a truly divine power."

That Leonardo knew *On Painting* well is clear from his notebooks, which are shot through with echoes of Alberti's ideas. One that recurs repeatedly is the notion of the artist as a figure who, thanks to his careful study of the workings of the world, has become a Creator. "The divine character of painting," Leonardo wrote at one point, "means that the mind of the painter is transformed into an image of the mind of God." At another point he elaborated on the idea. "The painter is lord," he wrote, and then continued, "In fact, whatever exists in the universe—in essence, in appearance, in the imagination—the painter has first in his mind and then in his hand; and these are of such excellence that they can present a proportioned and harmonious view of the whole, which can be seen simultaneously, at one glance, just as things in nature."

A small sketch in one of Leonardo's notebooks, datable to sometime between 1478 and 1480, gives this idea a strikingly visual form. It shows a young artist, possibly Leonardo himself in his studio, drawing with the help of what he calls a "perspectograph," a device that corresponds nicely to one described by Alberti in *On Painting*. And what the young artist is putting into perspective, so that it can be seen at one glance, is surely not just a random choice. It's a miniature model of the cosmos, known as an armillary sphere—a device at the center of which artists and theologians of the period sometimes imagined they could see the figure of Christ embodying the earth (**Figures 17 and 18**).

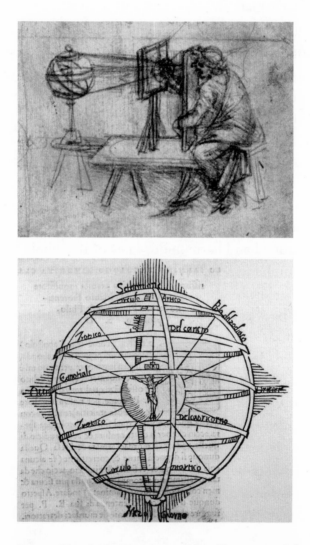

Figures 17 and 18. Top: A possible self-portrait of the young Leonardo, drawing an armillary sphere with the help of his "perspectograph" (c. 1478–80). *Above:* A sixteenth-century illustration of an armillary sphere with Christ at the center, embodying the world.

* * *

IT'S IMPOSSIBLE TO say when Leonardo first embraced the idea of the artist as a kind of creator-god, but the idea was one he would carry with him throughout his life. It wasn't only Alberti who taught him to think this way. By the time he had begun to work independently, this sort of idea was part of the air he breathed in Florence, especially after he began interacting with the city's elite. In Lorenzo de' Medici's circle, Neoplatonism was all the rage—and one of the movement's central tenets was that the human spirit, if properly cultivated through the study of the liberal arts, could partake of the divine.

The idea had an ancient pedigree. "Understand that you are god," Cicero had declared in his *Dream of Scipio,* a widely studied metaphysical fable written not long before Vitruvius composed his *Ten Books.* "You have a god's capacity of aliveness and sensation and memory and foresight, a god's power to rule and govern and direct the body that is your servant, in the same way as God himself, who reigns over us, directs the entire universe."

The Neoplatonists in Florence, who emerged as a cultural force in the latter half of the fifteenth century, latched onto this analogy between the human and the divine. The movement's hugely influential leader, the scholar and translator Marsilio Ficino, deployed it in a vast treatise titled *Platonic Theology.* Human nature, he wrote, "possesses in itself images of the divine things upon which it depends. It also possesses the reasons and models of the inferior things. . . . Therefore it can with justice be called the center of nature, the middle point of all that is, the chain of the world, the face of all, and the knot and bond

of the universe." Ficino wasn't the only one thinking this way. In 1486 one of his disciples, Giovanni Pico della Mirandola, laid down a famous variation on the theme in his *Oration on the Dignity of Man,* a work that quickly became something of a humanist manifesto. In the *Oration,* Pico had God address Adam not long after creating him. "I have placed you at the very center of the world," God tells him, "so that from that vantage point you may with greater ease glance round about you on all that the world contains." Visual variations on this theme would appear in countless Renaissance texts (**Figure 19**).

Ahead of his time, Alberti pursued the logical implications of this human analogy years before Ficino and Pico della Mirandola, bringing it down to earth in a way that would appeal powerfully to the young Leonardo. Lofty Ciceronian

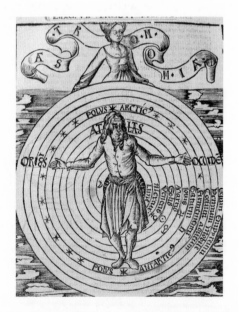

Figure 19. Man and the cosmos, from Gregor Reisch's *Margarita philosophica* (1503).

talk about the godly nature of the human spirit was fine for scholars, Alberti suggested. But scholars were pale, flaccid, ineffectual creatures—"chained," he wrote, "to the reading of manuscripts and condemned to solitary confinement . . . in the wretched obscurity of libraries." Artists could offer a much more practical and accessible sense of all that the world contains, he suggested, by thoroughly investigating the proportions of the human body.

As a guide to that investigation, Alberti decided to make a map.

For inspiration, he looked to a model laid out by the ancient Greek polymath Claudius Ptolemy. In the second century A.D., Ptolemy had produced a text known as the *Geography,* in which he had described the mapping of the world according to the coordinate-based system we still use today: latitude and longitude. Not only that, he had gathered together the coordinates of some eight thousand places, which allowed him to plot a fuller and more mathematically consistent map of the world than had ever been made before. After Ptolemy's death the work had disappeared for centuries, and with it the idea of coordinate-based mapping. But it resurfaced in Europe in about 1400, in Florence, and as the century progressed it exerted an increasingly powerful influence on Renaissance thought. In the minds of the city's humanists, in particular, the *Geography* provided not just a cartographic picture of the ancient world but also a visual metaphor for a powerful new idea: that the individual human mind, with the help of ancient learning, could find its way to a scientific understanding of the world as a whole.

This idea appealed to Alberti, who studied Ptolemy carefully. When, in the mid-1400s, he decided to map the human body, he devised a coordinate-based system of his own, which he explained in detail in a treatise titled *On Sculpture*. The system didn't rely on latitude and longitude. Instead, it used a coordinate system designed to allow the mapping of a body in three dimensions. The key was an instrument of his own design, which he called the *finitorium,* or "definer": a circle marked off in degrees with one end of a ruler attached to its center. This, Alberti, proposed, could be placed centrally over a human subject or statue, allowing one to measure the location of any part of a body along three different axes: height, width, and depth (**Figure 20**).

Alberti designed his system so that, in theory, sculptors could map and therefore re-create any body they wanted. But what he cared about most was the reproduction not of any one specific body, with all its eccentricities and imperfections, but rather of the human ideal—which is precisely what he went on to do in *On Sculpture.* After introducing his readers to the *finitorium,* he explained his method:

> So that the subject may be clarified by examples and my work most useful to many people, I took on the task of recording the dimensions of man. I proceeded accordingly to measure and record in writing, not simply the beauty found in this or that body, but, as far as possible, that perfect beauty distributed by Nature, in fixed proportions, as it were, among many bodies; and in doing this I imitated the artist at Croton, who, when making the likeness of a goddess, chose all remarkable and elegant beauties of form

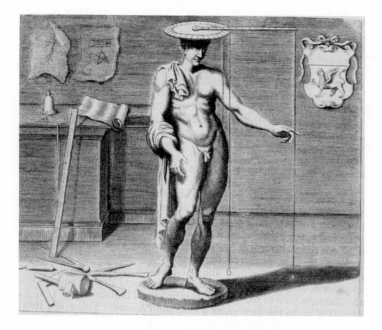

Figure 20. Alberti's "definer," a device for mapping the human body in three dimensions, from a seventeenth-century edition of Alberti's *On Sculpture.*

from several of the most handsome maidens and translated them into his work. So we, too, chose many bodies, considered to be the most beautiful by those who know, and took from each and all their dimensions, which we then compared one with another, and leaving out of account the extremes on both sides, we took the mean figures validated by the majority of models.

Just as Ptolemy had done in the *Geography,* Alberti appended a matter-of-fact list of coordinates to the text of his treatise under the heading "Tables of Measurements of Man." He listed

sixty-eight different bodily dimensions, covering everything from the basics (overall height, arm span, head size) to such minor details as the height of "the recess below the fleshy part

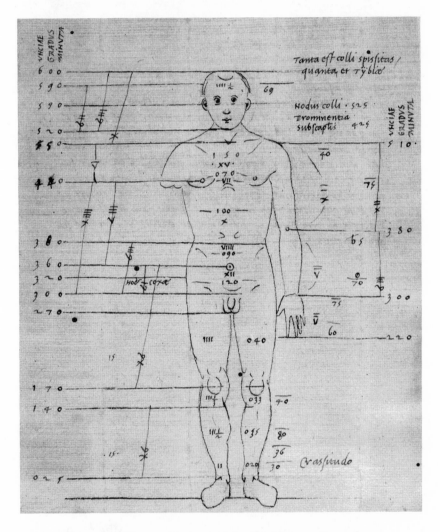

Figure 21. The proportions of the ideal human form, from a late-fifteenth-century manuscript of Alberti's *On Sculpture.*

of the inside lower leg," the "maximum width between nipples," and the "thickness of the arm at the wrist." And at last, using the data he had gathered so methodically, he—or the copyists of his manuscripts—cobbled together a visual geography of the human ideal (**Figure 21**).

Ten manuscript copies of *On Sculpture* survive, the earliest of which dates to 1466, the year Leonardo arrived in Florence. During his time in Verrocchio's studio or in his early working life as an independent young artist, Leonardo is sure to have come across the work and discussed it with colleagues and friends. In one of his notebook sketches he played directly with Alberti's approach to body mapping, and on another page, in a passage datable to about 1490, he set out some preliminary thoughts for a text of his own, also to be titled *On Sculpture,* in which he explained how to transfer specific bodily measurements from a clay model to a marble statue. These examples suggest that Leonardo read Alberti's *On Sculpture* literally, as a practical guide. But in the heady Neoplatonic spirit of his times, he would also have understood Alberti's geography of the human ideal as something more ambitious—as a kind of map of the microcosm that could reveal all sorts of metaphysical truths.

Alberti himself seems to have felt the same way, as he made clear in *Momus,* a literary work he produced at about the same time as *On Sculpture.* "Let me tell you what I was told by a certain painter," he wrote. "In studying the lineaments of human bodies, he saw more than all you star-gazing philosophers put together."

4

MILAN

The painter's mind must of necessity enter into nature's mind.

—Leonardo da Vinci (c. 1492)

EONARDO HAD TROUBLE with deadlines.

His first recorded commission dates to 1478. On January 10 of that year, the Florentine authorities awarded him the job of painting the altarpiece in the chapel of the Palazzo Vecchio, the town hall of Florence. It was a hugely desirable assignment, for which he received an ample advance. But he never delivered. In 1481 he received another important commission, this time to paint an altarpiece for a monastery just outside the city. Records from the period show him to have been struggling financially at the time—but once again he failed to complete the job.

It was a pattern that would endure throughout his career. According to a story recounted by Vasari, when Leonardo, late

in his life, was commissioned by the pope himself to paint a portrait, he didn't set to work immediately, as most painters would have done. Instead, he began an intense round of experimentation with different herbs and oils, trying to concoct a special new varnish that he could apply to his finished portrait. "Alas!" the exasperated pontiff exclaimed. "This man will do nothing at all, since he is thinking of the end before he has made a beginning." Vasari himself more charitably attributed the problem to Leonardo's genius. "In his imagination," he explained, "he frequently formed enterprises so difficult and so subtle that they could not be entirely realized and worthily executed by human hands. His conceptions were varied to infinity."

Indeed they were. But there's a more prosaic way of explaining Leonardo's trouble with deadlines. By the time he received his first independent assignment he had decided that he would not—and could not—simply churn out generic works as part of a factory collective. What he wanted to do was to become, as he put it, "the universal master of representing every kind of form produced by nature." But to achieve that, he realized, he would have to investigate the makeup and function of *everything*: a gloriously fruitful but ultimately quixotic quest that would last for the rest of his life. Decades later, he was still grasping out in every direction to collect pieces of the ever-expanding puzzle. "Describe the tongue of the woodpecker and the jaw of the crocodile," he wrote at one point. "Of the flight of the 4th kind of butterfly that consumes winged ants," he wrote at another.

Most artisans and craftsmen of Leonardo's time wouldn't have dreamed of concerning themselves with such things. They inhabited the realm of surfaces and appearances. Natural philosophy was the province of the scholastics: learned univer-

sity types who toiled away minutely parsing the Bible and the doctrinally acceptable works of the great ancient and medieval authorities, which, they assumed, contained all it was necessary to know about the natural world and the meaning of existence.

Leonardo—the unlettered craftsman, the artist-engineer, the playful tinkerer, the mixer of potions, the visual thinker— recoiled at this idea. He stayed down-to-earth. His approach to natural philosophy, he decided, would be resolutely empirical: he would get his hands dirty. The scholastics considered such an approach ignorant and ignoble, but he didn't care. "They will say," he wrote, "that because I have no book learning, I cannot properly express what I desire to treat of. But they do not know that for their exposition my subjects require experience rather than the words of others."

It's not clear exactly how or when Leonardo began thinking this way. But by the time he struck out on his own as an artist he'd already started. In notes that survive from the early 1480s, for example, when testing out a new pen he scribbled variations on the phrase *"Dimmi"* ("Tell me"). "Tell me . . . tell me whether . . . tell me how things are . . . tell me if there was ever." These are the tics of an increasingly hungry mind.

He began asking such questions of others, too. In one note, which dates from about 1481 and is written alongside sketches of a sundial, a pneumatic or hydraulic water clock, and various geometrical figures, he lists eight Florentines whom he seems to want to consult. Of those eight, three have yet to be identified, one is a painter, and the remaining four are men whose areas of expertise hint at the rapidly diversifying range of Leonardo's curiosities. The first, Carlo Marmocchi, was an

astronomer and geographer whose quadrant (or treatise *The Quadrant*) Leonardo noted an interest in; the second, whom Leonardo called Benedetto of the Abacus, was a well-known local mathematician; the third, Paolo dal Pozzo Toscanelli, was one of the great sages of fifteenth-century Florence; and the fourth, Joannes Argyropoulos, was a hugely influential Byzantine scholar who had fled to Italy after the fall of Constantinople in 1453.

It's no surprise that Leonardo was drawn to Toscanelli and Argyropoulos. Each was nearing the end of an illustrious life, and both had reputations as men who could teach Leonardo a great deal. During his exile, Argyropoulos had been pivotal in helping the humanists of Florence translate and reassess the works of Aristotle, whose broad range of writings on natural philosophy had been studied only very selectively in Europe during the Middle Ages, by Christian scholars interested only in those parts of his work that would help buttress their theology and metaphysics. Toscanelli, for his part, would have been a hugely appealing figure to Leonardo. A widely respected authority on subjects as varied as astronomy, geography, linear perspective, mathematics, and optics, and a friend of artists, humanists, and scholastics alike, he exerted a long and powerful influence on Florentine intellectual and cultural life. His circle included not only Alberti, Verrocchio, and Marsilio Ficino, the dean of the Florentine Neoplatonists, but also Brunelleschi—inside whose dome, in about 1468, he constructed a giant gnomon that for centuries afterward was used to make precise observations of the sun's wanderings. Today, however, he's best known for something else: the letter he wrote to a Portuguese friend in 1474,

proposing that the best way to reach the Far East from Europe was not to sail east, under Africa, but west, across the uncharted Atlantic. Several years later, that letter would catch the attention of Christopher Columbus, who in turn would write to Toscanelli to ask for more information—and the brief correspondence the two men entered into supposedly helped convince Columbus to set sail in 1492. All of which leads to a remarkable thought: in the year or two before his death, in 1482, Toscanelli may have dispensed advice to both Leonardo da Vinci and Christopher Columbus.

Needless to say, Leonardo's investigations into natural philosophy consumed vast amounts of time and energy, and, inevitably, his productivity as an artist suffered. (Given the almost infinitely expanding nature of his interests and investigations, however, the wonder really is not that he finished so few paintings in his lifetime; it's that he started any at all.) Most Florentine artists of his day did their work on private commission, for which a contract would be struck, a deadline established, and an advance given, with the balance to be paid upon delivery. The system served many artists well. But for Leonardo it was no way to make a living. What he needed was a royal patron of some kind, a powerful ruler who might hire him as an artist in residence but also allow him to pursue his own interests.

Finding such a position in Florence, he knew, wasn't possible. The city had no monarch. Not only that, his star was waning: he was developing a reputation for not finishing his work, he didn't fit naturally into the city's literary-humanist milieu, and he probably still carried with him the taint of his sodomy charge. His notes from the time contain hints of despair, unre-

quited love, and a longing for something different. The great city in which he had come of age seemed now to be rejecting him. Not surprisingly, he began to entertain thoughts of leaving.

The final straw came in 1481, when the pope asked Lorenzo de' Medici to send some of Florence's best artists to Rome to help decorate the recently completed Sistine Chapel. By the merits, Leonardo was an obvious choice. Despite his failings, he had proved himself to be a master of rare genius; not only had he collaborated with Verrocchio on a number of prestigious projects, he had also already produced some of the great paintings for which he is famous today, among them the remarkable *Annunciation* and his portrait of Ginevra de' Benci. Lorenzo knew all of this. But he passed Leonardo over anyway, picking Sandro Botticelli, Domenico Ghirlandaio, and two other artists instead.

The slight must have stung—and so, when Lorenzo later that year asked Leonardo to travel to Milan, perhaps to take part in a music festival or contest there, instead of taking umbrage he seems to have resolved to make the most of the opportunity. Feeling unloved and unappreciated, he decided he wouldn't just visit Milan. He would move there—and try to win the patronage of Ludovico Sforza, the arts-besotted tyrant who just two years earlier had seized control of the city.

MILAN SITS NOT far south of Lake Como and the Swiss Alps, in the middle of the fertile Po Valley. Known to the Romans as Mediolanum (from *in medio plano,* "in the middle of the plain") and to the Goths as Mailand (probably a further corruption of the Roman name), the city represented a vital military and

commercial link between Rome and the countries of northern Europe. By Leonardo's time, under the military rule of the newly ascendant Sforza family, the city had become something of a colossus, one of the richest, most populous, and most powerful cities in Europe.

The Sforzas had seized control of Milan only in 1450. Before them, for more than a century, the noble Viscontis had ruled the city. The most famous head of the family had been Giangaleazzo Visconti, who, at the end of the fourteenth century, had launched a series of military campaigns that put Milan in control of much of northern Italy. Acknowledging this new reality in 1395, the Holy Roman Emperor had granted him the title of duke of Milan. In the half century that followed he and his successors had made Milan into a kind of anti-Florence: a monarchy, modeled on the aristocratic courts of northern Europe, that was predominantly Gothic in style, militaristic in spirit, and steeped in medieval chivalric culture. Needless to say, by the early 1400s Florence and Milan had become bitter enemies.

When the Sforzas took control of Milan in 1450, they had no hereditary claim to power. To bolster their legitimacy, they therefore embarked on a grand program of urban renewal, central to which was an effort to complete the city's gargantuan cathedral. Construction of the cathedral had begun in 1386, at the instigation of Giangaleazzo Visconti, who, fully aware that the Florentines were hard at work on a cathedral that they hoped would become the largest in all of Christendom, had decided that *his,* not theirs, would earn that distinction.

In the decades that followed, central Milan became a vast cathedral construction site. Huge walls and pillars arose, defining the monumental outlines of the cathedral's transept and

nave, and thrusting their way upward toward a yet-to-be-built vault. Inside, open to the elements, stood a maze of timber supports and giant scaffolds—and the old church of Santa Maria Maggiore, still being used for services while the cathedral gradually came into being around it. Partially finished sculptures of monsters, saints, and angels sat atop cornices or lay on the floor, not yet put into their places; gaping holes in the walls awaited stained-glass windows. For years construction continued in fits and starts, but all the while, the overseers and builders of the cathedral argued back and forth about what sort of dome they should crown the structure with—a debate that Leonardo himself, after having moved to Milan, would eventually try to resolve.

BY THE 1470s a rapprochement was under way between Florence and Milan. Always on the lookout for new ways of making money, the bankers and merchants of Florence, led by Lorenzo de' Medici, recognized the value of forging economic ties with the Milanese. The duke and his courtiers, for their part, recognized that Florence offered them not only a prosperous trading partner but also precious human resources, in the form of the city's great architects, artists, musicians, scholars, sculptors, and writers, who could help boost Milan's cultural prestige. In 1471, as part of this rapprochement, the young duke of Milan, Galeazzo Maria Sforza, paid a grand state visit to Florence, bringing with him a magnificent retinue intended to dazzle Florentines with its aura of courtly sophistication and wealth. A host of courtiers, dressed in costumes embroidered in gold and silver thread, turned up in twelve covered carriages, accompanied by

a vast train of musicians, dancers, poets, priests, secretaries, servants, and foreign slaves—and no doubt enough dwarfs, buffoons, and exotic animals to keep everybody entertained. Along with the whole retinue came an army of animals: a thousand horses, according to one account, and five thousand pairs of hounds.

For Leonardo, only nineteen at the time, the visit offered an eye-opening introduction to the glories of Milan. It also provided him with an inside sense of what life at the Milanese court might be like, because in preparing for the visit Lorenzo de' Medici asked Verrocchio to redecorate his palace's guest quarters in a style sumptuous enough to impress his Milanese visitors. Leonardo, the star apprentice, may well have had a hand in the job.

To some Florentines, proudly bourgeois as they were, the whole visit reeked of aristocratic decadence. A generation later, when Niccolò Machiavelli wrote his history of Florence, he described the latter half of the fifteenth century as a period of slackening morals in the city, which he attributed in part to the visit of this Milanese delegation.

> There now appeared disorders commonly witnessed in times of peace. The young people of the city, being more independent, spent excessive sums on clothing, feasting, and debauchery. Living in idleness, they wasted their time and money on gaming and women; their only interest was trying to outshine others by luxury in costume, fine speaking, and wit. . . . These unfortunate habits became even worse with the arrival of the courtiers of Milan. . . . If the

duke found the city already corrupted by effeminate man-
ners worthy of courts and quite contrary to those of a repub-
lic, he left it in an even more deplorable state of corruption.

That's surely not how the young Leonardo felt. What did
he care about the political ideals of the Florentine republic or
the austere classicism of its humanists? Elegant music, luxu-
rious clothing, effeminate manners, witty talk, parlor games,
domesticated animals, playful encounters with the exotic and
the grotesque: he delighted in all of these things. In Milan, sur-
rounded by such finery and generously supported by the duke,
he might be able to pursue his interests in an environment far
removed from the noise and mess of the Florentine workshops
in which he had come of age. "The well-dressed painter," he
later wrote, describing the studio of his dreams, "sits at great
ease in front of his work and moves a very light brush, which
bears attractive colors, and he is adorned with such garments
as he pleases. His dwelling is full of fine paintings and is clean
and often filled with music or the sound of different beautiful
works being read, which are often heard with great pleasure,
unmixed with the pounding of hammers or other noises."

When Florence seemed to be turning against him later in
the decade, it's easy to understand how Leonardo might have
allowed himself to imagine creating a new life for himself at the
Milanese court—and why, when Lorenzo asked him to travel
there in 1481 as a kind of musical ambassador, he decided to
make the most of the opportunity. If music, rather than painting,
was to be his entrée into this new world, so be it.

* * *

ON DECEMBER 26, 1476, in Milan, Duke Galeazzo Maria Sforza and a small entourage arrived at the Church of Santo Stefano, planning to attend Mass. Minutes later, the duke lay lifeless on the floor, knifed to death by three local assassins.

The murder created a political vacuum; Sforza's elder son, Giangaleazzo, was only seven years old. Two years of bitter infighting and political maneuvering ensued, until, in 1479, the duke's younger brother Ludovico seized power. Declaring himself regent, Ludovico cynically announced that he would rule until his late brother's son came of age. "I take up the burden of power," he said, "and leave the honors of it to my nephew." In all but name, he had become the city's duke. Many of his subjects, alluding to the swarthy color of his skin, soon began calling him simply the Moor.

Born in 1452, the same year as Leonardo, Ludovico received a respectable education as a boy. He read Latin and was proud of his skills as an orator. As a young man he spent several years living in exile in Tuscany, and while there came to recognize the degree to which Milan lagged behind Florence as a cultural power. Upon becoming regent he decided to rectify matters, devoting himself to matters of not only war and politics and commerce but also the arts.

Ludovico embraced the atmosphere of triumphant medievalism that he had inherited from his predecessors. He lived in a castle. He had a passion for heraldry. He commissioned churches in the Gothic and Lombard style. He surrounded himself with scholastic astrologers, doctors, and philosophers. He hired a fawning coterie of poets and painters to record his

greatness. He sought out talented musicians and dancers from all over Europe to adorn his court. He sponsored lavish pageants, hosted jousting festivals, and hunted with hounds.

At the same time, not immune to the Renaissance fever sweeping other parts of Italy, he launched a genuine program of cultural improvement in his city. From Florence and other important Italian cities he imported architects, artists, and writers, even going so far as to bring one Florentine writer to his court to help smooth out what he considered "the coarse speech of the Milanese." He had an eye for genuine artistic talent, too—and when Lorenzo de' Medici sent a certain Master Leonardo to play music at his court as a goodwill gesture on the part of the city of Florence, he recognized that the man had it in spades.

Leonardo traveled to Milan sometime between late 1481 and early 1483—quite possibly in mid-February 1482, to perform or compete in the city's Ambrosian festival. By Vasari's account, he arrived bearing an eccentric lute of his own design, made of silver and wrought in the shape of a horse's head: "a form," Vasari noted, "calculated in order to render the tone louder and more sonorous."

That sounds a lot like Leonardo. In the days that followed he proceeded to enchant Ludovico with not only his instrument and his musicianship but also his talents as an improviser of light verse. "He surpassed all the musicians who had assembled to perform," Vasari wrote, "and so charmed the duke by his varied gifts that the nobleman delighted beyond measure in his society."

Charming the Moor temporarily was one thing. But winning permanent gainful employment at his court was another—and

there's no evidence that Leonardo did so. Instead, the first surviving trace of him in Milan emerges in the spring of 1483, when a contract identifies him as part of an art studio run by the de Predis brothers. The contract makes him the lead artist in the job of painting an altarpiece, a work that would become his famous *Virgin of the Rocks.*

The de Predis brothers had good connections to Ludovico's court, which may be why Leonardo attached himself to their operation. But what they had to offer him was not the studio of his dreams. Instead, more than a year after his arrival in Milan, he was back in the kind of environment he knew all too well: the workshop collective. In the early 1480s Milan was home to about a hundred workshops, which produced not only paintings and sculptures but also a variety of the other objects required by a court: armorials, draperies, furniture, illuminated books, medallions, miniatures, paper feathers, pennants, tapestries, and more.

In the eyes of many at Ludovico's court, Leonardo's association with a workshop made him a second-class citizen. How dare he, a poorly educated artisan, breeze into town with his paintbrushes, his fancy lute, and his rose-colored tunic, spouting light verse, and aspire to join Ludovico's coterie of refined scholars and writers? Painting involved a certain amount of training and skill, of course, and Leonardo was an acknowledged master—but still, it was a menial craft, not a liberal art. Its practitioners certainly couldn't ever qualify as natural philosophers, despite what this impudent Florentine charmer seemed to believe. Did Master Leonardo, by any chance, know any . . . Latin? Was he well versed in the rules of grammar and oratory, as laid out by Quintilian and Cicero? How much

time, exactly, had he devoted to the study of Aristotle? Had he immersed himself in the thought of St. Augustine, the Venerable Bede, Hugh of St. Victor, and Thomas Aquinas—or, for that matter, the really *quite* informative encyclopedias of Pliny the Elder, Isidore of Seville, Vincent of Beauvais, and Albertus Magnus? Did he have any idea of the years of applied study it took to master the intricacies of astrological medicine? Perhaps he would care to share his thoughts on scientific works of Ptolemy and the Arabs? Had he ever even *heard* of a Roman architect named Vitruvius?

Leonardo bristled at being condescended to in this way. Ludovico had surrounded himself with court dandies, he felt, who didn't understand the nature of true learning, and he dismissed them as nothing but "trumpeters and reciters"—men who "strut about puffed up and pompous, decked out and adorned not with their own labors but by those of others." Much of the "knowledge" they so arrogantly and mindlessly referred him to was simply wrong, he believed—and he resolved to prove it.

So began a new phase in Leonardo's career: his inspired, frantic, sprawling, obsessive, free-associative, and ultimately lifelong effort to discover not only how things worked the way they did but also *why*. Its beginnings can be traced back to his time in Florence, but in Milan a new tone of seriousness creeps into his work, rooted in the sense, which must have dawned on him with an almost frightening cosmic grandeur, that everything in the world was governed and bound together by a set of universal laws, principles, relationships, and forces. If he pursued his empirical investigations of the world diligently enough, he began to feel, he might drill right down to the inner causes of

things—and then explain them for others in his art, far more efficiently and accurately than any writer could ever do.

Painting wasn't just painting, in other words. It was the act of holding up a mirror to nature. It was the visual transmission of not only surface appearances but also deeper, much more powerful essences, which he defined as "quality, the beauty of nature's creations, and the harmony of the world." In the sprawling *Speculum naturale*, or *Mirror of Nature*, the thirteenth-century encyclopedist Vincent of Beauvais had devoted 3,718 chapters to summing up all that was known about science and the natural world. Leonardo, for his part, dreamed of capturing it all in his art—perhaps even in a single picture.

In this context, anything could become for Leonardo a useful analogy for thinking about something else. A human body wasn't just a human body. It was a machine: a system of gears, pulleys, cables, and levers, animated by a variety of mechanical, hydraulic, and pneumatic forces. A machine, by the same token, wasn't just a machine. It was a body that, if designed harmoniously and kept in tune, like a musical instrument, could spring to life when acted upon by those same forces. Architecture could be thought of as a kind of anatomy; anatomy as a kind of geography; geography as a kind of mathematics; mathematics as a kind of geometry; geometry as a kind of music; music as a kind of physics; and so on. Proportion, Leonardo decided, was the key to it all and could be discerned "in numbers and measurements but also in sounds, weights, times, spaces, and in whatsoever power there may be."

Hungry for knowledge in its own right but also motivated by a desire to prove the superiority of his art and gain employment at the Milanese court, Leonardo plunged himself into his

investigations. The whole business was intoxicating—and dizzying. The challenge was how to keep track of everything. He needed a way of collecting his observations, comparing his data, pinning down his thoughts, capturing his visions, roughing out his pictures, remembering what he'd been told, recording what he'd read, and reminding himself of his plans.

5

THE ARTIST-ENGINEER

The work our hands do at the command of our eyes is infinite.

—Leonardo da Vinci (c. 1490)

HE SOLUTION he came up with, probably sometime in the early 1480s, was to keep a set of notebooks. It wasn't a new idea. Master artists in workshops had long given their apprentices copybooks to learn from and encouraged them to build collections of their own studies and drawings. Leonardo began keeping sketchbooks early in his career, probably while working under Verrocchio—and he certainly was doing so by the time he arrived in Milan. Not long after he arrived there, for example, he set down a detailed inventory of his work that reads distinctly as though he's flipping through the pages of his portfolio.

Many flowers copied from nature; a head, full-face, with curly hair; certain St. Jeromes; measurements of a figure;

designs of furnaces; a head of the duke; many designs of knots; 4 drawings for the picture of the Holy Angel . . . a head of Christ done in pen; 8 St. Sebastians; many compositions of angels . . . a head in profile with beautiful hair style; certain forms in perspective; certain gadgets for ships; certain gadgets for water . . . many necks of old women; many heads of old men; many complete nudes; many arms, legs, feet, and postures; a Madonna finished; another, almost finished, which is in profile; the head of Our Lady who ascends to heaven; a head of an old man with an enormous chin; a head of a gipsy; a head wearing a hat.

Many of these items are exactly what one would expect from a workshop artist trained in fifteenth-century Florence: the heads of Christ, all those saints and angels and Madonnas. But some of the others—the designs for machines and gadgets—reveal that by the early 1480s Leonardo had already begun to think of himself not just as a painter or a sculptor but as something altogether more ambitious: an artist-engineer.

Leonardo's role model in this regard was the remarkable Filippo Brunelleschi. Originally trained as a goldsmith and watchmaker, Brunelleschi early in his career had proved himself to be an artist of great technical skill. Memorably, in 1418, he had perfected and introduced Florentines to the technique of linear perspective, the most important artistic development of the fifteenth century. But the work for which he became most famous was the magnificent dome he built atop the cathedral of Florence.

When Leonardo first arrived in Florence, in the late 1460s, Brunelleschi was already the stuff of legend. Alberti had set the

tone in 1436, just after the dome had been consecrated, when he dedicated the Italian edition of *On Painting* to him. "What man," he wrote, "however hard of heart or jealous, would not praise Filippo the architect when he sees here such an enormous construction towering above the skies, vast enough to cover the entire Tuscan population with its shadow, and done without the aid of beams or elaborate wooden supports? Surely a feat of engineering, if I am not mistaken, that people did not believe possible these days and was probably equally unknown and unimaginable among the ancients."

Everybody in Florence knew the story of Brunelleschi and his dome: How the renowned Roman architect Arnolfo di Cambio had been hired in 1292 to transform a dilapidated church in the center of the city into a monumental symbol of Florentine wealth and ingenuity, intended to rival the massive cathedrals that were sprouting up all over northern Europe. How di Cambio, or somebody else in the decades that followed, had decided that the signature feature of the cathedral would be the largest dome in the world. How the overseers of the project, in 1367, had decided that the dome should actually consist of *two* interlocking domes: one on the exterior, which would rise to an unprecedented height; and one on the interior, which, protected and supported by the external dome, would appear to hover weightlessly over the body of the church, almost like the dome of the sky itself. How, by 1400, work on the church had stalled completely, because nobody could figure out how to actually build such a dome. How, in 1418, desperate to move ahead with the project, the overseers of the cathedral had announced a public contest to find a solution. And how Brunelleschi, despite

not having any experience as a practicing architect, had entered the contest and saved the day.

Brunelleschi's solution came in the form of a brick model. The ingenuity of its design appealed to the overseers, and in 1420, not without some apprehension about his qualifications for the job, they awarded him the commission for the dome. The risk paid off spectacularly. For some sixteen years he personally supervised all aspects of the dome's construction: overseeing the efforts of swarms of lumberjacks, quarriers, carpenters, masons, bricklayers, and other laborers; grappling daily with emerging design challenges; and working with enormous winches, hoists, and cranes of his own secretive design, which allowed him to quickly and safely raise huge amounts of heavy building materials hundreds of feet above the ground and then move them laterally into place. Year by year, in what amounted to a de facto public works project, the dome gradually came together, until at last, at nine in the morning on August 30, 1436, the bishop of the nearby town of Fiesole climbed up to the top of the dome and symbolically set its final stone in place. Trumpets blared, bells rang out, and all across the city Florentines, ballooning with civic pride, clambered to their rooftops to gaze at the spectacle.

It was a stunning achievement. Brunelleschi's dome clearly rivaled the greatest of all domes, that of the Hagia Sophia in Constantinople—a dome that the Greek scholar Manuel Chrysoloras, an important mentor to many of Florence's early humanists, had praised not long before, using terms that Florentines now began to apply to their own new dome. "This work," Chrysoloras had written, "makes the spectator wonder

at the ready intelligence and capacity to achieve great things not only of this architect and of the other builders but of the whole human race. . . . The dome reveals inventiveness, elevated thought, dignity, and power such as no one before ever would have imagined."

Ready intelligence, inventiveness, the capacity to achieve great things: these were the traits that Florentines came to associate with the man who had built their great dome. Soon Italians everywhere were celebrating Brunelleschi as a symbol of the almost limitless potential of the human mind. The shadow of the great man, like the shadow of his dome, loomed large over Florence in the fifteenth century—and, inevitably, over the young Leonardo as he came of age in the city. Brunelleschi became a role model for Leonardo: a lowly craftsman who, thanks to his ingenuity, had ennobled his profession and earned himself lasting glory as an artist-engineer.

Like so many other Florentines, Leonardo fell prey to the *malattia del duomo.* As the affliction took hold, Brunelleschi's dome began to dominate the landscape of his thoughts. Some of his earliest surviving sketches show the giant machines that Brunelleschi had devised to construct it, and scattered across the early pages of his notebooks one finds both hasty sketches of and careful plans for domes based on Brunelleschi's original. The collective effect is mesmerizing: a ghostly procession of images, reflected in drawings like his famous *Study for the Head of St. James,* that for years seem to have mirrored the dissolving patterns of his dreams (**Figure 22**).

Figure 22. Domes and study for the head of St. James,
by Leonardo da Vinci (c. 1495).

* * *

BRUNELLESCHI SEEMS NOT to have kept notebooks or put his engineering ideas onto paper. Instead, obsessed with guarding his secrets, he preferred to work with three-dimensional models and keep the details in his head. But other artist-engineers of his generation did sketch out their thoughts and designs, and in their work one finds a precedent for the notebooks that Leonardo would begin keeping in the early 1480s. The most influential of these figures was Mariano di Jacopo, a Sienese colleague and confidant of Brunelleschi, known in his day as Taccola ("the Crow").

Taccola and Brunelleschi had much in common. Almost the same age, both men had started out as craftsmen: Brunelleschi as a goldsmith, Taccola as a wood-carver. Both had worked as sculptors and artists. Both had risen to prominence in their native cities as engineers and inventors with a special interest in public works, architecture, the lifting and moving of weights, the harnessing of water power, and the design of boats, aqueducts, and war machines. By the time they met, Brunelleschi's fame as an architect and engineer extended far beyond Florence. Taccola, for his part, was known as the Sienese Archimedes, a reference to the ancient Greek mathematician and inventor Archimedes of Syracuse, who in the third century B.C. had invented a variety of pumps, water screws, siege engines, and other devices, a number of which Vitruvius would catalogue in the *Ten Books*.

Unlike Brunelleschi, however, Taccola sketched out scores of engineering designs and ideas, which survive today in two works. The first, *On Engines*, dates from the 1420s and 1430s;

the second, *On Machines,* dates from the 1440s. Both brim with idiosyncratic illustrations that are by turns practical and fanciful: a variety of winches, gears, levers, cranks, cranes, siphons, pumps, catapults, ladders, and mills; animal-powered aquatic vehicles, a sail-powered land vehicle, and an underwater breathing apparatus; an underground explosive mine; plans for constructing harbors and desalinating seawater. Taccola's illustrations also include some of the earliest known drawings of the devices invented by Brunelleschi for the construction of his dome (**Figure 23**).

Figure 23. A machine of Brunelleschi's, as illustrated by Taccola. "It is built for [four] reasons," its caption reads. "First, because it turns rapidly. Second, because it facilitates lifting as large weights are raised on high. Third, because it runs forward and not backward. Fourth, it does not waste time."

Copies of Taccola's manuscripts and illustrations circulated among artist-engineers in the latter half of the fifteenth century. Given his interests, Leonardo is likely to have sought them out in either Florence or Milan, and if he did he can't have missed one haunting illustration—executed as a kind of Vitruvian self-portrait—that Taccola included in *On Engines*. The illustration shows a naked figure inscribed in a circle and a square, above which appear a compass, a set square, and a plumb line. On a literal level, these are simply the tools of the architect and engineer. But in the accompanying caption Taccola makes clear that he wants the whole drawing to be understood symbolically, if not in the manner of Vitruvius himself, then at least in the manner of the many medieval illustrators who had summoned up the ghost of Vitruvian Man. "He from whom nothing is hidden created me," the caption reads. "And I have all measure in me, both of what is heavenly above and what is earthly and infernal. And who understands himself understands much" (**Plate 7**).

That's a potent distillation of medieval ideas about the microcosm. But Taccola provided a twist. Nowhere did he identify his subject as Adam or Christ or God, as Hildegard of Bingen and so many other illustrators had done. Instead, in a shift that reflects the emerging spirit of the Renaissance— and the emerging can-do spirit of the artist-engineer—his subject was the individual, who, through the pursuit of self-knowledge, can access the godlike creative powers latent in all human beings. This was an idea, resonant with Neoplatonic and Albertian overtones, that would appeal greatly to Leonardo

when he began to imagine himself as an architect-engineer, and not long afterward, when he would conjure up his own vision of Vitruvian Man.

LEONARDO DIDN'T JUST model his notebooks on the sketch-books of artists and engineers. He also turned to another source for inspiration: the commonplace book, designed to preserve not pictures but words.

Students receiving a formal education in Leonardo's day were taught from a very early age to keep commonplace books—notebooks, that is, in which they collected excerpts from their reading, organized not by author or book but by subject. Central to the pedagogy of the age, the commonplace book had two main functions. It helped students develop educationally desirable habits of mind, based on the categories their teachers had them divide their notebooks up into, and it allowed them to organize a store of the best that had been thought and said. This, so the thinking went, would serve them well in their ongoing studies, and, indeed, throughout their lives.

The keeping of commonplace books was so widespread a practice that Leonardo may well have been asked to keep one during the patchy education he received as a young boy in Vinci. If not, he surely came across an abundance of examples in Florence, especially after he began seeking out and spending time with the city's humanists and scholars. A how-to guide for the keeping of commonplace books even survives from the early 1500s. "Make a book of blank leaves of a proper size," it reads. "Divide it into certain topics—so to say, into nests. In one, jot

down the names of subjects of daily converse: the mind, body, our occupations, games, clothes, divisions of time, dwellings, foods; in another, idioms or *formulae docendi*; in another, *sententiae*; in another, proverbs; in another, difficult passages from authors; in another, matters which seem worthy of note to you or your teacher."

The instructions were modern, but the practice had ancient roots. Writing in the first century, Seneca had described it in a manner that would have appealed very much to Leonardo. "We should imitate bees," he wrote, using an analogy much cited during the Middle Ages and the Renaissance, "and keep in separate compartments whatever we have collected from our diverse reading, for things conserved separately keep better. Then, diligently applying all the resources of our native talent, we should mingle all the various nectars we have tasted and turn them into a single sweet substance, in such a way that, even if it is apparent where it originated, it appears quite different from what it was in its original state."

Consciously or not, as Leonardo began to keep his notebooks he combined elements of the sketchbook and the commonplace book. Flitting about very much like a bee in an open field, he observed no real boundaries: he copied the works of artists he admired, he made sketches from nature, he played with ideas for paintings, he drew landscapes and mapped cities, he jotted down his thoughts, he wrote rough drafts of letters, and he began composing formal treatises, almost entirely in his trademark backward script. Farther and farther out he went in all directions, dreaming up inventions both practical and fanciful, experimenting with new kinds of draftsmanship, analyzing

geometrical problems, studying the behavior of light, exploring visual analogies, making lists of things he wanted to know and do, and collecting allegories, jokes, and fables.

No matter how disparate his investigations seemed, however, they had a powerful underlying unity of purpose: the search for nectar that he could transform into the sweet substance of his art. The Greeks had been right, he felt. The world was a kind of giant animate being, and even its smallest part contributed vitally to the harmonious functioning of the whole. "Everything proceeds from everything," he wrote, paraphrasing the ancient Greek philosopher Anaxagoras, "everything becomes everything, and everything can be turned into everything else." Limning the implications of this idea, he anticipated what modern chaos theorists call the butterfly effect. "The earth is moved from its position," he wrote, "by the weight of a tiny bird resting upon it."

Leonardo covered all of this and much more in his notebooks. What they reveal about his mental life—his preternaturally visual way of thinking, the startlingly free-associative nature of his ideas, the ever-widening range of his interests, the rapidly accelerating pace of his studies and investigations—boggles the ordinary mind. A torrent of ideas and images flooded into his head each day, and he used his notebooks as a way of trying to capture and make sense of them. "My concern now," he wrote at one point, "is to find 'cases' and inventions, gathering them as they occur to me; then I shall put them in order, placing those of the same kind together. Therefore, you will not wonder nor will you laugh at me, Reader, if here I make such great jumps from one subject to the other." Ultimately, he would

fill an estimated thirty thousand manuscript pages with notes and drawings that cover just about every conceivable subject of human inquiry. More than six thousand of those pages survive, some as loose sheets, some in giant miscellanies gathered and bound after his death, and some in notebooks preserved largely as he left them, ranging from large folios to the tiny pocketbooks he kept hanging from his belt. Almost everything we know about Leonardo derives from his notebooks—which, considered together, surely represent the most astonishing testament to the powers of human observation and imagination ever set down on paper.

LEONARDO MUST HAVE spent hours every day at work on his notebooks. But he had yet to resolve the vexing practical matter of gainful employment.

By 1483 he had delighted Ludovico Sforza with his music and his verse. Allied with the de Predis brothers, he had even received the commission for the *Virgin of the Rocks*. But he was still far from getting what he wanted: a permanent, salaried position at the court. Not only that, he began to realize that neither music nor painting was likely to allow him to achieve that end. That's because between 1482 and 1484 Sforza had something more pressing on his mind than art. Venice had invaded Lombardy—and was threatening war with Milan.

Leonardo recognized this as an opportunity. After all, he had learned the techniques of metal casting under Verrocchio and had seen plenty of armorers' workshops and arsenals in Florence. On his own, he had studied projectile physics and experimented with gunpowder. He had interrogated bombar-

diers. He had closely studied the machines and engineering techniques of Brunelleschi, which involved lifting devices and gear systems that could be applied effectively to the problems of siege warfare. He had already constructed at least one stringed instrument, which, as a design challenge, hadn't differed dramatically from the construction of, say, a crossbow. He had seen illustrations of scores of weapons and machines, both real and imaginary, in treatises on the art of war—most notably in *On Military Matters* by the Italian engineer Roberto Valturio, a volume first published in Latin in 1472 (but then, helpfully for Leonardo, translated into Italian in 1483) (**Figure 24**).

The odds are good that he had also studied the engineering manuscripts of Taccola, who had designed a variety of imaginative, if not always practical, war machines, some of which had been copied by Valturio. By this time he surely had also heard of Francesco di Giorgio Martini—the renowned Sienese artist turned engineer with whom, in 1490, he would travel to Pavia as an architectural consultant for Ludovico Sforza. In the previous decades, Francesco had written his own treatise on military architecture and had won himself a highly respected position in the service of the duke of Urbino.

Military engineering: it seemed a natural choice, representing for Leonardo a chance not only to make a good living and win favor with Ludovico Sforza but also to continue pursuing his endlessly proliferating investigations of how things worked. Since everything was related to everything else, it didn't really matter where he chose to begin his investigations; no matter where he started, he knew he'd end up arriving at the same universal laws and first causes. War was an unavoidable reality in fifteenth-century Italy and seemed imminent for the Mila-

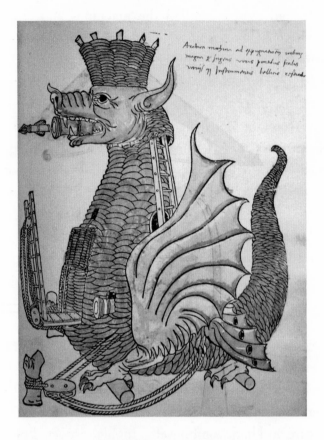

Figure 24. Siege engine in the form of a dragon,
by Roberto Valturio (1472).

nese, so why not make the most of what the situation had to
offer him?

Leonardo launched himself into the study of military engi-
neering with unbridled enthusiasm and creativity. This often
troubles those who prefer to think of him as the contemplative
master who would spend hours serenely pondering the addition
of single brushstrokes to such masterpieces as the *Mona Lisa*

and *The Last Supper,* or as the gentle vegetarian who, accord-
ing to Vasari, bought caged birds solely for the delight of set-
ting them free. But his notebooks reveal a different side of
him. Strewn across page after page are designs for machines of
defense and destruction. By turns ingeniously practical, weirdly
archaic, and creatively implausible, they show a mesmerizing
variety of inventions: scaling ladders, siege engines, trench dig-
gers, tunnel borers, small weapons, machine guns, cannons,
armored tanks, gunboats, a giant catapult, a gargantuan cross-
bow, chariot-powered scythes (**Figure 25**).

The more time and energy that Leonardo invested in inves-
tigating the study of military engineering, the more confident
he became in his own abilities and inventions. If Roberto Val-
turio or Francesco di Giorgio Martini could succeed in the
field, winning themselves both fame and fortune, then surely
so could he. And so, in about 1484, he drafted a remarkable
letter to Ludovico Sforza, detailing how he could serve the duke
by designing portable bridges, siege machinery, silent tunnel
diggers, armored tanks, aquatic attack vehicles, fire throwers,
catapults, and mortars—in short, as he put it, "an infinite variety
of machines for both attack and defense."

Whether Leonardo actually ever sent this letter is unclear.
The odds are that he didn't, but even if he did, little came of it.
As was his wont, he had dawdled a bit too long. On August 7,
1484, the Venetians signed a peace treaty that brought their
military expansionism in northern Italy to an end. For the Mila-
nese, the prospect of war faded, and gradually, after a horrifying
outbreak of the plague, a new era of peace and prosperity began,
allowing Ludovico once again to focus on the beautification
of his capital. What interested him now were projects of not

Figure 25. Studies of gun barrels, mortars, and, at bottom, a manned nautical machine gun, by Leonardo da Vinci (c. 1485–90).

military but civil engineering: the improvement of sewers, the paving of streets, the shoring up of walls, the demolition and renovation of aging structures, the construction of new ones.

Sensing a shift in the winds, Leonardo drifted away from military engineering. Instead, he began focusing on architectural projects—and, in 1487, turned his attention to the unfinished cathedral of Milan. Perhaps, like Brunelleschi before him, he could place a dome atop one of the world's greatest cathedrals and earn lasting glory for himself as an ingenious master builder.

6

MASTER BUILDERS

I shall show . . . the causes that bring ruin to buildings, and what is the condition of their stability and permanence.

—Leonardo da Vinci (c. 1488)

B Y THE TIME Leonardo decided to try his hand at their game, the cathedral builders of Europe had long established themselves as a kind of medieval fraternity. What's known of their story begins in the early twelfth century, with the work of a Benedictine monk named Suger.

Suger served as the abbot of Saint-Denis, a church near Paris that since the time of Charlemagne had been the burial site of the kings of France. It was a plum job. But when he first arrived there, in 1122, he found the church in a sad state of disrepair—and its monks in a corresponding state of moral collapse. He wasn't alone to notice this. When the philosopher Peter Abélard sought refuge at Saint-Denis in the 1120s, feeling more than a bit glum after the public revelation of his famous affair with

Héloïse, which had led to his castration, he was appalled at what he encountered. Life at Saint-Denis, he wrote, was "completely worldly and depraved."

Suger resolved to restore order. He would rebuild his church, he decided, in a style designed to inspire a new kind of religious contemplation—a style, it turned out, that would give rise to the great cathedral spaces of Europe. Ruminating on the kind of church he hoped to create and inhabit, he wrote, "I see myself dwelling, as it were, in some strange region of the universe that exists entirely neither in the slime of the earth nor in the purity of heaven." He then went on to explain what would happen to him, or anybody else, who entered that strange region. "By the grace of God," he wrote, "I can be transported from this inferior to that higher world in an anagogical manner."

Anagogy. Now, *there's* a word not thrown around much today. Derived from the Greek verb *anagein* ("to lift up") and the related noun *anagoge*, the word had long been used by Latin and Greek theologians to signify the spiritual uplift that comes from discovering signs of Heaven in earthly things. Christian scholars and theologians regularly employed the technique in parsing Scripture and had long used it, in both the Latin and Greek traditions, to unpack what the Bible taught about the Church. In the seventh century, for example, discussing the building of churches, the Venerable Bede had written, "The foundation of the temple is to be understood mystically." At about the same time, a Greek abbot named Maximus had expanded on the theme. After describing a church as "a figure and image of the entire world," he had gone on to note, "For those who are capable of seeing this, the whole spiritual world seems mystically imprinted on the whole sensible world in symbolic forms."

Nobody saw all of this more clearly than Hildegard of Bingen—who, as it happened, corresponded with Abbot Suger during the first half of the twelfth century. When Hildegard became an abbess at St. Rupert, the monastery she founded near the town of Bingen, like Suger she undertook the building of a church. During the years she oversaw its construction, architectural imagery flooded into her mind, laden, she felt, with symbolic and anagogic import.

In Hildegard's view, God was the master builder responsible for the architecture of everything. She wasn't alone in thinking this way. Her contemporary Alan of Lille referred to God as "the elegant architect of the world"—an increasingly popular idea that manuscript illuminators began to translate into visual form at about this same time (**Plate 6**).

Hildegard and Suger didn't play a role in the technical design and construction of their churches. Instead, each gave general instructions to a master builder—a sort of general contractor who, in turn, relying on a team of masons, carpenters, and other manual laborers, would have done his best to make her architectural visions a reality. In keeping with the practices of their age, however, Hildegard and Suger didn't feel it necessary to record the names of their master builders. Next to nothing is known about them. They were craftsmen, experts at what they did, but part of a lowly professional class considered worthy of little mention. That's a shame, because it was medieval master builders who, in the twelfth and thirteenth centuries, set in stone some of the most enduring, elaborate, and monumental visions of the microcosm ever produced: the great cathedrals of Europe.

* * *

PITY THE POOR master builder tasked with creating Suger's "strange region of the universe." Whoever he was, he turned out to be a man of rare genius. Given the job of creating an other-worldly sense of uplift and light, he devised a new architectural style that would define church building in Europe for centuries to come. Initially known simply as the French style, it combined such already existing elements as the pointed arch, the ribbed vault, the flying buttress, and the elevated stained-glass window, and made possible churches of previously unimaginable size and grandeur. It all seemed the fulfillment of a biblical prophecy. "It shall come to pass in the latter days," the Book of Isaiah read, "that the mountain of the house of the Lord shall be established as the highest of the mountains, and shall be raised above the hills; and all the nations shall flow to it."

And so up they rose, the mountainous cathedrals of medieval Europe—stone by stone, column by column, arch by arch, spire by spire, vaulting skyward, enclosing vast expanses of space and light. Rising to unprecedented heights, intricately geometrical in design, they were marvels of structural engineering that awed and delighted visitors, but they came together according to no single master plan or coherent set of proportions. Instead, inspired by the ideas of Suger and other religious leaders, they evolved in fits and starts over the course of decades and even centuries, constantly changing in response to the whims of their sponsors and the technical challenges encountered by their builders.

Not everybody appreciated the style. By the early fifteenth century, it had become anathema to the architects of the Italian Renaissance, who were developing a very different idiom: clean, spare, and based (they claimed) on the architecture of ancient

Greece and Rome. The Florentines, in particular, rejected it when considering the design of their own cathedral. As the self-anointed heirs of the Roman tradition, they felt they could do better than those barbarian Goths and Franks, whose gangly, monstrous cathedrals they saw spreading all over Europe like a plague. The cathedrals of northern Europe were all so hideously *Gothic*: good enough for the boorish warmongers of Milan, maybe, but not for the dignified republicans of Florence. Giorgio Vasari summed up the view in the sixteenth century when writing a history of architectural style.

> We come at last to another sort of work called German, which both in ornament and in proportion is very different from the ancient and the modern. Nor is it adopted now by the best architects but is avoided by them as monstrous and barbarous, and lacking everything that can be called order. Nay, it should rather be called confusion and disorder. In their buildings, which are so numerous that they sickened the world . . . they made endless projections and breaks and corbelings and flourishes that throw their works all out of proportion. . . . This manner was the invention of the Goths. . . . May God protect every country from such ideas and style of buildings!

All of this raises an interesting question. Did the convoluted, elaborately geometrical plans of the cathedrals encode the symbolic ideals of their patrons, or did they simply represent ad hoc engineering solutions worked out by their builders? It's a complex question with no easy answers—but there's no doubt, at least, that many medieval Christian thinkers under-

stood cathedrals as an important way of prompting believers to contemplate the awe-inspiring design of the cosmos. Cathedrals were universes in stone, three-dimensional renditions of the diagrams and maps of the microcosm that had long appeared in religious texts.

The cathedrals made this idea manifest in all sorts of ways. Laid out on an east-west axis in the form of a cross, not unlike the town plans of the Roman surveyors, the cathedrals reached out to the four corners of the earth, bringing cosmography and geography together in the manner of the great medieval world maps. Their mountainous exteriors summoned up images of the natural world, re-creating the terrible splendors that Europe's pilgrims and crusaders were beginning to experience in the Alps as they made their way to and from the Holy Land: the forbidding summits, the jumble of steeply rising slopes, the sheer cliffs, the precarious overhangs, the precipitous drops, the shadowy crevasses. Inside the cathedrals, too, the natural world came to life: the tops of columns sprouted leaves and faces; strange races of monsters lurked in the building's dark recesses; and haunting all things great and small, as it did in cosmic diagrams and world maps, was the ghost of the human figure itself.

Cruciform churches had long evoked the idea of the human body, in the form of Christ on the cross. The tradition was still alive and well in the thirteenth century. European cathedrals took this to the next level, offering visitors an almost anatomical view of the church as a microcosmic body. A prominently visible spine extended along its full length, framed by a skeleton of ribs and joints that themselves were covered over with a skin of stone and glass. The bishop of Mende, William Durandus, formerly the dean of the canons at Chartres, summed up the

basic idea near the end of the century. "In the articulation of its parts," he explained, "the arrangement of the material church resembles that of the human body: the chancel, where the altar is placed, represents the head; the transepts, to the left and right, the hands and arms; and the other part, which lies westward, the rest of the body."

The idea would have great staying power. Fifteenth-century visitors would describe the cathedral of Florence in remarkably similar terms, and when Leonardo turned his attention to the cathedral of Milan in 1487, he, too, would approach its design with the human analogy in mind.

FRUSTRATINGLY LITTLE IS known about the specifics of cathedral construction in medieval Europe. But this much can be said with certainty: the cathedrals did not arise according to a set of "organic" proportional relationships, like the ones proposed by Vitruvius. Instead, they arose according to abstract principles of geometry. Each individual element of the building, and the building as a whole, was built not according to pre-established numerical ratios (if the width of the base is x, the height must be y) but according to reiterations of particular shapes, most commonly the triangle and the square.

The theory seems to have gone something like this. Building a cathedral *ad triangulum* ("to the triangle") or *ad quadratum* ("to the square") meant that no matter how haphazardly and idiosyncratically it arose, its soundness as a structure would be guaranteed by the basic rules of geometry. These were the same rules, after all, that God the architect, with metaphorical set square and compass in hand, had used in constructing

the universe. And geometrical shapes, of course, had symbolic meanings. The triangle, with its three sides, signified the Trinity and represented the elements surrounding the earth (air, water, fire). The square, for its part, with its four sides, signified the earth itself and represented all of the other sets that came in fours: the elements, the bodily humors, the cardinal directions, the seasons, the Gospels, and more.

Then as now a down-to-earth lot, builders aren't likely to have cared much about all of this. Geometry for them was primarily a practical means to an end: the successful construction of a building. They probably had no choice but to sit through many a long-winded lecture from their patrons, however, about the importance of geometrical symbolism. One eleventh-century German monk, Heribert of Cologne, seems to have given many such lectures; he is described in one manuscript as "seeking out architects from foreign borders and imparting to them the science of all building." For monks like Heribert, geometrical symbolism, not the hands-on cobbling together of structures, was the true science of all building.

No figure in European history provides a more revealing or entertaining view into this forgotten world of medieval church building than an idiosyncratic thirteenth-century Frenchman named Villard de Honnecourt.

Nobody really has any idea who Villard was. His name has survived for one reason alone: sometime in the early 1200s, thirty-three parchment sheets of his illustrations were bound into a pigskin folio, along with his notes, annotations, and a dedicatory preface. "Villard de Honnecourt greets you," he wrote in the preface, "and prays to all who will use the devices found in this book that they will pray for his soul and remember

him, because in this book you can find sound advice on the great techniques of masonry and on the devices of carpentry. Also, you will find the technique of representation that the discipline of geometry requires and instructs."

The sense of didactic purpose in Villard's dedication, combined with the wealth of architectural and geometrical detail that his portfolio contains, suggests that he may have been a builder of some sort: a wise master, perhaps, who pulled the portfolio together as a model book for his apprentices. But his dedication has the strong feeling of a cursory, after-the-fact justification of a personal indulgence—and nothing in the portfolio suggests that he actually ever did any work as a builder. No record of his name or deeds survives anywhere outside his portfolio, in fact, which has led a growing number of modern scholars to argue that he was more of a crossover figure: an itinerant, educated dilettante, who loved architecture and geometry and machines, who thought primarily in terms of visual analogies, and who couldn't help recording and working out his thoughts by doodling in private. If that's the case, he represents the emergence of the artist-engineer in Europe: a fascinating new breed that would eventually give rise to such figures as Brunelleschi, Taccola, Francesco di Giorgio Martini, and Leonardo.

Villard's illustrations are a delight to look at. He showed his readers details and plans of the churches he visited; he sketched a variety of building tools and machines, including a mill-powered saw; he detailed a variety of geometrical techniques; and everywhere, all over his pages, he doodled playful portraits of people and animals. And many of his most memorable illustrations, needless to say, make unusual and striking connections between architectural form and the human body. On one sheet,

which juxtaposes a drawing of the Madonna and Child with a sketch of a nave-aisle window from Reims cathedral, the general contours of the two images are so similar that the ghosts of Mary and Jesus seem to have taken shape and arisen directly from the window (**Figure 26**). On another sheet Villard drew two wrestlers, and on the sheet directly opposite them he drew the plan for a church choir that he says he himself "imagined." The two pictures again are so remarkably similar in outline that it seems as though the wrestlers themselves helped Villard come up with the church plan—and, indeed, one scholar has superimposed the two images to show just how neatly they correspond, in both form and scale (**Figure 27**).

Figures 26 and 27. Left: Madonna and child, and a nave-aisle window from Reims cathedral, by Villard de Honnecourt. *Right:* Wrestlers and church choir, by Villard de Honnecourt, drawn separately but here superimposed to highlight their correspondences.

But Villard didn't just see the human body in the makeup of churches. He also saw geometrical figures—notably, triangles and squares—in the makeup of the human form (**Figure 28**). This is a far cry from the ideas of Vitruvius about the relationship between the human body and architecture. Villard reduced the form of whatever he was drawing not to numerical proportions but to geometrical figures, and that—whether or not Villard was actually an architect himself, or thought about geometry in mystical terms—aligns him with the master builders of medieval Europe's cathedrals.

BY THE END of the fourteenth century, it wasn't just northern Europeans who were building cathedrals and looking to master builders for help. Many of the big Italian cities had decided to get into the game.

That was certainly the case in Milan. Local leaders there had drawn up plans for a cathedral in 1386, ambitiously imagining that they could erect it themselves. As work got under way, however, they soon recognized that they were out of their depth. Unable to decide such matters as whether the cathedral "ought to rise according to the square or the triangle," as church records put it, they reluctantly decided to seek the advice of a northern expert. The man they ended up with, in 1399, was a French engineer named Jean Mignot, who, not long after he arrived, having discovered the ad hoc manner in which the project was advancing, threw up his hands in disgust.

One can understand why. A key element of the plan that the overseers had hatched for their cathedral involved the construction of what they called a *tiburio*—a central cupola, or dome,

Figure 28. The geometrical underpinnings of everything:
a sheet from Villard de Honnecourt's portfolio.

the vertical dimensions of which, grandly, had been designed to correspond to those of the Pantheon, in Rome. Mignot doubted the soundness of the proposed structure. Oozing scorn, he lectured the Milanese about the need to marry the practical art of masonry and building, which Italians were renowned for, with something northern builders knew much more about: the theoretical science of geometry.

The Milanese didn't want to hear it. Geometry was important, they acknowledged, and they made noises to Mignot about having worked with the dictates of geometry in mind. But science was one thing and art another, they told him. They had devised their plan according a symbolic model that involved much more than the mere arrangement of triangles and squares—a model that they knew *their* artisans could render durably in stone. In their model, they explained, "The Lord God is seated in Paradise in the center of the throne, and around the throne are the four evangelists according to the apocalypse, and these are the reasons why they were begun."

This kind of talk made Mignot's blood boil. The overseers were designing their cathedral "in a fashion more willful than sound," he wrote. They were "ignorant people" who didn't understand that "art without science is nothing," which could lead to only one outcome. "If the church were to be made with said towers in this position," he declared, "it would infallibly fall"—as had happened a century earlier, with the collapse of the choir vaulting at Beauvais cathedral, in France.

The Milanese kept Mignot on for more than a year, during which time he continued to make his case, at one point even appealing to a committee of other northern experts. Not

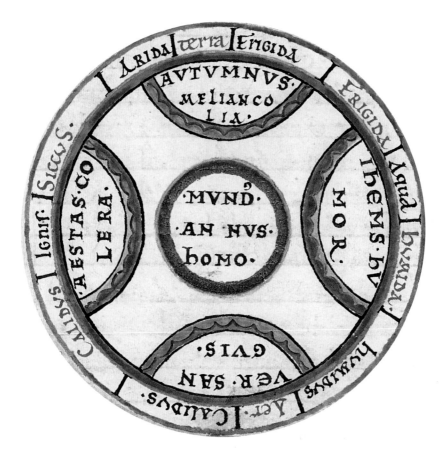

Plate 1. An eleventh-century diagram of the microcosm-macrocosm analogy. The human being (*homo*) occupies the same circle as the world (*mundus*) and the year (*annus*), and thus embodies all of time and space. The four elements link everything together. Fire, air, water, and earth make up the world, and their characteristics (heat, moisture, cold, and dryness) define the four seasons and the four bodily humors.

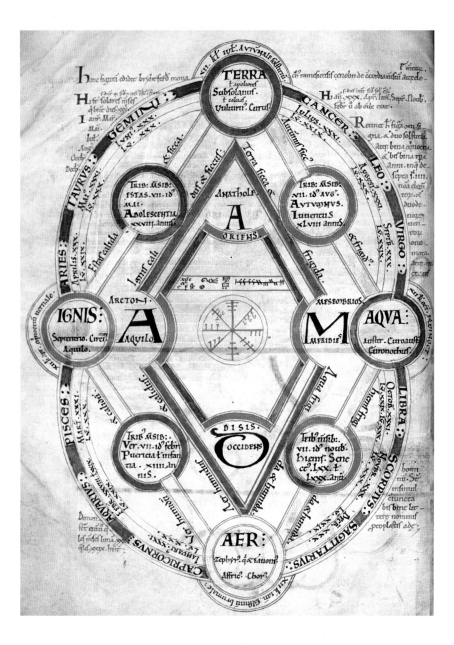

Plate 2. A twelfth-century diagram of the macrocosm-microcosm analogy. The four elements are linked to the four seasons, the four humors, the four cardinal directions, the four ages of man, the twelve winds, the twelve months, and the twelve signs of the zodiac. At the corners of the central diamond are the four cardinal winds, named in Latin and Greek. The initial letters of the Greek names spell out the name of Adam, who, in tiny script inside the red circle at the center, is identified with Christ, abbreviated as ΧΡΣ.

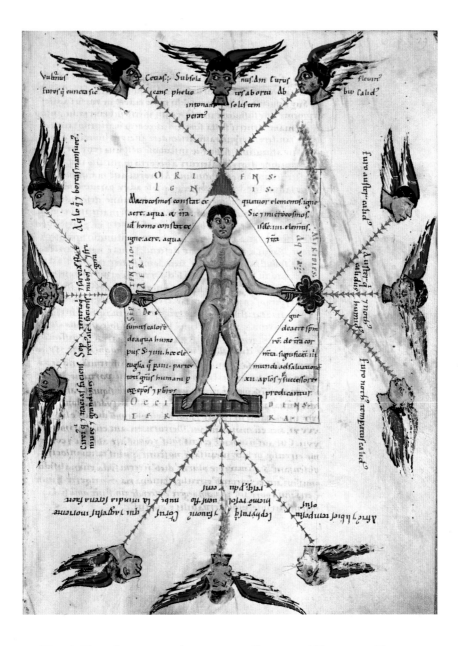

Plate 3. The microcosm and macrocosm, from a twelfth-century German manuscript. The illustration gives human form to the sort of geometrical scheme laid out in Plate 2, and its layout underlies the microcosmic vision of Hildegard shown in Plate 5.

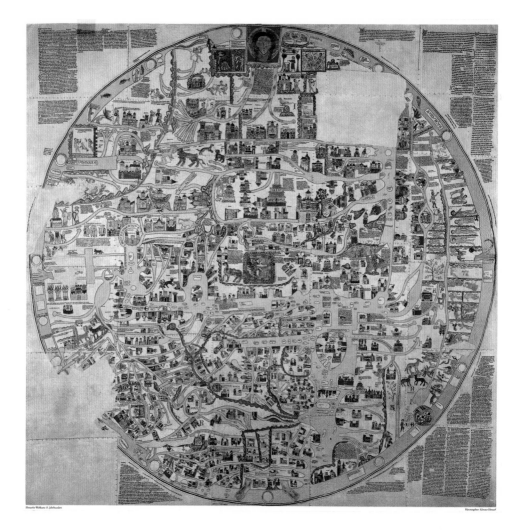

Plate 4. A geographical anatomy of the microcosm: the Ebstorf mappamundi, from the early thirteenth century. East is at the top, and the earth consists of three parts: Asia (*top*), Europe (*bottom left*), and Africa (*bottom right*). The entire image is also an embodiment of Christ, whose head appears at the top, whose feet appear at the bottom, and whose hands appear at the sides.

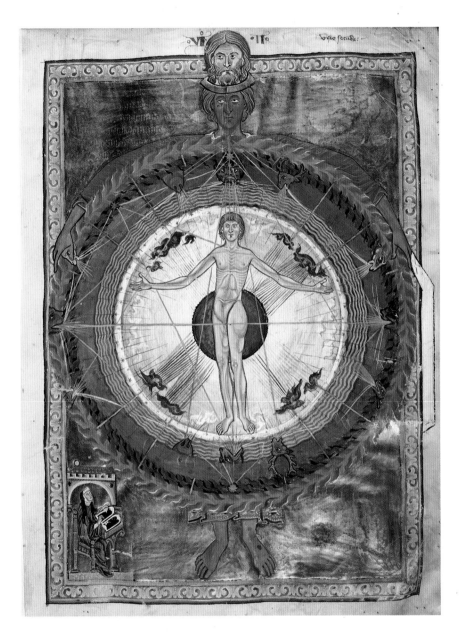

Plate 5. The microcosm as envisioned by Hildegard of Bingen. At the center, superimposed on the earth, is a human figure who at once represents Adam, Christ, and all of humanity. At the circumference, embodying the whole of the cosmic order, is the Holy Ghost, above which, beyond time and space, presides the Godhead.

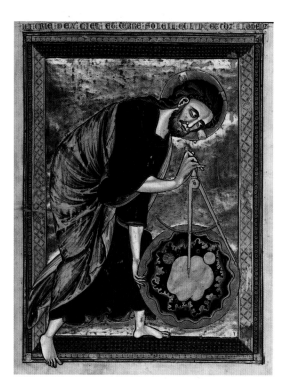

Plate 6. God as architect of
the world, from an illustrated
early-thirteenth-century Bible.

Plate 7. The architect as God,
and man as microcosm, by
Taccola (c. 1430). "I have all
measures in me," the cap-
tion reads, "both of what is
heavenly above and of what
is earthly and infernal."

Plate 8. Two of Leonardo's proportional skull studies (1489). "Where the line *am* intersects the line *cb*," a note at the left reads, "will be the confluence of all the senses"—the seat of the human soul.

Plate 9. Vitruvian Man. Leonardo da Vinci (c. 1490).

surprisingly, they came down in support of his views, as did a few of the cathedral deputies themselves, one of whom focused politely on the technical qualifications of those currently working on the cathedral. "You have appointed as engineers," he told his colleagues, "workers in granite, painters, glove-makers, and carpenters, decent men for the rest as I see it, but inexpert in these things." Another Mignot supporter expressed himself less diplomatically, insisting that a complex building project had to be carried out "by a prudent geometrician, expert in such things, and not by idiots who call themselves masters yet know nothing." Observing how work was proceeding on the cathedral's first great northern pier, another of the cathedral deputies couldn't contain himself. "May God help me," he exclaimed, "I've seen shacks and huts of straw and hay constructed with better order. . . . The whole thing should be torn down."

The majority of the cathedral's deputies remained unconvinced, however, and gradually their patience with Mignot wore thin. On October 22, 1401, they dismissed him and proceeded to build their cathedral as planned.

By the early 1470s, after a succession of failed efforts, a dome of some sort was at last in place—and by the early 1480s it was on the verge of collapse. What happened next isn't clear. Either the dome actually did collapse, or the deputies, fearing that outcome, had it dismantled. What *is* certain is that in the early 1480s they summoned another northern master builder to help them build a new dome: this time a German, who for several years grappled with the problem of the dome's construction. In late 1486, however, after some kind of falling-out with the

deputies, he returned home, leaving behind nothing to show for his efforts except a newly rancorous debate among the Milanese authorities about how to proceed with their dome.

The whole episode exasperated Ludovico Sforza, who, with the threat of war fading, was eager to forge ahead with his projects of urban renewal and beautification. This endless squabbling simply wouldn't do—and so, on September 4, he decided to put an end to it. "Because of the departure of the German master who undertook to build the *tiburio,* and his bad behavior," he wrote in a letter to his personal secretary, "I wish you to hold a council in the castle with the best engineers in the Duchy, to explain the quarrel to them, to discuss it all with them well, and then to provide for what they will decide."

IT WAS THE moment Leonardo had been waiting for. "When fortune comes," he would write in about 1490, "seize her firmly by the forelock, for she is bald at the back." Already he had made himself known to the Sforza court as a precociously talented artist and engineer. Now he had a chance to prove what he could do as an architect, by helping to solve one of the great building challenges of his age, just as Brunelleschi had done in Florence.

Whether Leonardo attended the initial council meeting isn't known. But there's plenty of circumstantial evidence to suggest that he did. In the months that followed the meeting he began to use paper that has been traced back to the cathedral supply. He started doodling designs in his notebooks for the cathedral's dome, too, many of them distinctly modeled after Brunelleschi's

Figure 29. Ideas for the *tiburio* of Milan cathedral,
by Leonardo da Vinci (c. 1487).

dome (**Figure 29**). And in the summer of 1487 he hired a local
carpenter to build an elaborate wooden model of a solution he
had worked out for the dome, the cost of which the cathedral
deputies themselves covered.

The model took more than a month to complete. When at
last it was ready, Leonardo submitted it to the deputies with a
cover letter, a draft of which survives in his notebooks. It's worth
quoting at some length.

My lords, deputies, fathers . . .
You know that medicines, when well used, restore health
to the sick, and he who knows them well will use them well

if he also understands the nature of man, of life and its con-
stitution, and of health. Knowing these well, he will know
their opposites, and being thus equipped he will be nearer
a cure than anyone else. The need of the invalid cathedral is
similar. It requires a doctor-architect who well understands
what an edifice is, and on what rules the correct method of
building is based, and whence these rules are derived, and
into how many parts they are divided, and what are the
causes that hold the structure together, and make it last,
and what is the nature of weight, and what is the desire of
force, and in what manner they should be combined and
related, and what effect their union produces. Whosoever
has a true knowledge of these things will satisfy you by his
intelligence and his work. . . . Therefore, I shall try, without
detracting and without abusing anyone, to satisfy you partly
by arguments and partly by works . . . fitting them with
certain principles of ancient architects.

The letter is classic Leonardo. It shows him thinking by anal-
ogy and trying, as usual, to perfect his art by roving among
disciplines and tracing everything back to first causes. Medi-
cine requires an investigation of the fundamental nature of life;
architecture requires an investigation of the fundamental laws
of physics; and both disciplines, at some point, point back to
universal principles of design.

What's especially interesting, however, is that passing remark
about "certain principles of ancient architects." Those survived
only in the work of Vitruvius—which means that by 1487 Leo-
nardo had begun thinking about the *Ten Books*.

* * *

HE HAD PROBABLY been hearing about the work for years. It was a natural source for him to consult in Milan, for example, when he began to investigate problems of military engineering. Its final chapter contained a detailed discussion of precisely the sorts of machines that he was studying and designing in the early 1480s. Renaissance engineers and architects, moreover, liked the *idea* of Vitruvius, even if they didn't know his work directly, and in offering their services to Europe's powerful rulers they often proposed a working relationship modeled explicitly on the one Vitruvius had maintained with Julius Caesar and Augustus. The Romans, they often suggested in the fawning prefaces to their works, had won glorious victories and built the world's greatest empire thanks to the ingenuity of military and civil engineers—and now *you, sire*, they told their prospective patrons, have a unique opportunity to help win back and rebuild that empire, thanks to *my* mastery of ancient and modern engineering techniques. Leonardo's letter to Ludovico Sforza proposing himself as a military engineer was written in precisely this mode.

Naturally, Leonardo's growing interest in architecture also led him to Vitruvius, as did the company he began to keep. During the 1480s in Milan, for example, he developed a close friendship with Donato Bramante, the architect who brought the Renaissance style to the city and who, in the early 1500s, would produce the initial design for the astonishing domed Basilica of St. Peter, the largest church in the world.

Bramante was some eight years older than Leonardo. But

the two men had much in common. Like Leonardo, Bramante was originally trained as a painter, and in that capacity he may even have preserved a stylized image of himself and Leonardo in Milan in the form of a clumsily rendered portrait of Heraclitus and Democritus, the ancient Greek philosophers whose response to the human condition was, respectively, to cry and laugh (**Figure 30**). There's something to this idea: painters of the time often inserted portraits of themselves and their contemporaries into their work. Both men's features are exaggerated in order to

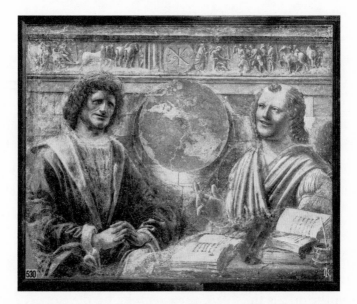

Figure 30. A possible vision of Leonardo (*left*) and Donato Bramante (*right*) together in Milan: the portrait of Heraclitus and Democritus by Bramante (c. 1490–97). Democritus is round-faced and balding, as was Bramante. Heraclitus wears the kind of clothing and hairstyle that Leonardo was well known for—and, tellingly, he sits next to a page of text written from right to left, like Leonardo's own mirror script.

accentuate their identities as crying and laughing philosophers, but if indeed their features are based on those of Leonardo and Bramante, the portrait represents something remarkable: the only picture of Leonardo to have survived from his time in Milan.

Bramante was a model of what Leonardo could become in Milan. He, too, had moved in search of a new life to Milan, just a few years before Leonardo, and had made a name for himself there by playing the lute, composing satirical verses, and staging plays and festivals. Gradually he had also managed to reinvent himself with great success as an architect. By the mid-1480s he was engaged in a number of high-profile projects for Ludovico Sforza, who made sure to include him in the group of engineers he summoned in 1486 to come up with a plan for building his cathedral's dome.

As a Renaissance architect who worked in the antique style, Bramante knew of Vitruvius and must have discussed ancient architectural ideas with Leonardo, especially after the first edition of the *Ten Books* appeared in print in 1486. But Leonardo read Latin poorly, and Vitruvius remained ferociously hard to understand even for those who read him well, so both Bramante and Leonardo are likely to have encountered most of his ideas indirectly. Much of what they knew about Vitruvius and the principles of classical architecture, in fact, derived from one hugely influential modern source: *On the Art of Building, in Ten Books,* by Leon Battista Alberti.

* * *

ALBERTI WROTE *On the Art of Building* in Rome in the 1440s. It was an audacious act.

In the 1,500 years since Vitruvius had presented his *Ten Books* to Augustus, not a single writer had produced another practical guide to architecture. Medieval master builders didn't write books. But the time was now right for a successor volume, Alberti decided, one that would be updated for the modern age. And so he set out to write a monumental survey of architectural history and practice, modeled in many ways on the *Ten Books,* in which he would explain not only how buildings and towns had been constructed during antiquity but also how they might be constructed better in the future.

The job presented daunting challenges, even for a man as gifted and experienced as Alberti. Much of the problem stemmed from Vitruvius himself, whom Alberti described as "an author of unquestioned experience, though one whose writings have been so corrupted by time that there are many omissions and shortcomings." Vitruvius was famously hard to understand, but Alberti didn't attribute this just to the ravages of time. He also blamed Vitruvius himself. "What he handed down," Alberti complained, "was not refined, and his speech such that the Latins might think that he wanted to appear a Greek, while the Greeks would think that he babbled Latin."

Alberti felt he could do much better. He resolved to synthesize the best of classical learning about architecture—by making as much sense as he could of the *Ten Books* and by carefully examining every ancient building he could find. In the latter case he followed the example set by Brunelleschi, who, in the early 1400s, in order to learn all he could about

architecture, had spent the better part of a decade studying the ruins of ancient Rome. "He made careful drawings of all the classic arches and vaults that still stood," Vasari would later write about Brunelleschi,

> and if he found fragments of capitals, cornices, or foundations of buildings buried in the earth, he engaged workmen to unearth them. . . . He never rested until he had drawn every kind of structure: temples, round, square, or octagonal; basilicas, aqueducts, baths, arches, the Colosseum, amphitheaters. In every church built of brick he examined all methods of binding and clamping, as well as the turning of vaults and arches. He made notes on how the stones were joined, and all the means of securing the equilibrium of the parts. . . . In his imagination, [he] beheld Rome as she was before her ruin.

But Alberti wanted to do much more than just describe the architecture of the past. In the Neoplatonic spirit of his own times, he wanted to get at underlying principles and present a universal theory of design that could guide future architects of the Renaissance. It was a job that turned out to be a nightmare. "My gods!" he exclaimed after finishing. "It was a more demanding task than I could have imagined when I embarked on it. Frequent problems in explaining matters, inventing terms, and handling material discouraged me and often made me want to abandon the whole enterprise."

But he didn't. This was the Renaissance, after all. Rome was rising again, and *somebody* had to revive and adapt the great architectural principles of antiquity for the modern age. How

else would his people, the new Romans, be able to build on what the ancients had bequeathed them and at last assemble their own harmonious body of empire?

As Alberti and other Italian humanists saw it, Europe had been plunged into centuries of intellectual decline and social decay after the western half of the Roman Empire had fallen to the Germanic tribes of the north in the fifth century A.D.—those barbarous Goths and Franks. Political structures had fallen apart; temples and monuments had collapsed; moral standards had declined; whole fields of knowledge had gone to seed; Latin had devolved into a divergent sprawl of corrupt spoken dialects; and scientific treatises and literary works had been destroyed or lost. Engineering know-how had disappeared. Nothing more aptly symbolized the general state of collapse than the ruins of ancient Rome itself, which the humanist Poggio Bracciolini would describe, in 1430, after surveying the city from atop the Capitoline Hill, as a jumble of ruins covered in filth, half buried in the ground, grown over with weeds, plundered for the building of modern homes, and ignored by passersby. Those ruins, Poggio was moved to reflect, were all that remained of the imperial body of Rome, which now lay "prostrate and stripped of all its splendor, like a giant corpse with every part corrupted and eaten away."

Alberti saw the city in the same way, as did the pope he served in the early 1450s: Nicholas V, himself a learned humanist. So when Alberti presented a first draft of his *On the Art of Building* to Nicholas during those years, the symbolism of the gesture would have been obvious. At the dawn of an imperial age, Vitruvius had written a ten-book guide to the building of empire and had given it to the man in charge of Rome—and

now Alberti was doing the same. Not for nothing did he soon come to be known as the Florentine Vitruvius.

Alberti began *On the Art of Building* by defining what he considered an architect to be. He didn't mean a medieval master builder—a craftsman, that is, who, following the plans of a patron, oversaw the business of construction. He had in mind a high-level court adviser, a man of rare genius and experience. Thoroughly versed in the liberal arts, as Vitruvius had recommended, and working always with nature as his guide, Alberti's architect designed and built the things that made civilization and empire possible: towns and cities, houses, public monuments, temples, theaters, streets, walls, sewer systems, wells, baths, bridges, aqueducts, harbors, tunnels, mills, construction devices, machines of war. "Let it be said," Alberti wrote, summing up the job, "that the security, dignity, and honor of the republic depend greatly on the architect: it is he who is responsible for our delight, entertainment, and health while at leisure, and our profit and advancement while at work, and, in short, that we live in a dignified manner, free from any danger."

On the Art of Building came out in print for the first time in 1485, just as Leonardo and Bramante were developing their friendship, and the two no doubt spent much time discussing it. (In the early 1500s, Leonardo would even record owning a copy, although it's not clear when he acquired it.) What Alberti had to say about the role of the architect must have been music to Leonardo's ears. Here was one of the great figures of the Renaissance, a role model in so many ways, redefining the role in a way that tailored it almost exactly to Leonardo's talents and interests. There was that annoying part about being well educated in the liberal arts, of course—but he was working on that.

But Leonardo had little interest in ancient architectural orders and different building styles. What attracted him most about *On the Art of Building,* as reflected in many of his notebook jottings, were Alberti's grand ideas about design—among them those laid out in *On Sculpture* and *On Painting.* In those two books Alberti had tried hard to elevate the status of the artist from menial laborer to conceptual thinker. Now he was doing the same for the architect. Buildings could be not only useful and lasting but also beautiful and true, Alberti wrote. That would only be possible, however, if in everything he did the architect adhered, just like the sculptor and the painter, to certain principles of universal proportion and harmonious design—the very principles that Vitruvius had so concisely embodied in his famous man in a circle and a square. "The harmony is such," Alberti explained, "that the building appears to be a single, integral, and well-composed body."

ALBERTI DIDN'T WRITE *On the Art of Building* for practicing architects and engineers. He wrote it primarily for Italy's newly powerful humanistic elite: rulers such as Pope Nicholas V, in Rome, whose interest in antiquity had led him to found the Vatican Library and begin restoring the city's ancient monuments; and Lorenzo de' Medici, in Florence, to whom the printed edition of *On the Art of Building* was dedicated.

These were men Alberti knew personally. Their training as humanists meant that they already appreciated the value of ancient learning and ideas, and their roles as powerful rulers and patrons meant that they could bring about big changes— which, when it came to architecture, was exactly what Alberti

wanted. He wrote *On the Art of Building,* in effect, as an extended rhetorical argument. The book was an attempt to persuade his friends and colleagues in high places to embark on an ambitious new building program rooted in classical ideas but executed with a modern touch, in what today we'd call the Renaissance style.

Another of the powerful friends with whom Alberti shared his ideas and his manuscript was Federico da Montefeltro, the duke of Urbino, best known today as one of Machiavelli's models for *The Prince.* A cunning soldier and politician, Federico was also the patron of a great humanistic court who, in the middle of the century, had decided to found a library that would rival the Vatican Library in its range and magnificence. Sparing no expense, he amassed one of Europe's most comprehensive collections of ancient and medieval manuscripts, which included, according to one late-fifteenth-century cataloger, "works on architecture [and] all books treating of the machines of the ancients for conquering a country." It was a collection that attracted all sorts of visitors—among them the young Sienese engineer Francesco di Giorgio Martini.

Francesco was a figure of diverse talents and responsibilities. Born in 1439 as the son of a poultry farmer, early in his career he established himself as a talented painter and sculptor in Siena. But his range of interests and activities soon broadened significantly. In 1469 he signed on with the town's waterworks department as a hydraulics engineer, and two years later he received his first architectural commission, the renovation of a local chapel. By the middle of the next decade he had attracted the attention of Duke Federico—who, at least according to Francesco, came to love him like a son. That may

well have been true. Francesco would work in the duke's service as an architect and military engineer for most of the next fifteen years.

Francesco's gifts were obvious from the moment he arrived in Urbino. But so was his one great deficiency: he lacked a strong background in the liberal arts. To rectify the situation, Federico encouraged him to learn what he could from the scholars of his court and to read widely from his huge collection of manuscripts. Given the run of the duke's library, Francesco soon found his way to all those works on architecture and military engineering, among them the *Ten Books* of Vitruvius.

Like so many others in Renaissance Italy, Francesco recognized that the *Ten Books* represented a treasure trove of information about the architectural ideas and practices of classical antiquity. Lacking a formal education, however, he had a hard time making sense of the text, which had confounded even the immensely learned Alberti. All he could reasonably hope for, as a visual artist and practicing architect, was that he might learn something from its illustrations. But it didn't have any.

A survey of architectural styles with no pictures? The idea seems bizarre today. But before the arrival of printing, words, not illustrations, were considered the most reliable way of transmitting technical knowledge and information. In the eras of the scroll and then the manuscript, scribes were able to reproduce text much more quickly and faithfully than images, which required special artistic talents to reproduce accurately and which degraded quickly when copied imperfectly generation after generation. "Pictures are very apt to mislead," wrote Pliny the Elder in the first century, after detailing such problems. Some fourteen centuries later, Alberti seems to have

felt the same way: *On the Art of Building* itself contained no illustrations.

Francesco thought differently. As a member of the breed of artist-engineers that was emerging in fifteenth-century Italy, he believed, above all, in the explanatory power of images. He had copied the engineering drawings of Taccola, under whom he may have studied in Siena, and knew just how effective pictures could be in transmitting information—about, say, the various machines devised by Brunelleschi (**Figure 23,** page 115) or, for that matter, in conveying the idea of the human body as the source of all measure and design (**Plate 7**).

The problem, as Francesco understood it, was a basic one. Without images, one couldn't convey to others the precise nature of a building or a machine, much less an analogy or a metaphor. Verbal explanations always gave rise to "as many interpreters as readers," he believed, whereas images, if properly executed, nailed things down.

To make his point he began to load up his own work with illustrations. He did so most memorably in his *Treatise on Architecture, Engineering, and the Art of War*—a work, dedicated to Federico, that he began in the mid-1470s, or perhaps even earlier, and then continued to revise as his self-education progressed and his stature as an architect grew. Employing relatively new drawing techniques, such as linear perspective and the cutaway view, he scattered pictures everywhere in the *Treatise,* showing church plans, facades, columns, cornices, cranes, mills, water pumps, machines, weapons, and more (**Figure 31**).

But Francesco wanted to do more in his *Treatise* than just describe buildings and machines. Like Alberti, he wanted to explain their inner workings (hence his use of the cutaway

Figure 31. Cutaway view of a water-powered grain mill, from
Leonardo's copy of Francesco di Giorgio Martini's *Treatise* (c. 1481–84).

view) and to demonstrate, in doing so, that architecture was
an elevated intellectual discipline rooted in a fully rationalized
program of thought—the central principle of which, he would
later write after having studied Vitruvius, was that all harmoni-
ous design should derive from "a well-composed and propor-
tioned human body."

Plenty of other Renaissance architects had expressed simi-
lar thoughts, most recently Antonio di Pietro Averlino, better
known as Filarete—yet another Florentine artist turned archi-
tect who had moved to Milan in search of a career in the ser-
vice of the city's duke. In 1464, in fact, Filarete had produced
the only other significant treatise on architecture to appear in
fifteenth-century Italy: the *Libro architettonico,* a curious work
of narrative fiction, didactic in nature and heavily influenced by
both Vitruvius and Alberti, that abounded with references to

the human analogy. "I will show you that the building is truly a living man," Filarete wrote, echoing Alberti and anticipating both Francesco and Leonardo. "You will see what it must eat in order to live, exactly as it is with man. It sickens and dies, or sometimes is cured of its sickness by a good doctor."

Alberti and Filarete both deployed the human analogy as a literary conceit. But Francesco decided that in his *Treatise* he would do something different: he would try to capture it *visually*, for scholars and practitioners alike. Hence the ghostly images of the human form that he insinuated into so many of his church plans (**Figures 2** and **3**, page 9) and architectural drawings (**Figures 32** and **33**).

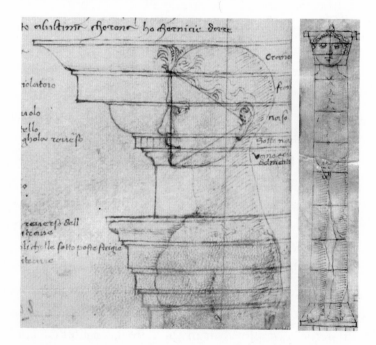

Figures 32 and 33. The human analogy in architecture, from Francesco di Giorgio Martini's *Treatise* (c. 1481–84).

* * *

VITRUVIUS, ALBERTI, FILARETE, Francesco di Giorgio Martini: these were the writers whose works Leonardo would have been exposed to when he began thinking hard about architecture in the mid- to late 1480s. Each in his own way had toyed with the human analogy. No doubt the subject also came up often when Leonardo discussed architectural matters with builders, engineers, scholars, and church deputies, and in his many conversations with Bramante. He and everybody else could even see its physical embodiment right in the center of Milan, in the form of the city's hulking, unfinished cathedral—which, as one local author put it in 1489, "seems to outline the shape of the human body, lying down and spread out."

It's not hard to imagine Leonardo in the grip of this idea himself, entering the cathedral to study its form, pondering Brunelleschian ideas for the design of its great dome, and, as he wandered about, gradually finding himself overtaken by the eerie sensation that he was indeed *inside a giant body.* In the late 1480s, as Francesco and Villard had both done before him, he began to make associations between architecture and the human body, but he also discerned something new: specific anatomical correspondences, which in the late 1480s began to creep into his notebook doodlings (**Figure 34**).

Leonardo certainly had the human analogy in mind when he wrote his letter to the deputies of the cathedral of Milan. Like Filarete, he deployed it in the letter as a literary conceit. But privately, in his own investigations, he was also about to take things a step further. If architecture and the human body

Figure 34. Neck and skull, column and capital: visual analogies between anatomy and architecture, by Leonardo da Vinci (c. 1487).

were intimately related—as the ancient Greeks and Romans had declared, as so many Christian theologians had insisted, as the medieval master builders had made manifest in stone, and as Taccola, Alberti, Filarete, and Francesco had all demonstrated in their work—then as an artist, an architect, and even a natural philosopher, there was something he would have to do. More thoroughly than anybody had ever done before, he would have to investigate the nature and makeup of the human body, inside and out.

7

BODY AND SOUL

A good painter has two chief objects to paint:
man and the intention of his soul. The former is easy,
the latter hard.

—Leonardo da Vinci (c. 1490)

THE FROG JUST wouldn't die.

Gradually, methodically, Leonardo had removed its head, its heart, its intestines, and even its skin, but the animal still showed signs of life.

The year was 1487, and Leonardo's investigations were proliferating with an almost Malthusian relentlessness. Architecture was on his mind: in his notebooks that year he played with a variety of ideas for the *tiburio* of the cathedral of Milan, and on page after page doodled a dreamy procession of arches and columns, domes and churches, temples and palaces. But he did much more. He roughed out preliminary studies for paintings and statues. He sketched people and animals, landscapes and

plants. He designed an ideal city and drew maps. Incessantly, almost involuntarily, he *invented* things: cannons, ditch diggers, a device for raising and lowering curtains, water pumps, flying machines, musical instruments, a parachute, stage props, underwater breathing devices, submarines. He explored aspects of physics and chemistry, wrestled with geometrical problems, collected observations on the nature of art. He jotted down fables, moral precepts, and jokes. He compiled lists of things to do, books to read, experts to seek out, and questions to ask. Always he sought ways of arriving at first causes—which is why he ended up taking apart that frog. He was interested in the frog's anatomy for its own sake, of course, but he also had larger concerns. What made it possible for an animal to move? How did it generate warmth? What kept it alive? For that matter, what *was* life?

Leonardo was no stranger to the study of animal anatomy when he began working on his frog. For some time he had been studying the makeup of whatever animals he could get his hands on. Bats, bears, birds, dogs, hares, horses, monkeys, pigs, oxen, even lions: there's ample evidence in his notebooks that in the late 1480s he dissected them all. He wanted to learn how animals were put together not just to satisfy his natural curiosity but also because he recognized that the better he understood the specifics of their design, the more beautifully and subtly he would be able to reproduce them in his art. Hoping to win the commission for the giant equestrian statue that Ludovico Sforza had long talked of erecting in Milan to honor his late father, for example, he devoted countless hours to the study of the proportions and anatomy of the horse. He scrutinized the anatomy of winged animals, too, but for a different reason:

because of the insights they promised him into the mechanics of flight. And in all of his investigations he sought out information about specific aspects of anatomy and physiology that related to his interests: the nature of the eye, which could shed light on his study of optics; the design of the heart and lungs, which powered hydraulic and pneumatic systems of marvelous efficiency; the layout and function of the various other organs, which worked together as a kind of chemical factory. Animal bodies were living machines, marvels of biological engineering, and Leonardo wanted to learn how the elegant architect of the world—which he tended to define simply as Nature rather than as a bearded, compass-wielding God—had constructed them.

With only one known exception, the animals Leonardo worked on shared a defining characteristic: they were all dead. Only in the case of the frog is he known to have inflicted suffering on a live animal—and in all likelihood he endured considerable moral anguish while doing it. According to Vasari, after all, he was a man who "took an especial delight in animals of all sorts, which he treated with wonderful love and patience." He bought caged birds solely for the pleasure of setting them free, and, bizarrely for his time, adopted vegetarianism as a kind of personal philosophy. "He would not kill a flea for any reason whatsoever," his friend Tommaso Masini would later recall; "he preferred to dress in linen, so as not to wear something dead." In this respect Leonardo seemed almost Hindu, a thought that occurred explicitly to one Florentine traveler, Andrea Corsali, during a visit to India early in the sixteenth century. The Indians he had spent time with, Corsali reported in a letter home, "do not feed on anything that has blood, nor will they allow anyone to hurt any living thing, like our Leonardo da Vinci."

Nevertheless, in the case of the frog, Leonardo's curiosity got the better of him. Only by dissecting it alive, he decided, would he have any chance of finding answers to some of his most profound questions about animal vitality. And so, as dispassionately as he could, he proceeded to decapitate, dismember, and disembowel the poor creature.

The results surprised him greatly. "The frog," he observed in his notes, "retains life for some hours." Only when he pithed it, pricking its spine at the base of its skull, did the animal at last expire, in an involuntary spasm of nerves. "The frog immediately dies when its spinal medulla is perforated," he wrote. "It thus seems that here lies the foundation of motion and life."

This seemed a momentous discovery to Leonardo. And because he so often thought by analogy, it raised a natural question. If he could make this sort of discovery by studying the simple anatomy of a frog, then what far greater discoveries might he make if he were to venture inside the human body itself? Two years later, in 1489, he would get a chance to find out.

"HAVING PLACED IN the supine position the body of one who has died from beheading or hanging, we must first gain an idea of the whole, and then of the parts."

So declared the Bolognese physician Raimondo de' Luzzi—better known as Mundinus—in 1316. The statement, one of the earliest surviving references to the practice of medical dissection in Europe, appeared in a brief treatise titled the *Anatomy,* a work that would become the standard textbook in northern Europe until well into the 1500s. By the late 1480s it was cir-

culating widely in manuscript and print form, and Leonardo knew it well.

Leonardo had been introduced to the superficial study of anatomy much earlier in his career, in Florence. All of the authorities he looked up to as a young apprentice agreed that a working understanding of the human anatomy was essential to the production of fine art. Verrocchio made his students study human proportions and sketch body parts, and sometimes even had his studio models dipped into molten wax in order to create lifelike molds. Alberti, for his part, had encouraged aspiring artists to adopt an inside-out approach. "Sketch in the bones," he wrote in *On Painting,* "then add the sinews and muscles, and, finally, clothe the bones and muscles with flesh and skin." The famous Florentine sculptor Lorenzo Ghiberti had offered similar advice some fifteen years later in his own influential commentary on art. "It is necessary," he explained, "to have seen dissections, in order that the sculptor, wishing to compose a lifelike statue, knows how many bones are in the human body, and, in a like manner, knows the muscles and all the tendons, and their connections."

Ghiberti chose his words carefully. What was important in his view was for artists to have *seen* dissections, not that they carry them out—and there's no hard evidence that any artist before Leonardo actually did conduct any.

Leonardo and many other artists of his day are very likely to have attended dissections. Since the early 1300s, a number of universities in Italy and northern Europe had sponsored public dissections, generally one or two a year, each of which was generally carried out over the course of several days. This was the operating theater in its original sense, and Mundinus's *Anatomy*

often provided the script. Sitting or standing on an elevated podium in front of a large audience, a professor would read ponderously from the works of the great ancient and medieval medical authorities, while below him a lowly barber-surgeon (one of whose other main jobs in life, as a wielder of scissors and knives, was the bleeding of the sick) "illustrated" the lecture by slicing into the body of an executed criminal to reveal the parts of the body under discussion.

Leonardo had ample opportunity to attend public dissections not only in Florence but also in Milan and the nearby town of Pavia, all renowned centers of medical learning and practice. Guidelines established at the University of Tübingen in 1492, just a few years after Leonardo began his anatomical investigations, record how public dissections typically unfolded and make clear that dissection was not the taboo practice in medieval and Renaissance Europe that many authors have argued it was. "The professor," declared the guidelines, "shall read from the writings of the Doctors, especially Mundinus, about the part of the body to be demonstrated. After discussion, each organ shall be shown plainly for inspection." A memorable image of the scene survives from the same period in a medical miscellany that Leonardo himself owned—a work, needless to say, that contained the *Anatomy* of Mundinus (**Figure 35**).

Public dissections probably both fascinated and enraged Leonardo. Here were officially sanctioned opportunities to peer inside an actual human body (which Mundinus, true to medieval custom, identified as the "microcosm, that is, the smaller world"), but in Leonardo's view the professors running the show wasted those opportunities year after year. They didn't investigate or try to understand anything. Instead, in the pompous,

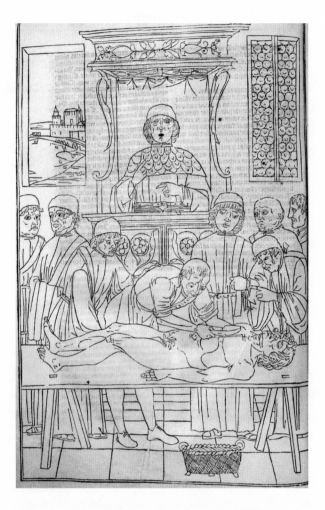

Figure 35. A public dissection, from the 1495 edition
of Johannes Ketham's *Fasciculus medicinae.*

scholastic manner that so offended Leonardo, they delivered
unthinking recitations of traditional learning, reading from the
texts of Mundinus and other late-medieval authorities, whose
works themselves amounted to little more than a rehash of the

medical writings of the Arabs and the Greeks, translated crudely into Latin in the twelfth and thirteenth centuries.

Much of this was mind-numbingly dull. One can imagine the scene as Leonardo witnessed it. A lecturer decked out in full scholarly regalia stands on the podium. Below him, in front of a sizable audience, a barber-surgeon stands at center stage, knife at the ready above a partially opened corpse. "Having observed the guts," the professor declares, reading directly from the *Anatomy*, "you should proceed to the next organ—I mean, the stomach. Note carefully the place or site thereof." He looks up for a brief moment, nods at the barber-surgeon to resume slicing, and then picks up where he left off. "Now, the stomach is the cell of the food, as Galen says in his *De juvamentis stomachi,* Part 5, Chapter 2, where everything that is to be said of the stomach is contained, and where there is a discussion of the gut—and Haly Abbas also, in his *Dispositio regalis,* in the part *Theorice,* Section 3, Chapter 20." On and on he drones, to Leonardo's growing dismay. "The place of the stomach is in the middle of the body, between upper and lower, between right and left, and between anterior and posterior. Here you may wonder why the stomach is not nearer the mouth. The reason I declare to be twofold . . ."

What would have bothered Leonardo even more than the style of these lectures was their substance. That's not to say he didn't learn from them. He most certainly did. But the more he learned, the more he realized that much of what was being peddled as established fact by the medical scholars of his day was just plain wrong. High up on their podiums with their heads buried in their texts, at a literal remove from their subject, they were blind to the obvious. Just because Aristotle had

claimed that women had fewer teeth than men, or that the life span of animals was proportional to the number of their teeth, did that make those statements true? Was it really the case that men had one fewer rib than women (because God had used one of Adam's to create Eve)? Of course not. Yet despite readily available evidence to the contrary, often laid out on a table right in front of their eyes, the authorities continued to recite untruths that had been repeated mindlessly for centuries. Not only that, they repeated a panoply of subtler errors rooted in one basic problem: that many ancient teachings about the human anatomy derived from the dissection not of people but of animals.

Mundinus was as guilty as anybody in that regard. "You see," he continued in his description of the stomach, "to the right it has the liver, by the five lobes of which it is clasped, as by a hand with five fingers." That sounds authoritative, but in fact nobody attending a public dissection would have been able to see anything of the sort, for one simple reason: dogs, not people, have a five-lobed liver. Anticipating puzzled looks from members of his audience when the barber-surgeon held the liver up for all to examine, Mundinus covered himself. "In man," he explained, "these lobes are not always distinct."

That scholars would so blindly cling to such verifiably mistaken ideas disturbed Leonardo greatly—never more so than when, in the late 1480s, he began to ponder the nature of the eye. Scholars of his day subscribed to an ancient theory, elaborated on at great length by medieval Arab writers, in which the eye sent out particle emanations—the "visual spirit," as Mundinus and other medieval authorities called it. These emanations traveled outward until they collided with the various

objects in one's field of vision, the result of which was sight. But simple common sense made Leonardo wary of this idea. If you opened your eyes outside, he noted, you would see an object at arm's length at exactly the same time you would see the sun. Everything in one's field of vision appeared instantaneously, in other words. This simply couldn't be possible if the visual spirit existed: traveling outward from the eye, its emanations would naturally reach nearby objects before they reached a distant object like the sun. Ergo, the so-called experts had to be wrong. "Down to my own time," Leonardo wrote in 1490, "the eye, whose function we so certainly know by experience, has been defined by an infinite number of authors as one thing. But I find, by experience, that it is another."

This undermined everything. If one couldn't always trust what the medical authorities and the natural philosophers had written about the little things, which were easy to observe and define, how much faith could one put in what they had written about the big things, which were not so easy to pin down—the meaning of life, say, or the nature of the soul?

LEARN BY EXPERIENCE: this became Leonardo's mantra in the late 1480s. He observed natural phenomena, conducted experiments in physics, mixed pigments and varnishes, dissected animals, analyzed construction techniques, built models—and, above all, never stopped asking questions.

It was at this exact point in his career that Leonardo recorded that memorably eclectic list of things he wanted to find out: how the men in Flanders propel themselves on ice, how mortars are positioned on bastions, how to square a tri-

angle, how to think about proportion like a physician, how to repair locks and canals in the Lombard manner, how to build a crossbow. But in that list he also noted his interest in finding two scientific treatises—dense works in scholarly Latin, written by great medieval authorities of centuries past. The preening manner and the rote approach to learning of the scholastics may have struck him as vacuous, but his interest in those texts makes clear that he realized that he nevertheless had much to learn from the world of letters. Which is why, in the late 1480s, adding to the already dizzying range of his activities, he dedicated himself to a voracious program of literary self-education.

Today, in the popular imagination, Leonardo represents the archetypal Renaissance man: a visionary figure with almost magical powers of invention who possessed unlimited abilities and knowledge. But his early notebooks reveal a different picture. Alongside the masterful drawings, the ingenious inventions, and the flights of visual and intellectual fancy, one finds evidence of something much more mundane: a man hard at work trying to teach himself the basics of medieval learning. Anatomy, architecture, astrology, botany, cosmography, geography, geology, geometry, mathematics, medicine, military arts, natural philosophy, optics, perspective, surgery, even veterinary medicine: Leonardo wanted to learn about them all, as a backdrop to his own empirical study of the world. And in order to do any of *that,* he had to begin with something even more basic. The great master—in the prime of his life, having already produced some of the world's greatest paintings and drawings, and having launched himself into scientific investigations centuries ahead of their time—had to sit down at his

desk and struggle humbly, like a schoolboy, with the age-old ritual of *amo, amas, amat*. He had to teach himself Latin.

He had no choice. In fifteenth-century Europe, as had been the case for centuries, Latin was the official language of learning. In the late 1200s and 1300s Dante, Petrarch, and Boccaccio had begun to make the Italian vernacular a respectable language for literature, and as the 1400s progressed Alberti and a few other Italian humanists had begun to write didactic treatises in Italian. But still, if you wanted to familiarize yourself with the learning of the ancient Greeks and Romans, the teachings of the Church Fathers, the science of the Arabs, or the scholarly and theological works of any number of medieval authorities, you simply had to know Latin.

Hobbled as he was by a lack of formal schooling, Leonardo would never master Latin or even develop much comfort with the language. But he did manage to teach himself enough to get by—and that made a world of difference. Gradually, instead of having to rely on what friends and experts could tell him about the various subjects he was interested in, he began to seek out and read books about them on his own.

He had plenty of places to turn. Never before had so many books been available to so many people. Printing had been invented in Germany not long before he was born, and during his lifetime had spread to cities across Europe. Starting in the 1470s, all sorts of classical, medieval, and modern texts suddenly appeared for sale in Italy in inexpensive printed editions: works previously available only in precious manuscript editions reserved for special use by monks and scholars, and often kept chained to the shelves of monastery collections and private libraries.

Leonardo therefore came of age as part of the first genera-
tion of Europeans to have access to cheap, portable, and widely
available books—and when he began to pursue his program
of self-education he made the most of what was now on offer
to him. By 1490 or so, he owned at least 45 books, already an
impressive number for the time. A decade later, he owned at
least 116.

The range of both collections, as Leonardo itemized them in
his notebooks, was extensive. He owned not only encyclopedic
compendiums and scientific treatises, as is to be expected, but
also all sorts of less predictable texts: works of classical litera-
ture, treatises on religion, guides to grammar and rhetoric, col-
lections of sonnets, saucy romances, joke books, and more. He
read for both edification and pleasure.

But printing was still in its infancy when he began actively
seeking out books. There were plenty of important works that
he couldn't find in printed form or couldn't afford to buy. For
access to those works, which existed only in manuscript form,
he had to turn to other sources: friends, friends of friends,
local monks, university scholars, visitors to the court, ducal
librarians. One 1489 note about finding two scientific treatises
provides a glimpse of how he worked. "Get the Brera friar to
show you *De ponderibus,*" he wrote, referring to a medieval
work on mechanics owned by a monastery in central Milan. A
few lines later he mentioned the other text, a work on optics
by a thirteenth-century writer known today as Witelo, and the
place he hoped to find it. "Try to get Vitolone," he wrote,
using an alternate spelling of the author's name, "which is in
the library at Pavia."

* * *

PAVIA.

Home to one of the great universities in northern Italy, the town lay only a short ride south of Milan, across the Lombard Plain. The thought of everything Leonardo could learn there, from its resident scholars and its books, tugged powerfully at his imagination. In the summer of 1490 he would travel there as an architectural consultant in the company of Francesco di Giorgio Martini. But his notebooks suggest that this wasn't his first visit. By 1489, at least, he had already befriended Fazio Cardano, a leading doctor and lawyer in the town, and had made more than one reference in his notes to the holdings of its famous library.

By all accounts that library, now dispersed, was a wonder to behold. Founded in the fourteenth century by the Visconti family, which had ruled Milan until the arrival of the Sforzas, it had become one of the largest and most famous manuscript libraries in all of Italy, a rival of the best collections in Rome and Florence. Scholars came from far and wide to peruse its holdings—and they weren't disappointed. Upon seeing the library's great hall for the first time, one young scholar is said to have fallen on his knees with amazement at the sight of hundreds of priceless manuscripts laid out on shelf after shelf before him, many of them originally part of the great collection amassed by Petrarch. Often copied on the finest parchment, illuminated with gold leaf, and covered with dyed velvet or damask, the manuscripts were secured to their shelves with chains of silver. Even veteran bibliophiles couldn't help admitting to feelings of astonishment. One high-ranking official from the court of Rome declared himself hap-

pier while visiting the library than while visiting the holy sites of Jerusalem.

Whenever it was that Leonardo first entered the library, he must have felt a similar thrill. Here, under one roof, was virtually the entire known range of Western thought. The works from antiquity alone were enough to keep a scholar busy for a lifetime: dialogues by Plato; texts on natural philosophy by Aristotle; political essays by Cicero; poetry by Virgil and Ovid; Pliny the Elder's massive *Natural History*; Ptolemy's treatises on astronomy and geography; Euclid's *Elements of Geometry*; writings on anatomy and medicine by Galen; Roman land-surveying manuals; and, miscatalogued under the name "Virturbius de architretis," the *Ten Books* of Vitruvius.

But that was just the start. As he wandered around the library's great hall, Leonardo would have realized with mounting excitement that he also had at his disposal many of the seminal works of medieval learning and literature. The roster of names alone would have made his eyes pop open. Augustine and Aquinas. Dante and Petrarch. Mundinus and other medical authorities. The encyclopedists Isidore of Seville, the Venerable Bede, and Albert the Great. The mystical theologians Honorius, Hugh of St. Victor, William of Conches, and Alan of Lille. The astronomer Sacrobosco, the mathematician Witelo, and a number of Arab scholars, among them Averroes, Albumasar, and Alcabitius (as they were known in Latin). Contemporary authors were well represented, too, among them Alberti and Filarete.

In much of what he read in Pavia and elsewhere, Leonardo encountered a common organizing principle: the human analogy. This was a connection he can't have missed, given his inter-

ests in the 1480s. It was everywhere. The Greeks had likened the human body to the cosmos, and the Romans had elaborated on the idea. Vitruvius had made the human body synonymous with harmonious design, geometrical perfection, and the Augustan body of empire. In the Middle Ages, inspired in part by Vitruvius, Christian thinkers had joined the fray. Isidore and Bede had called the human body a microcosm. In the centuries that followed, writers in Europe and the Islamic world alike had run with the idea, specifying the human body's relationship to both Heaven and Earth—and developing elaborate scientific, medical, and philosophical models based on those connections. Later still, as the Middle Ages gave way to the Renaissance, a variety of humanists, philosophers, artists, and architects adapted the idea for their own purposes.

How much of this Leonardo was able to absorb directly by reading is impossible to say. The books and manuscripts he bought for himself and encountered in libraries were indeed shot through with the human analogy. Most were written in archaic, medieval, and specialized varieties of Latin that would have been difficult for him to understand in full.

But many would still have provided him with a cursory but memorable introduction to ideas about the microcosm—in their illustrations.

LEONARDO WAS A visual thinker, first and foremost. So as he struggled to make sense of what he read, he did what anybody groping through a difficult work does: he turned to the pictures for help. And as he flipped from image to image, what came to life before his eyes must have been an almost cinematic

montage: phantasmal visions of the human body spread-eagled on the page again and again, deployed there as an organizing principle for knowledge. He saw schematic diagrams in which the body incorporated the elements and unified the cosmos. He saw mystical drawings in which it symbolized the human and the divine. He saw maps in which it became one with the world. And, in abundance, he saw medical and astrological illustrations in which the human body, laid bare, revealed the secret inner workings of the microcosm.

This last category of images is likely to have interested Leonardo most of all. There was certainly no shortage of them. Early versions of such figures as Bone Man, Nerve Man, and Muscle Man appeared in twelfth- and thirteenth-century texts. By the fifteenth century these figures not only had proliferated, appearing in stock form in all sorts of medical miscellanies, but also had spawned a variety of (predominantly male) progeny, among them Zodiac Man, in whom the various celestial signs and bodies were linked, with increasing anatomical specificity, to parts of the body (**Figure 36**); Bloodletting Man, an astromedical relative of Zodiac Man, whose body indicated to barber-surgeons and physicians where, and when, to bleed patients (**Figure 37**); and the long-suffering Wound Man—a glorious, if inadvertent, symbol of the human condition, whose pierced, bludgeoned, and maimed body was designed to itemize for doctors the various injuries they might encounter in their rounds (**Figure 38**).

Leonardo combed through medical texts to learn whatever practical information he could about the human body. But since he could never help thinking by analogy, he soon found his way to the idea—discussed by the ancients and popularized by medieval Arab writers—of the body as a miniature anatomical

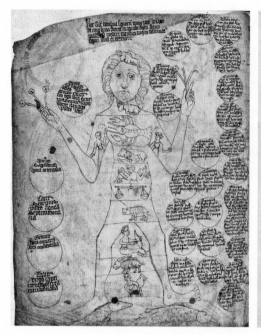

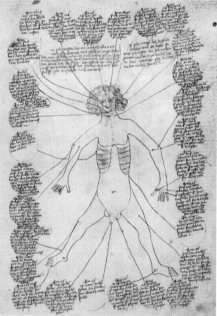

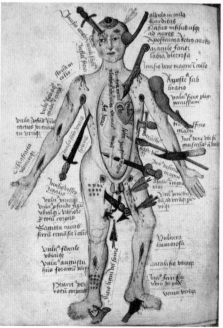

Figures 36, 37, and 38. Top left:
Zodiac Man (c. 1410), showing
the relationship between the body
and the signs of the zodiac. *Top
right:* Bloodletting Man (c. 1410),
showing where and when patients
should be bled for various ailments.
Right: Wound Man (c. 1450),
showing the kinds of injuries a
medieval doctor would be likely
to encounter.

model of the world. In about 1490 he summed up his thoughts on the subject.

> By the ancients man was termed a lesser world, and certainly the use of this name is well bestowed, because his body is an analogue for the world, in that it is composed of water, earth, and fire. Just as man has in himself bones, the supports and armature of the flesh, the world has rocks; just as man has within himself a lake of blood, in which the lungs increase and decrease in breathing, so the body of the earth has its oceanic seas, which likewise increase and decrease every six hours with the breathing of the world; just as in that lake of blood the veins originate, which make ramifications throughout the human body, similarly the oceanic sea fills the body of the earth with infinite veins of water. Nerves are lacking in the body of the earth. The nerves are not to be seen there because the nerves are made for the purpose of movement, and the world being perpetually stable, movement does not occur.

Not surprisingly, Leonardo grew frustrated in his anatomical studies by the texts he was able to find—works full of obvious untruths and subtle misperceptions, which he would later describe as "tortuously ponderous, long-winded, and confused." And those ghastly illustrations! The kind of anatomical text he could really learn from—a comprehensive guide to the human body, based on empirical investigation but illustrated by a master artist—seemed simply not to exist. If he wanted such a treatise, he realized, he had only one option. He would have to produce it himself.

* * *

LEONARDO LAID OUT his initial idea for an anatomical treatise in early 1489. It would be titled *On the Human Body,* he wrote in his notes, and it would be unlike anything ever seen before. Under the heading "On the Order of the Book," he laid out his plans in ambitious detail:

> This work should begin with the conception of man, and describe the form of the womb, and how the child lives in it, and to what stage it resides in it, and in what way it is given life and food. Also its growth, and what interval there is between one degree of growth and another, and what it is that pushes it out of the body of the mother, and for what reason it sometimes comes out of the mother's belly before due time. Then you will describe which parts grow more than others after the infant is born, and give the measurements of a child of one year. Then describe the grown-up man and woman, and their measurements, and the nature of their constitution, color, and physiognomy. Then describe how they are composed of veins, nerves, muscles, and bones. This you will do at the end of the book. Then, in four drawings, represent the universal conditions of man: that is, joy, with different ways of laughing, and draw the causes of laughter; sorrow, in different ways, with its cause; strife, with different acts of slaughter, flight, fear, ferocity, daring, murder, and all things which pertain to such cases. Then draw work, with pulling, pushing, carrying, stopping, supporting, and similar things. Then describe attitudes and movement. Then perspec-

tive, through the function of the eye; and on hearing—you
will speak of music. And treat of the other senses. Then
describe the nature of the senses.

Leonardo being Leonardo, this was only the beginning. As
the idea for the book took hold, he began jotting down other
topics that he would have to cover: how the eyebrows were
raised and lowered; how the eyes opened and closed; how the
mouth and lips moved to form different facial expressions;
how nerves transferred movement from shoulder to elbow
to hand to fingers, and from thigh to knee to foot to toes.
Soon the ideas were tumbling out in a free-associative cas-
cade: "Represent whence catarrh [phlegm] is derived. Tears.
Sneezing. Yawning. Trembling. The falling sickness. Madness.
Sleep. Hunger. Sensuality. Anger, where it acts in the body.
Fear, likewise. Fever. Write what the soul is. . . . Illustrate
whence comes the sperm. Whence the urine. Whence the milk.
How the nourishment proceeds to distribute itself through
the veins. Whence comes intoxication. Whence the vomit. . . .
Whence dreams."

This was a far cry from the plodding *Anatomy* of Mundi-
nus. But Leonardo planned to distinguish his treatise from all
others not just in the audacity of its scope. Having come to
appreciate in his engineering and architectural studies just how
efficient and powerful a tool a well-drawn image could be, he
made a momentous decision: his treatise would be primarily
visual, not verbal. He would undertake an exhaustive hands-on
investigation of the human anatomy and then would present
the results of that investigation with unprecedented graphic
precision, using a range of new architectural and perspectival

drawing techniques never before applied to anatomy: plans and elevations, cutaway views, see-through body parts, rotating images, and more. What he was beginning to envisage was nothing less than a comprehensive anatomy of the microcosm: a three-dimensional map of body and soul. He said as much himself in about 1509 in another note spelling out plans for *On the Human Body*—a work that, regrettably but not surprisingly, he would never manage to finish.

"You will have set before you the cosmography of the lesser world," he wrote, "on the same plan as was adopted before me by Ptolemy, in his *Geography*. . . . And, thus, might it so please our Creator that I may be able to demonstrate the nature of man."

WRITE WHAT THE SOUL IS.

Leonardo very deliberately included that remark in the list of anatomical features and functions he wanted to cover in *On the Human Body*. That's because, at least at this stage in his career, he believed the soul to be a physiological entity.

Here Leonardo was getting himself involved in a debate that had kept philosophers busy since ancient times. There were two basic positions. Either the soul had an independent existence, as Plato had proposed, and served only temporarily as an adjunct to the body, during a person's life; or it had no independent existence, as Aristotle had proposed, and formed an inseparable part of the body, one that quickened and died with it, just like any other organ.

Leonardo, whose notes show him to have read up on this subject, took Aristotle's side. Moreover, he believed, as many

early philosophers had done, that the soul did not inhabit the body as a whole but instead had as its seat the noblest, most elevated part: the head. Leonardo's study of the frog seemed to confirm this idea. But by 1489 he had realized that the study of animals would never provide him with the detailed information he needed to produce a truly comprehensive map of the human anatomy. Nor would studying traditional medical texts or attending the occasional public dissection. His only option was to start taking apart the human body himself.

For an investigator as insatiably curious as Leonardo, whose interests had for years been shifting from surface appearances to interior causes, this was an inevitable decision. Once he started thinking about the human body, he simply had to learn as much as he could about it—and that meant going *in*. The decision also makes sense given his interest in the relationship between architecture and anatomy. Already he had wandered around inside the bodies of churches, studying their anatomy, meditating on their health, searching for the design principles that animated them, and pondering the design of their domes. So why not now turn to the thing itself?

Leonardo may also have been nudged toward his human dissection by a surprising source: *The City of God*, by St. Augustine. Any number of the scholars whom Leonardo sought out for help in learning about the nature of the soul might have referred him to the work, written in the fifth century and long considered by Europeans one of *the* indispensable texts in any program of higher education. Medieval manuscripts of the work existed in abundance, and printed editions were widely available: the first edition had been published in 1467, part of the first wave of books to be printed in Europe, and before the

end of the fifteenth century some twenty different editions had appeared. By the early 1500s, at the latest, Leonardo himself owned a copy.

Like Aristotle, Augustine had argued that the soul and the body were one. Near the end of *The City of God* he made that case and then left his readers with some remarkable final thoughts on the subject.

> This would be more apparent to us if we were aware of the precise proportions in which the components [of the body] are combined and fitted together; and it may be that human wit, if it sets itself to the task, can discover these proportions in the exterior parts, which are clearly visible. As for the parts which are hidden from view, like the complex system of veins, sinews, and internal organs, the secrets of the vital parts: the proportions of these are beyond discovery. Even though some surgeons, anatomists they are called, have ruthlessly applied themselves to the carving up of dead bodies, even though they have cut into the bodies of dying men to make their examinations and have probed into all the secrets of the human body . . . even after all that, no man could ever find—no man has ever dared to try to find—those proportions of which I am speaking, by which the whole body, within and without, is arranged as a system of mutual adaptation. The Greeks call this adaptation *harmony,* on the analogy of a musical instrument; and if we were aware of it, we should find in the internal organs also, which make no display of beauty, a rational loveliness so delightful as to be preferred

to all that gives pleasure to the eyes in the outward form—preferred, that is, in the judgment of the mind, of which the eyes are instruments.

Given the widespread popularity of Augustine's work and the nature of Leonardo's interests, it's quite possible that he would have encountered this passage in his program of self-education. If indeed he did, he would have found it at once fascinating, misguided, and provocative—especially that remark about the body's secret internal proportions being "beyond discovery." Leonardo begged to differ. To make his case, in early 1489, he sawed open a human head.

IT WAS A grisly task.

As he began, Leonardo surely found himself assaulted by competing emotions: curiosity, revulsion, excitement, wonder, fear. Not that any of those feelings would have surprised him. In a way, he had anticipated this very moment several years earlier. Perhaps after waking from a powerful dream, he had jotted down an allegory of imminent discovery in which he had described that precise nexus of feelings. "Driven by an ardent desire and anxious to view the abundance of varied and strange forms created by nature the artificer," he wrote,

having traveled a certain distance through overhanging rocks, I came to the entrance to a large cave and stopped for a moment, struck with amazement, for I had not suspected its existence. Stooping down, my left hand around my knee,

while with the right I shaded my frowning eyes to peer in, I leaned this way and that, trying to see if there was anything inside, despite the darkness that reigned there. After I had remained thus for a moment, two emotions suddenly awoke in me: fear and desire. Fear of the dark, threatening cave; and desire to see if it contained some miraculous thing.

In 1489, at least, desire won out over fear—and the result, based on the dissections Leonardo then undertook, was a magnificent set of skull studies the likes of which had never been seen before in the history of art or science. Executed in a profoundly new and imaginative visual idiom, deriving from the cutaway views that he and others were producing to illustrate architectural and engineering treatises, the skulls leap off the page with a clarity, precision, and grace that appeal powerfully to the modern eye—and that in significant ways anticipate the work of today's anatomical illustrators and even imaging radiologists.

Studying the skulls in sequence, you can watch Leonardo as he goes in. He starts with a frontal view, reminiscent of many of his proportional studies of the face, that illustrates the throbbing veins that lie just under the skin of the forehead (**Figure 39**). Then he strips the flesh away entirely to expose the skull, which he renders in a split view that allows him to illustrate, with an eerie beauty, the structures of the face at two different depths: a technique, groundbreaking for its time, that is still in use today (**Figure 40**).

Many of these anatomical features had never before been drawn or described. In that respect, they certainly represent a fundamental break with the past. As fresh and modern as they

look, however, Leonardo's skull studies in fact illustrate a profoundly medieval idea: that somewhere inside the brain exists the locatable seat of the human soul. "The cavity of the orbit and the cavity of the bone that supports the cheek," he wrote alongside his split skull, "and that of the nose and of the mouth, are of equal depth, and terminate in a perpendicular line below the *sensus communis.*"

Below the . . . *what?*

Today we consider common sense a quality of mind, an intangible faculty of judgment. To Leonardo, however it was the *sensus communis*, or Common Sense: an actual part of the human anatomy. Philosophers and medical authorities in his day subscribed to an age-old theory known as the cell doctrine, in which the powers of the human mind were said to reside in three or more interconnected cells at the center of the brain.

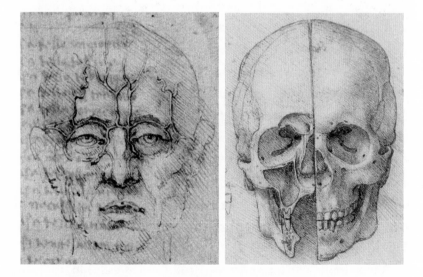

Figures 39 and 40. Studies of the human head and skull (1489), by Leonardo.

Such cells, now known as ventricles, do indeed exist, and for centuries they seemed the natural place to locate mental activity. It surely couldn't take place in all of that mushy, useless gray matter that surrounded the ventricles.

European and Arab writers had proposed a number of variations on this theme over the centuries, but the basic version, summarized by Mundinus in the *Anatomy,* went something like this. The *sensus communis,* residing in the foremost ventricle, was a kind of central processing unit linked to the body's various sense organs. "The parts pertaining to sensation end here," Mundinus explained, "as do streams at a fountain." It also housed the powers of fantasy and the imagination, which allowed it not only to receive sensory information but also to create ideas based on that information. Then came the middle ventricle, devoted to cogitation on whatever perceptions and ideas the *sensus communis* might pass along. Finally, at the back lay the third ventricle, in which memory was created and stored.

Leonardo knew the cell doctrine well. He read and owned all sorts of texts in which the theory was laid out, often with the help of rudimentary illustrations (**Figures 41** and **42**).

But Leonardo didn't just read about the idea. Appalled by the crudity of the illustrations he came across, he decided to draw his own. In 1490, for example, he laid out both a plan and an elevation of the human head—cutaway views, similar to architectural drawings he was making at the time, that showed, with fanciful precision, the interior location of the ventricles (**Figure 43**).

When he began his studies of the human skull in 1489, he had these ideas powerfully in mind. "The soul," he speculated, "seems to reside in the judgment; and the judgment would seem

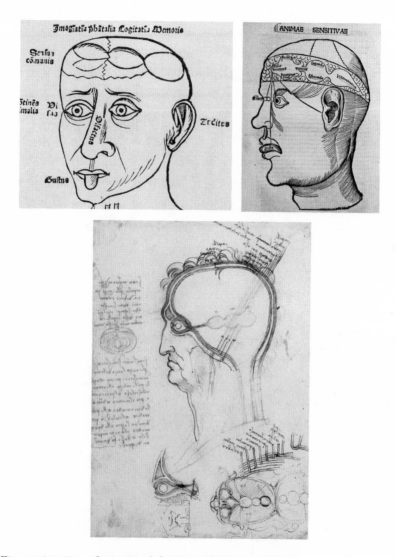

Figures 41, 42, and 43. Top left: The cell theory of the brain as illustrated in 1489, the year Leonardo began his own skull studies. *Top right:* A more detailed diagram from 1503, showing connections from the eyes, nose, tongue, and ears to the *sensus communis,* near the front of the head. *Bottom:* The theory as illustrated by Leonardo in 1490. The image at the lower right of the drawing represents the skull sawed open and viewed from above, with the top half folded over and faintly visible to the right.

to be seated in that part where all the senses meet; and this is called the *sensus communis*." Philosophers and physicians alike had been spouting vaporously about the nature of body and soul for centuries, but Leonardo decided he could do better. Just two years earlier, after all, in exploring the simple anatomy of a frog, he had managed to locate the source of all movement and life. So why shouldn't he be able to go a step further and locate the seat of the human soul? Here, at last, was a way he could *prove* that artists could be natural philosophers of the first order—a point he desperately wanted to get across to the scholars who condescended to him at the court of Milan.

And so in he went, sawing into the top of the skull, flipping it open, and removing the brain. He left no record in his notes of what he did next, but Mundinus showed him the way. "Now, cut carefully through the midst," Mundinus wrote, guiding his readers toward the *sensus communis*, "until you come upon the great fore ventricle." The rest was easy. By simply cutting toward the rear of the brain, he explained, dutifully citing the authority of Avicenna, Aristotle, and Galen, you could then expose and carefully examine its other two ventricles.

This was hogwash—as Leonardo already knew from his dissection of animals. When taken out of its housing and cut open, the brain, which has roughly the consistency of Jell-O, loses its structural integrity. The ventricles become as easy to see as the five lobes on a human liver.

But that didn't stop Leonardo, who now turned his attention from the brain to the interior of the skull that housed it. Observing what he could, and processing that information in the context of medieval brain theory, he then proceeded to produce a series of hauntingly beautiful illustrations (**Plate 8**).

What tends to impress viewers most about these illustrations today is their attention to anatomical detail and their artistic beauty. But their main point, quite literally, is metaphysical. With the confident precision of an architect and an engineer, Leonardo imagined cutaway views of the skull's interior—and then coolly proposed coordinates for the seat of the human soul. "Where the line *am* intersects the line *cb*," he wrote, referring to the grid he had superimposed over the lower skull, "will be the confluence of all the senses."

It's an astonishing moment: an act of visual speculation in which art, modern science, and medieval philosophy all come together in a statement of boundless investigative possibility. The hidden proportions of body and soul are *not* beyond discovery. Everything can be known; the microcosm can be mapped in full.

8

PORTRAIT OF THE ARTIST

Painting is philosophy.

—Leonardo da Vinci (c. 1490–92)

*I*N 1488 OR 1489, in the midst of all his other activities, Leonardo launched yet another vast project: an exhaustive survey of human proportions.

According to a contemporary who copied some of his now-lost notes, Leonardo envisaged a survey of nothing less than "the universal measure of man." At the most basic level, this meant that his focus would be not anatomy but *anthropometry,* or the measurement of the body's parts. He was by no means the first to take this on, of course. It was precisely the sort of information that the sculptor Polykleitos had codified in his *Spear Bearer* statue and lost *Canon*; that Greek builders had embodied in their metrological reliefs; that Vitruvius had summed up in his *Ten Books*; that Augustine, in *The City of God,* had suggested might allow a superior human mind to grasp the

nature of the soul; that Hildegard and so many other medieval theologians had used to connect the bodies of Adam and Christ to the order of the heavens; and that Alberti, in *On Sculpture*, with the help of his *finitorium*, had begun to chart in his geography of the human ideal.

In the scope of his ambition, however, Leonardo outdid all of his precursors. Basing his work on the comparative study of a number of live models, he conducted a series of almost unimaginably thorough studies of human proportions. From head to toe, from back to front, he scrutinized every part of the body and meticulously recorded the results of his observations. Even the briefest sampling of his notes and illustrations reveals the obsessive attention to detail that he brought to bear on his task (**Figure 44**).

Figure 44. Proportions of the human body standing, kneeling, and seated, by Leonardo da Vinci (c. 1489).

From the top of the ear to the top of the head is equal to the distance from the bottom of the chin to the lachrymatory duct of the eye, and also equal to the distance from the angle of the chin to that of the jaw—that is, $\frac{1}{16}$ of the whole. The small cartilage that projects over the opening of the nose is halfway between the nape and the eyebrow.

The distance from the top of the throat to the pit of the throat, below *qr,* is half the length of the face and the eighteenth part of a man's height.

The smallest thickness of the arm in profile *zc* goes 6 times between the knuckles of the hand and the dimple of the elbow when extended, and 14 times in the whole arm, and 42 in the whole man.

The foot, from where it is attached to the leg to the tip of the great toe, is as long as the space between the upper part of the chin and the roots of the hair *ab,* and equal to five-sixths of the face.

Significantly, he didn't just analyze the body in one static pose, as others did before him. He asked his models to *move.* They twisted their bodies and bent their limbs, they stood and sat and knelt—and at every step of the way, peering close, he tried to capture the changing proportional relationships of their bodies' parts ("*yl* is the fleshy part of the arm and measures one head; and when the arm is bent this shrinks $\frac{2}{3}$ of its length").

On and on he went, month after month, gradually amassing reams of data. Today the whole enterprise seems radically

misguided, but to Leonardo it must have felt vital. If he could carry out his task with enough determination, rigor, and insight, if he could somehow make sense of his data and synthesize them with what he was learning in his anatomical investigations, then perhaps he really might be able to take the universal measure of the human body—and soul.

MEANWHILE, THE DEBATE about the cathedral of Milan's *tiburio* was at last coming to a head.

Leonardo had submitted his model in 1488. But he later returned to the project with renewed interest, fussing with his design and asking that the overseers return his model to him for modifications. On May 10, 1490, they did just that and even advanced him money for the job: a sign, it would seem, that although they had received at least nine other submissions, they still considered him a contender. But he had precious little time to make his changes. Eager to move forward with the project, the overseers had invited Francesco di Giorgio Martini of Siena to help them evaluate the proposals they'd received—and he was due to arrive in a matter of weeks.

Francesco had made quite a name for himself in the preceding fifteen years. Despite his humble beginnings in Siena, he had enjoyed great professional success in Urbino, serving Duke Federico as a master of artillery and building some 136 structures in the area, mainly forts and churches. He had also written a number of technical treatises, most notably his *Treatise on Architecture, Engineering, and the Art of War*—the influential work, replete with all those images of the human body inhabiting architectural forms, that Leonardo himself would later own.

In 1489 he had finally returned to Siena, where, celebrated as one of the town's most distinguished citizens, he had set to work on a number of local projects and begun a busy new life as a traveling consultant.

By the time Francesco arrived in Milan to weigh in on the *tiburio* project, he had also transformed himself into an expert on classical architecture. Over the years he had regularly visited Rome and other cities to examine ancient ruins, which he had sketched, annotated, and gathered in a manuscript he called *Ancient Monuments,* the first illustrated survey of classical architecture ever compiled. And in the late 1470s or early 1480s, as a natural complement to that project, he had decided to take on an even more ambitious task: translating Vitruvius into Italian.

Nobody had ever attempted a translation of the *Ten Books* into any language. It was a daunting job, and when Francesco began he was almost laughably ill-prepared to carry it out. His Latin was weak, his Greek nonexistent, and his understanding of ancient history and literature neither broad nor deep. But he plunged into the work, spurred on by his career ambitions and his developing fascination with the architecture of antiquity. For months, perhaps even years, he stole as much time as he could to work on the project: teaching himself Latin, reading widely, consulting scholars of Latin and Greek, combing through Alberti's *On the Art of Building,* studying classical ruins all over Italy—and, gradually, based on what he was learning, applying himself to the actual job of translation. By the mid-1480s, through sheer force of will, it would seem, he had in his possession something unique in Europe: a translation, however partial and imperfect, of the only ancient guide to the classical

art of building. He felt justly proud. "The art of architecture has been almost rediscovered anew," he wrote, alluding to both his translation and his study of ancient monuments, "and with no small effort."

By June 8 Francesco had arrived in Milan, and less than two weeks later he was in the company of Leonardo, traveling south across the Lombard Plain to consult on the design of the cathedral in Pavia.

No record survives of whether the two men had met before that trip. It would be more than a little surprising if they hadn't, however, given their mutual involvement in the *tiburio* project, their shared connections in Milanese architectural circles, their overlapping interests in architecture and military engineering, and Leonardo's insatiable desire to seek out experts on matters that interested him. By the second half of June, at any rate, the two were together in Pavia. Of that there's no doubt, because the overseers of the Pavia project recorded payment for their lodging. "Item for 21 June," it reads. "Paid to Giovanni Agostino Berneri, host of Il Saracino, in Pavia, for expenses he incurred because of Masters Francesco of Siena and Leonardo of Florence, the engineers with their colleagues, attendants and horses, both of whom were summoned for a consultation about the building. Total: 20 lire."

At this point in the story, with Leonardo and Francesco having arrived and lodged together in Pavia, a fog of uncertainty sets in. How much time did they spend together? Did they get along? What did they talk about? The details are lost. But the two had so many common interests and concerns that one can imagine them engaging in a series of extraordinarily wide-ranging conversations. What they had to talk

about was almost endless. Designs for the cathedral in Pavia and the *tiburio* in Milan. Questions of physics and mechanics. Specialized building techniques and materials. Fundamental principles of architecture, engineering, and mechanized warfare. The challenges of self-education, and techniques for winning the favor of powerful rulers. The list goes on and on. They could have discussed the treatises of Alberti and Filarete, and treatises of their own; the importance, in art as in architecture, of studying both anatomy and proportion; the correspondence between architectural forms and the human body; the need, especially in churches and temples, for designs based on not only the human form but also the circle and the square. And inevitably they would have brought up the subject of Vitruvius, whose work tied so many of these strands of conversation together.

The odds are that Francesco had his translation of the *Ten Books* with him when he traveled to Milan and Pavia. In 1490, after all, he was actively relying on the work to help him make sense of and classify the classical ruins he came across in his travels—a job he liked to refer to, echoing Vitruvius (and anticipating modern literary theorists), as "reconciling the sign with the thing signified." In the late 1480s and early 1490s he was also borrowing directly from his translation as he revised and expanded his *Treatise,* working on the edition that Leonardo would later own. Given the amount of time he spent on the road in 1490 as an architectural consultant, it would seem to have been almost necessary for him to have carried both his *Treatise* and his translation of the *Ten Books* with him, so that he could not only consult and work on them in his spare time but also discuss and share them with friends, colleagues, scholars, and

employers. If indeed this is what he did, it's easy to picture him showing both books to Leonardo—and to picture Leonardo, for his part, pouncing at the chance to have a look.

WHICH BRINGS US, at last, to Vitruvian Man.

He was now some fifteen hundred years old. From the day of his birth, in the age of Augustus, he had been kept alive by a succession of anonymous scribes—but in written, not visual, form. He was an abstraction, a ghostly figure who existed in words alone. To be sure, as the centuries wore on, reflections of the idea did flicker across the pages of medieval manuscripts, embodied in all those mesmerizing illustrations of the microcosm: the diagrams of the cosmos, the guides to the constellations, the maps of the world, the pictures of Christ on the cross, the medical and architectural drawings. But throughout that entire period, as best it can be determined, nobody had ever attempted to conjure up an image of him based directly on how Vitruvius had described him in the *Ten Books*. Nobody had tried to work out in visual form, that is, exactly *how* the ideal human body might be made to fit inside both a circle and a square—until the 1480s, when, in the margins of one of his *Treatise*'s opening pages, Francesco di Giorgio Martini sketched the first known picture that can legitimately be called Vitruvian Man (**Figure 45**).

The illustration has a dreamy quality to it. But it was no idle fancy. It was an attempt to sum up the essence of the human analogy—the idea, as Francesco put it in his *Treatise,* that "all the arts and all rules are derived from a well-composed and proportioned human body." Many of the other human figures who

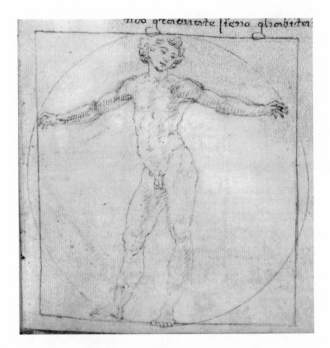

Figure 45. The first drawing of Vitruvian Man known to be based directly on the description in the *Ten Books*. From Francesco di Giorgio Martini's *Treatise* (c. 1481–84), owned by Leonardo.

inhabit Francesco's architectural drawings bear an uncanny likeness to this figure, and that's no accident. They are *all* Vitruvian Men.

Francesco was more suggestive than precise in drawing his Vitruvian Man. He drew him as an idea, it seems, but didn't worry much about the details. The circle and square that surround him are imperfectly drawn. So is the figure himself, whose proportions don't correspond terribly closely to those described by Vitruvius—and who, in general, doesn't fit especially neatly inside the two shapes. In drawing the picture Francesco also

chose to sidestep a basic problem with the Vitruvian text, one that Filarete had called out some two decades earlier in his own architectural treatise. "Vitruvius," he wrote, "says that the navel is the middle of the figure of man." So far, so good. "However," he went on, scratching his head as he confronted the obvious, "it does not seem to be exactly in the middle."

The navel indeed does not occupy the halfway point between the human head and feet—as is obvious to anybody who takes even a cursory look at the human body. Roughly speaking, the pelvic region occupies the halfway point, and Francesco drew his young man accordingly. Anatomically, that was the right choice, but, as he must have recognized, it meant that his figure did not live up to the Vitruvian ideal. Not that this seems to have troubled him much. In theory, he explained in his *Treatise,* following Vitruvius, a building's measurements should derive from an ideal canon of human proportions—but as a practical matter, he continued, they "can be decreased or increased somewhat at the choice of the artisan."

Did Francesco show Leonardo his drawing of Vitruvian Man? If so, did seeing it prompt Leonardo to draw his own? It's impossible to say for sure, but enough circumstantial evidence does survive at least to suggest a link between the two drawings. Before the 1480s, when Francesco summoned up his image of Vitruvian Man, nobody in the fifteen-hundred-year life of the *Ten Books* had ever translated the work into the vernacular, and nobody is known ever to have explicitly illustrated its famous man in a circle and a square—but then, in 1490, the very year that Francesco and Leonardo lodged together in Pavia, Leonardo decided to illustrate that very same figure. Leonardo didn't date his drawing, which ultimately makes its dating to

1490 a guess—but as guesses about Leonardo go, it's about as good as they get. The style of draftsmanship, the type of handwriting, and the kind of paper and pen that Leonardo used for his Vitruvian Man all correspond closely to other drawings that he is known to have produced in 1490. And that's the very period in his career when he was immersed in his intensive study of human proportions and had a special interest in comparing his own measurements to those listed in the Vitruvian canon.

AFTER ONLY A few days in Pavia, Francesco returned to Milan to help write a final report on the *tiburio* project. The report, dated June 27, detailed how the structure should be built. Not long afterward, the cathedral overseers at last picked two local architects to carry out the project.

Leonardo was not among them. Perhaps, having just spent time with Francesco, he knew already what the outcome would be and so decided to linger in Pavia rather than returning home to be let down. He does seem, at least, to have allowed himself some time in Pavia for research and sightseeing. In his notes he not only mentions the contents of the Witelo book he wanted to find, which suggests he spent time at the Visconti library, but he also praises the town's ancient equestrian statue, describes the design of the chimneys at the Visconti Castle, sketches one of the town's churches, and records the techniques he observed local workmen use as they shored up the foundations of the old city walls.

Leonardo made no mention of how long he stayed in Pavia. But sometime before July 22 he was back in Milan, because that night, according to his notes, he had dinner in the city with

another architect and military engineer who may have helped inspire him to draw Vitruvian Man: a mysterious figure known as Giacomo Andrea da Ferrara.

What little is known about Giacomo Andrea derives primarily from a remark made by the mathematician Luca Pacioli. In one edition of his *On Divine Proportion* (1498), which contains geometrical illustrations by Leonardo, Pacioli included a dedication to Ludovico Sforza that began with a list of the "many very famous and wise men" who served the duke at his court in Milan. Pacioli placed Leonardo prominently on the list, describing him in the most glowing of terms—and then, immediately afterward, singled out Giacomo Andrea as one of Leonardo's closest friends. "There was also Giacomo Andrea da Ferrara," Pacioli wrote, "as dear to him as a brother, the keen student of Vitruvius's works, but who is nonetheless well versed in his special military field."

That single, tantalizing sentence represents virtually the full extent of what survives of Giacomo Andrea in the historical record. One of the few other known references to him concerns the circumstances of his death. In 1499 the forces of the French king Louis XII invaded and occupied Milan—and the following year, evidently because of his continuing loyalty to Ludovico Sforza, they hanged Giacomo Andrea. Not only that, they quartered his body and displayed its pieces on the gates of the city: a gruesome warning to those harboring like sympathies.

Leonardo himself seems to have had substantially better relations with the French, but at the end of 1499 he decided to leave Milan. He would return to live there some seven years later, in the summer of 1506—whereupon, if he hadn't heard the news

already, he must have learned of Giacomo Andrea's death. No doubt still grieving for his old friend, he soon made another reference to him in one of his notebooks. "Messer Vincenzo Aliprando, who lives near the Inn of the Bear," he wrote, "has Giacomo Andrea's Vitruvius."

It's possible that Leonardo sought out Giacomo Andrea's copy of the *Ten Books* for purely sentimental reasons: as a memento of a dead friend. But there may be more to the story than that. According to the architect Claudio Sgarbi, who has spent years investigating the matter, Giacomo Andrea's copy of the *Ten Books* wasn't just *any* copy. It was a special manuscript that Giacomo Andrea produced for his own private use—and one that he may have collaborated on with Leonardo. Sgarbi believes that he has located the manuscript itself, in the Biblioteca Comunale Ariostea of Ferrara, where, miscatalogued unpromisingly as an "imperfect work starting from Book Seven" and misdated as a sixteenth-century edition of the *Ten Books*, it had long evaded the attention of scholars. Some twenty-five years ago, however, when Sgarbi first encountered the manuscript, he realized that in fact it dated to the 1490s, contained almost the full text of the *Ten Books,* and included an unprecedented 127 illustrations, all of remarkable sophistication.

Sgarbi was astonished by what he found. By illustrating a number of Vitruvian concepts in his *Treatise,* Francesco di Giorgio Martini had broken new ground—but even he had not attempted to systematically illustrate the *Ten Books* itself. Nobody had. The Ferrara manuscript thus represented a historical landmark, as Sgarbi announced in a 1993 journal article describing his discovery. "The manuscript," he declared, "is the

earliest surviving attempt to combine the text of Vitruvius's *De architectura* with a programmatic apparatus of illustrations. It must therefore be considered a completely original, perhaps revolutionary, work."

A fully illustrated Vitruvius. This on its own might explain Leonardo's interest in tracking the work down. But what particularly enthralled Sgarbi was an illustration he found buried deep in the body of the manuscript, on the reverse side of its seventy-eighth folio: a drawing of a distinctly Christ-like Vitruvian Man, which bears a powerful resemblance to Leonardo's own (**Figure 46**).

The correspondence is eerily close—and unique in the history of art. No other drawing of Vitruvian Man before the sixteenth century using this particular relationship between the circle and square survives. The two pictures correspond so closely, in fact (**Figure 47**), in terms of not only the circle and the square but also the figures' bodily proportions, that Sgarbi believes they must have been produced as part of some kind of collaboration. And the only person in the 1490s who could plausibly have worked on the drawing with Leonardo was Giacomo Andrea—one of only a handful of Italian experts on Vitruvius at the time, and the only one, other than Francesco di Giorgio Martini (whose drawings were very different), whom Leonardo seems to have known personally.

Of course, the Ferrara drawing might represent a direct or indirect copy of Leonardo's drawing. Sgarbi has yet to find firm documentary proof that the two men collaborated on their drawings. But the possibility of its being a copy is highly unlikely, he contends, because upon close inspection the Ferrara drawing reveals itself to be a very tentative effort, full of

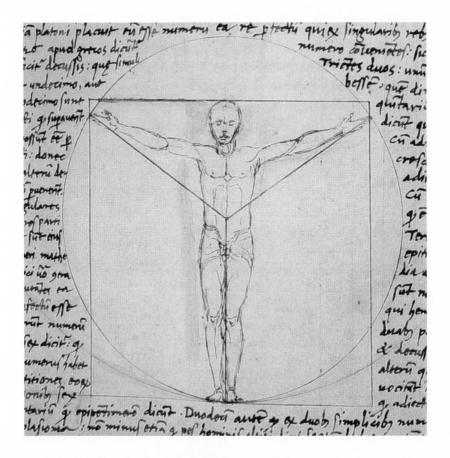

Figure 46. Vitruvian Man from the Ferrara manuscript
of Vitruvius's *Ten Books.*

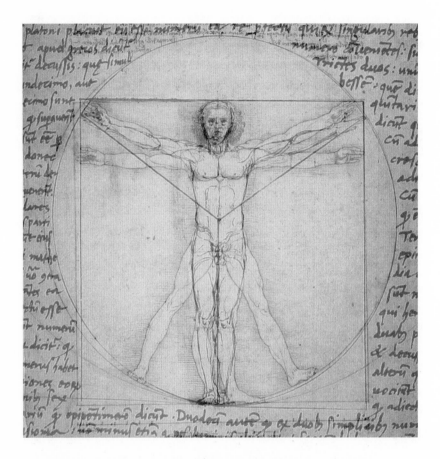

Figure 47. The Ferrara figure superimposed on Leonardo's, revealing a startlingly close correspondence between the two.

erasures, false starts, and corrections—all of which would have been unnecessary had its illustrator simply been trying to reproduce Leonardo's picture. Sgarbi instead imagines Leonardo and Giacomo Andrea working side by side, perhaps with Giacomo Andrea sketching out an initial idea rooted in traditional Christian imagery and with Leonardo then realizing how he could enhance the image to make it a statement of his own ideas and personal philosophy. Elsewhere in the manuscript are drawings of machines and engines that are so ahead of their times in terms of artistic technique that Sgarbi believes only one person could have conceived of, if not actually executed, them: Leonardo himself.

It's a fascinating theory. But as much fun as it is to ponder, the trail of speculation ultimately goes cold—as it does for anybody pondering the rich swirl of people, texts, images, and ideas that may have prompted Leonardo to draw his picture. Ultimately, despite how much can be said on all of those fronts, the picture stands alone. One has to let it speak for itself (**Plate 9**).

LEONARDO DREW THE picture on a sheet of paper measuring 13½ by 9⅝ inches—dimensions that make it just a bit larger than a standard letter-sized sheet of modern paper. He used a variety of implements as he worked: compass dividers and a set square (to define his circle and square, and to check his various measurements); perhaps a metal-point stylus (a predecessor of the pencil, which had yet to be invented, to trace the initial outlines of his drawing); and a pen and brown ink (to give the drawing its finished look). He appears to have drawn the circle and the square first, in the process pricking twelve holes in the

page with his compass divider; then to have placed his man inside the two figures; then to have inserted the scale underneath them, divided into units of fingers and palms; and, finally to have added his two paragraphs of text—the first above the picture, the second below it. The text itself, which he wrote in his trademark mirror script, is worth quoting in full.

Vitruvius, the architect, has it in his work on architecture that the measurements of man are arranged by nature in the following manner: 4 fingers make 1 palm, and 4 palms make 1 foot; 6 palms make a cubit; 4 cubits make a man, and 4 cubits make one pace; and 24 palms make a man; and these measures are those of his buildings. If you open your legs so that you lower your head by $\frac{1}{14}$ of your height, and open and raise your arms so that with your longest fingers you touch the level of the top of your head, you should know that the central point between the extremities of the outstretched limbs will be the navel, and the space that is described by the legs is an equilateral triangle.

The span to which the man opens his arms is equivalent to his height. From the start of the hair to the margin of the bottom of the chin is a tenth of the height of a man; from the bottom of the chin to the top of the head is an eighth of the height of the man; from the top of the breast to the top of his head is one sixth of the man; from the top of the breast to the start of the hair is a seventh part of the whole man; from the nipples to the top of the head is a quarter part of the man; the widest distance across the shoulders contains in itself a quarter part of the man; from the elbow to the tip of the hand will be the fifth part of a man; from this elbow

to the edge of the shoulder is an eighth part of the man; the whole hand is a tenth part of the man; the penis arises at the middle of the man; the foot is a seventh part of the man; from the sole of the foot to below the knee is a quarter part of the man; from below the knee to the start of the penis is a quarter part of the man; the portions that are to be found between the chin and the nose, and between the start of the hair and the eyebrows, are both spaces similar in themselves to the ear and are a third of the face.

There's a *lot* going on in these two paragraphs. For starters, even though Leonardo opens with a matter-of-fact reference to the contents of the *Ten Books*, Vitruvius actually doesn't say much of what Leonardo claims he does. Only ten of the twenty-two measurements that Leonardo mentions, in fact, derive from Vitruvius—and Leonardo has significantly altered two of them. (He makes the length of the foot equal to a seventh of the body's total height, rather than a sixth, and does the same for the distance from the top of the chest to the hairline.) The other eleven measurements he mentions either list units of measure common in Leonardo's day or can be traced directly to the reams of data on human proportion that he recorded in his notes. Leonardo makes Vitruvius his starting point, in other words, but when it comes to the details, he questions ancient authority and makes experience his guide.

The whole enterprise brings to mind the cartographic analogy that Leonardo would use in laying out his plans for *On the Human Body*. Painstakingly, over the course of months, he had gathered the precise coordinates of the body's various provinces, just as Ptolemy had gathered the precise coordinates of

the world's. The next logical step was to synthesize his data and create a single map of the whole, one that would not only portray it as it had been described in antiquity but correct that vision to reflect the results of modern discoveries. And that's the vision, of course, that Leonardo conjured up in his drawing.

At the most elemental level, the picture is a study of human proportions. It's a geography of the human ideal not unlike the one presented by Alberti in *On Sculpture*. The various lines that divide up the face and body parts of Leonardo's figure attest to this: they all correspond to the proportional relationships that Leonardo described in his text. But the picture contains details that extend far beyond what he spells out there. It encodes many of the minute proportional relationships that Leonardo recorded so abundantly in his notes—but with incomparably greater concision. In this respect, the drawing proves the point that Francesco di Giorgio Martini liked to make: that pictures, not text, are the best way of transmitting detailed scientific information. Leonardo himself would later make that point repeatedly in his notebooks, specifically in the context of the human anatomy. "You who think to reveal the figure of man in words, with his limbs arranged in all their different attitudes," he would write, "banish the idea from you. For the more minute your description, the more you will confuse the mind of the reader, and the more you will lead him away from the knowledge of the thing described."

Leonardo also used his picture to work out what Vitruvius meant when he said that a man could be made to fit inside a circle and a square. He addressed the basic problem that had vexed Filarete: the fact that the human navel doesn't actually lie at the midpoint between the crown and the feet. Instead

of drawing a circle and a square that shared a center with the human navel, as Francesco had done, Leonardo shifted his square downward—and, if Claudio Sgarbi is correct, he arrived at this solution after seeing the work of Giacomo Andrea. This allowed him to draw a single figure whose navel occupied the center of the circle and whose genitals occupied the center of the square: a figure, in other words, that corresponded to both the Vitruvian ideal *and* anatomical reality. Vitruvius in fact had never suggested that a circle and a square should be superimposed on the same human figure. Leonardo's drawing therefore represented what one modern scholar has called "an act of radical philology." Not only did it correct previous interpretations of an ancient text by decentering the circle and the square, it also managed, by laying the two shapes atop the same figure, to capture the essential message of the Vitruvian text: that the human form embodied the natural harmonies present in the circle and the square. Here Leonardo was up to one of his favorite tricks, doing two or more things at once—which, of course, is the essence of harmony. He doesn't just describe harmony, as Vitruvius had done; he demonstrates it.

One element of Vitruvian Man has puzzled many observers. The figure's left foot, which is turned out at a joint-crackingly unnatural angle, clearly doesn't correspond to anatomical reality. Why would an artist as talented as Leonardo, and one so utterly dedicated to anatomical accuracy, make such an apparently clumsy choice, especially in a picture designed to capture the essence of the human ideal? The answer is simple. Canons of proportion since antiquity had often used the foot as one of the basic units of measurement. The convention in Leonardo's time was therefore to accompany proportional studies with a

side view of the foot, creating a kind of visual key—as Francesco di Giorgio Martini did in his *Treatise* (**Figure 48**). Leonardo, however, decided to proceed differently. Interested in compressing as much visual information as possible into his drawing, he chose to incorporate a side view of the foot into his picture: a bit of visual shorthand that he knew contemporary viewers would understand.

The picture abounds with similar examples of visual shorthand and compression. Nowhere on the page does Leonardo bother to quote, or even mention, the text from the *Ten Books* on which his picture is based: the lines describing how a well-formed man, embodying the harmonies of cosmic design, can be inscribed in both a circle and a square. That's because Leonardo knew his viewers would get the reference—and that his picture itself summed up the idea more concisely and elegantly than words ever could. The age-old symbolic resonances of the circle and the square also went without saying, as did the meaning of a figure spread-eagled inside them. Wordlessly, unavoidably, the picture summoned up a parade of visual associations: all those visions of the microcosm in which a figure, at once human

Figure 48. Proportions of the human body and foot, from Francesco di Giorgio Martini's *Treatise* (c. 1481–84).

and divine, embraces and embodies the heavens and the earth. And in doing so it broadcast one of the most popular metaphysical propositions of the age. Taccola had spelled it out under his drawing of a man in a circle and a square ("I have all measure in me, both of what is heavenly above and what is earthly and infernal"); Francesco di Giorgio Martini had alluded to it in his *Treatise* ("Man, called a little world, contains in himself all the general perfections of the entire cosmos"); Marsilio Ficino had laid it out in his *Platonic Theology* (calling human nature "the center of nature, the middle point of all that is, the chain of the world, the face of all, and the knot and bond of the universe"); and Luca Pacioli, Leonardo's friend and collaborator, would soon sum it up in his *On Divine Proportion* ("From the human body derive all measures and their denominations, and in it is to be found all and every ratio and proportion by which God reveals the innermost secrets of nature").

Leonardo himself made similar statements. Best known is the famous note he made to himself at about the time he drew Vitruvian Man ("By the ancients man was termed a lesser world, and certainly the use of this name is well bestowed, because his body is an analogue for the world"). But he had expressed the idea even more succinctly in the early 1480s, before leaving Florence for Milan. "Man," he wrote, alluding to not only the human body but also the human spirit, "is a model of the world."

MOST OF LEONARDO'S notebook sketches feel hasty and unfinished, less like the result of thought than like thought *itself,* captured in action. But Vitruvian Man is different. Leonardo drew

the picture with uncharacteristic precision, almost as though he was carefully preparing it to be printed.

That's not an implausible idea. He seems indeed to have had some of his anatomical studies printed in about 1490, and although the originals are now lost, a few apparent copies survive in the work of others, most notably Albrecht Dürer. Leonardo himself would make clear later in life that he hoped his anatomical studies would be printed using high-quality copper plates rather than cheap woodblocks. "I beseech you who come after me," he wrote alongside some detailed drawings of the spinal cord, "not to let avarice constrain you to make the prints in wood." Less than a decade after Leonardo's death, the physician Paolo Giovio reiterated this idea when summing up Leonardo's legacy as an anatomist. "He then tabulated with extreme accuracy all the different parts," Giovio wrote, "down to the smallest veins and the composition of the bones, in order that this work, on which he had spent so many years, should be published from copper engravings, for the benefit of art."

All of this might explain why Vitruvian Man survives as an orphan sheet, detached for centuries from whatever notebook Leonardo originally drew it in. Perhaps, inspired by the works of Giacomo Andrea and Francesco di Giorgio Martini, he intended it to be transferred to a finely etched copper plate, for publication as part of a printed book: an illustrated edition of the *Ten Books,* say, or a treatise of his own on architecture. Or perhaps he drew it with a printed edition of *On the Human Body* in mind, as an introductory overview of the lesser world he hoped to map out in the book. Scholars have proposed all sorts of other possibilities: that he intended the picture as part of a treatise on painting; that he envisaged it as the frontispiece

of his own version of *On Sculpture;* even that he designed it, in the words of one modern theorist, as "a key to define the elementary set of measurable proportions he needed in order to solve the problems of the perspective construction in [*The Last Supper*]." Far less credible and vastly harder to verify are the various popular theories, ranging from the reasonable to the insane, about the mathematical, geometrical, medical, and mystical codes that Leonardo supposedly hid in the picture.

One little-discussed theory is worth pausing over, however: the idea that Leonardo drew his picture as part of a treatise on human movement. In *On Divine Perspective* (1498), Luca Pacioli mentioned just such a work and described it as already finished. Although the treatise has long been lost (if indeed it ever existed), many scholars believe that a manuscript known as the *Codex Huygens* contains copies of a number of its drawings— and what's striking about some of them is the eerie resemblance they bear to Vitruvian Man. This suggests a tantalizing idea: that Vitruvian Man, whose body is indeed as much a study of animation as it is of proportion, is the last surviving member of what was originally a whole tribe of restless Vitruvian Men (**Figure 49**).

There's a final possibility worth mentioning: that Leonardo drew Vitruvian Man as a self-portrait. Not a literal self-portrait, of course—the picture hews far too closely to an idealized set of proportions for that. But the man in the picture does seem to be about the right age (Leonardo would have been thirty-eight in 1490); he does correspond in appearance to descriptions of Leonardo by his contemporaries ("very attractive, well proportioned, graceful, and good-looking . . . beautiful curling hair, carefully styled"); he does bear some likeness to the possible

Figure 49. Possible copy of a now-lost study of
human motion by Leonardo, from the *Codex Huygens* (c. 1560).

portraits of him that survive (the Verrocchio statue of David, the
Bramante portrait of Heraclitus); and his face, drawn with far
more care and apparent emotion than the rest of his body, looks
for all the world like the face of a man studying himself intently
in a mirror. Think of the picture as an act of speculation, a kind
of metaphysical self-portrait in which Leonardo—as an artist, a
natural philosopher, and a stand-in for all of humanity—peers
at himself with furrowed brow and tries to grasp the secrets of

his own nature. This would be consistent with advice he offered other artists: namely, that in striving to capture the human ideal, they start by studying how they themselves measure up. "Measure on yourself the proportion of the parts of your body," he wrote, "and if you find any part in discord with the others make a note of it, and be careful not to use it in the figures composed by you. Remember this, because it is a common vice of painters to delight in making things similar to themselves."

That sounds a lot like somebody speaking from personal experience. Maybe, at some level, Leonardo just couldn't *help* drawing himself. At least one person who knew him in Milan believed precisely that to be the case: the court poet Gaspare Visconti. In a few tart lines of verse written at the end of the 1490s, Visconti accused Leonardo of indulging in the very vice that he had urged his own disciples to avoid. "There is one nowadays," he wrote, "who has so fixed in his conception the image of himself that when he wishes to paint someone else, he often paints not the subject but himself."

It's hard to read those lines without thinking of Vitruvian Man. Maybe, while lodging at Il Saracino in Pavia, Leonardo started out by imagining that he would draw the figure as Francesco di Giorgio did—as a dreamy embodiment of a classical idea. Maybe, back in Milan, he imagined that he would draw it as Giacomo Andrea did—as an allusion to Christ on the cross. Maybe he came to the idea even earlier, imagining it as an analogue to Alberti's geography of the human ideal, to Taccola's man in a circle and a square, or to any number of medieval visions of the microcosm. Maybe, true to form, he imagined it as all those things and more: as a study of human proportions; as an overview of the human anatomy; as an exploration of an

architectural idea; as an illustration of an ancient text, updated for modern times; as a vision of empire; as cosmography of the lesser world; as a celebration of the power of art; as a metaphysical proposition. His genius, in the end, was to bring all of these things together in a kind of universal self-portrait.

"He who understands himself understands much," Taccola wrote under his man in a circle and a square. That's surely the spirit, at once individual and all-encompassing, in which Leonardo summoned up the ghost of Vitruvian Man. Animated by the ancient philosophical injunction "Know thyself," containing worlds both great and small, and ceaselessly reconfiguring himself in the act of self-study, the figure captures a hinge moment in the history of ideas: the intoxicating, ephemeral moment when art, science, and philosophy all seemed to be merging, and when it seemed possible that, with their help, the individual human mind might actually be able to comprehend and depict the nature of . . . everything.

EPILOGUE

AFTERLIFE

A RE YOU READY?"
Upstairs at the Gallerie dell'Accademia, in Venice, Dr.
Annalisa Perissa Torrini looked over at me as I finished tugging
on my tattered white cotton gloves. We were standing at the
display table, about to open the folder containing Vitruvian
Man. A few others working in the area had quietly gathered
round, eager for a viewing themselves.

Nobody knows what Leonardo did with the picture after he
drew it. He never had it printed; he made no sketches or men-
tion of it in his notebooks; and not a single allusion to it has
ever turned up in the writings of his contemporaries. Illustrated
editions of Vitruvius did begin to appear in the early decades
of the sixteenth century, including one published during Leo-
nardo's lifetime, but the relatively crude renderings of Vitruvian
Man they contained clearly did not derive from his model. Only
one direct reference to the picture survives from the whole of

the sixteenth and seventeenth centuries: a cursory description recorded in passing in 1590 by an obscure Milanese theorist of art. The first copy didn't appear in print until 1784.

All of which brings a certain irony to the fore. Today Vitruvian Man has become one of the best-known and most frequently reproduced images in the world. But in Leonardo's time, and indeed for centuries afterward, the drawing remained almost entirely unseen and unknown.

What little is known about its early history is this. When Leonardo died, in 1519, he bequeathed all of his notebooks and drawings, Vitruvian Man presumably among them, to his favorite pupil and assistant, the Milanese painter Francesco Melzi. Throughout his life, Melzi guarded the works as treasures and showed them off to visitors with great pride, but after his death, in 1570, his heirs allowed the collection to disperse. What happened to the drawing in the two centuries that followed is anybody's guess, but it seems to have stayed in Milan. That, at least, is where it finally reappeared in 1770, bound by a certain Venanzio de Pagave into a private folio of drawings by Leonardo, which Pagave recorded as having received as gifts from the archbishop of Milan. The folio then soon passed into the possession of the Milanese art historian Giuseppe Bossi, a lifelong champion of Leonardo who, in 1810, published one of the earliest known copies of Vitruvian Man, along with the first accurate transcription of the accompanying text. After Bossi died, in 1815, the folio was acquired, and eventually disassembled, by a Venetian museum eager to expand its holdings: the Gallerie dell'Accademia.

Yet even then the picture remained almost completely out of view for more than another century. Only in 1956 did it

at last begin to attract widespread public attention, when the famous British art historian Kenneth Clark reproduced it in a landmark work titled *The Nude: A Study in Ideal Form.* The work became a best seller, and for Vitruvian Man the results couldn't have been more dramatic. Released into the ecosystem of popular culture, the picture began reproducing rampantly, in forms both serious and lighthearted, and has been doing so ever since (**Figures 50, 51,** and **52**).

* * *

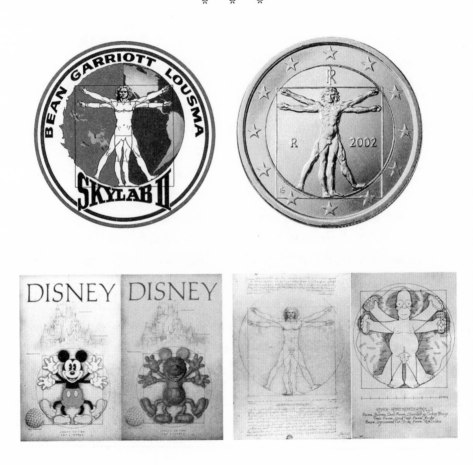

Figures 50, 51, and 52. Vitruvian Man in the modern world.
Opposite page, *top left:* The Skylab II logo; *top right:* The back
of the Italian one-euro coin. *Above:* Parody images.

* * *

CELEBRITIES, THEY SAY, always seem smaller when you meet
them in person. That wasn't my experience with Vitruvian Man.
When Dr. Perissa Torrini finally laid the drawing out on the
table, I found it larger than I'd expected, no doubt because
reproductions so often shrink it down. Not only that, as I peered
in close at the original I found myself arrested, as I never quite
had been before, by the fixity of the figure's gaze. He looks
straight ahead with eerie intensity, as if studying his own reflec-
tion. He's a vision of the human ideal, pinned forever in place
like a butterfly to a museum wall, yet he's also a study in per-
petual motion. He pushes one leg out to the side and pulls it
back, then does the same with the other; he raises one arm
and lowers it, then does the same with the other. Playing with
the possibilities, trying to understand himself, he shape-shifts
though a series of sixteen poses in all.

We spent close to an hour with the picture that morning,
studying it from all sides, reviewing its history, peering at tiny

details, discussing how and why it might have been drawn, holding it up to the light to see the pinpricks made by Leonardo's compass dividers. What struck me immediately about it was the quiet confidence of its line. Leonardo had drawn the figure with remarkable delicacy, but at the same time, digging grooves into the paper with his stylus, he'd practically etched it. Especially the hands and fingers, the feet and toes, and the outlines of the body: Leonardo had carved their contours right out of the page (**Figure 53**).

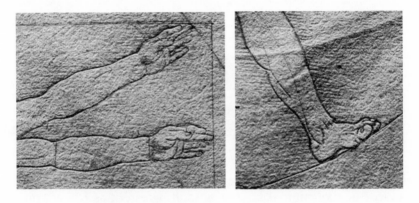

Figure 53. Hands and foot of Vitruvian Man.

The picture is reproduced so often today, and in so many different contexts, that it's hard not to think of it as ubiquitous, timeless, and inevitable. Looking at the original, however, I found myself drawn to the little things: the brittleness of the paper; the gently fading quality of the ink; the stray marks on the page; the occasional flourishes atop Leonardo's letters; the name "Leonardo da Vinci" written at the bottom of the page in an eighteenth- or nineteenth-century hand; the faint residue of glue on the back of the picture, where Venanzio de Pagave

had pasted it down into his folio. It all made me reflect on the utter contingency of the image, which could so easily not have existed. What if the Greeks had defined beauty and the nature of the cosmos differently? What if Octavius hadn't decided to reinvent himself as Augustus? What if Vitruvius had never written the *Ten Books*, or if medieval scribes, flummoxed by the difficulty of the text, had quit copying it? What if Christian theologians and mystics hadn't incorporated elements of Vitruvian Man into their worldview? What if Leonardo hadn't lived in Florence, studied with Verrocchio, or turned to the study of architecture and anatomy in Milan? As distractible as he was, what if he had just never quite gotten around to drawing the picture? Or what if it had simply disappeared after Francesco Melzi's death, like so many of Leonardo's other drawings?

One particular day more than five hundred years ago, I couldn't help thinking, Leonardo set other business aside, laid this particular sheet of paper down on a table somewhere—and then, after carefully dipping the nib of his pen into a pot of brown ink, began to draw Vitruvian Man. Perhaps he worked with Giacomo Andrea da Ferrara at his side. Perhaps he drew the picture after lodging with Francesco di Giorgio Martini in Pavia, or after discussing Vitruvius with Bramante in Milan. Perhaps he drew it to make sense of an age-old idea, to illustrate an ancient text, or to sum up the essence of the human analogy. Perhaps he flipped back and forth through his own notebooks as he worked, imagining that he'd include the picture in a treatise of his own. Perhaps he drew it to impress Ludovico Sforza, or perhaps he drew it only for himself, as a sort of metrological relief that he could consult privately while working on his paintings.

Perhaps he just *drew* it, without really knowing why.

Whatever the circumstances, he had much of his career still before him at that moment. He had yet to create his famous giant clay model of the Sforza horse, which would quickly win acclaim all over Italy as one of the greatest sculptures of all time—only to be reduced to rubble in 1499 by French soldiers celebrating their capture of Milan. He had yet to paint *The Last Supper* and the *Mona Lisa,* the works for which today he is best known. He had yet to conduct the remarkable series of anatomical investigations that would make him a true pioneer in the history of both medicine and art, and he had yet to devise some of his most famous experiments and inventions. He still had countless plans to make, pictures to draw, notebook pages to fill.

When he sat down to draw Vitruvian Man, in other words, the moment was ripe with potential. Already Leonardo had observed and studied the natural world more thoroughly than anybody before him, and now, by marrying his unique talents as a scientist and an artist, perhaps he felt he was on the verge of attaining what had eluded others for so long: the godlike ability to see and understand the nature of the world as a whole. That's the spirit, at once medieval and modern, and ultimately rooted in the quest for self-understanding, in which Leonardo would go on to live his life—and it's why, after his death, in 1519, his friend and final patron, King François I of France, eulogized him with the highest praise he could imagine. "I cannot resist repeating the words I heard the king say of him," a member of François's entourage wrote. "He said that he could never believe there was another man born in this world who knew as much as Leonardo, and not only of sculpture, painting, and architecture; and that he was a truly great philosopher."

"With what words, O writer," Leonardo wrote alongside one of his anatomical studies, "will you describe with similar perfection the entire configuration that the drawing here does?" He might as well have been describing Vitruvian Man. Brought into being more than half a millennium ago and born of concepts far older still, the picture contains whole lost worlds of information, ideas, stories, and patterns of thought. But look its subject directly in the eye, and you'll also see Leonardo da Vinci, staring out at you from the page. The man himself died centuries ago, but his ghost—timeless, watchful, and restless—remains unmistakably, unforgettably alive.

FURTHER READING

T HE ONLY OTHER book devoted exclusively to Vitruvian Man that I've been able to unearth is *Vitruvs Proportions-figur,* a scholarly monograph published in German in 1987 by the Leonardo expert Frank Zöllner. It's not easy to find, but much of its argument is reprised in the fifth chapter of Zöllner's giant and beautifully produced *Leonardo da Vinci, 1452–1519: The Complete Paintings and Drawings,* which is widely available in libraries and stores. The definitive source of information about the picture itself is *I disegni di Leonardo da Vinci e della sua cerchia,* a grand catalogue published in 2003, in a run of only 998 numbered copies, that contains facsimiles and meticulously detailed descriptions of all the Leonardo drawings owned by the Gallerie dell'Accademia, in Venice. The Accademia devoted an exhibit to Vitruvian Man in late 2009 and 2010, at which time it produced a companion volume of essays titled *Leonardo: L'uomo vitruviano fra arte e scienza,* which provides interesting reading for those who know Italian.

Books about Leonardo abound in such quantity and such varying quality that it can be hard to know where to start or which ones to trust. I found three general works particularly useful as I tried to get a handle on his life and thought: Charles Nicholl's *Leonardo da Vinci: The Flights of the Mind*; Martin Kemp's *Leonardo da Vinci: The Marvellous Works of Nature and Man*; and Serge Bramly's *Leonardo: Discovering the Life of Leonardo da Vinci*. A less comprehensive but extremely engaging introduction to Leonardo is *The Treasures of Leonardo* by Matthew Landrus, a lovingly produced volume that includes removable facsimiles of documents, drawings, and paintings by Leonardo and his contemporaries. For those interested in the earliest accounts of Leonardo's life, a particularly good source is *Leonardo da Vinci: Life and Work and Paintings and Drawings* by Ludwig Goldscheider, which gathers together several of them in a single place. Giorgio Vasari's invaluable but not always trustworthy short biography of Leonardo appears in Goldscheider's work, but it's also very easy to find in the many editions of Vasari's *Lives of the Artists* that have been published over the years.

For Leonardo in his own words, I relied primarily on two works: Jean Paul Richter's *The Notebooks of Leonardo da Vinci*, an essential and engrossing two-volume work originally published in 1883 but reissued in 1970; and Carlo Pedretti's two-volume *The Literary Works of Leonardo da Vinci,* a staggeringly detailed, entry-by-entry commentary on the contents of Richter's compilation, published in 1977. Richter painstakingly translated every remark he found in Leonardo's notebooks and then organized his translations by subject; Pedretti, for his part, updated and corrected Richter's translations, provided exten-

sive glosses, did his best to date every single entry, and published new material from the two Leonardo notebooks that were accidentally rediscovered in 1967 in the bowels of the National Library in Madrid. I also consulted *The Notebooks of Leonardo da Vinci*, a popular one-volume abridgment of Jean Paul Richter's two-volume collection, first published by his daughter Irma in 1952 but often reissued since, and in a few cases I relied on Edward MacCurdy's two-volume *The Notebooks of Leonardo da Vinci,* published in 1938. Another source I found extremely helpful was Philip McMahon's translation of and commentary on Leonardo's *Treatise on Painting*, a work begun haphazardly by Leonardo himself but then cobbled together into book form from his notebooks (including some now lost) after his death by his apprentice Francesco Melzi. For Leonardo's extensive writings on anatomy, I regularly consulted *Leonardo da Vinci on the Human Body,* compiled by Charles D. O'Malley and J. B. de C. M. Saunders, and discovered much useful related information in Martin Clayton's *Leonardo da Vinci: The Anatomy of Man.*

As for Vitruvius, I found Indra Kagis McEwen's *Vitruvius: Writing the Body of Architecture* an invaluable guide, not just to the man and his book but also to the complicated social, political, and religious context in which he wrote it. I also learned much from the two most recent English translations of Vitruvius's book: the very readable 2009 edition by Richard Schofield, published under the title *On Architecture*, and the amply annotated 1999 edition by Ingrid D. Rowland, published under the title *Ten Books on Architecture*. Both include a wealth of very helpful background information. One other English translation is worth consulting: the 1914 edition

produced by Morris Hickey Morgan, which has stood the test of time remarkably well.

The remaining sources I consulted while working on the book—on ancient Greece and Rome, on the early reception of Vitruvius in Europe, on Christian symbolism and mystical thought, on medieval master builders, on the early history of medicine, on the artists and architects of the Renaissance, on Leonardo, and more—are too numerous and varied to call out individually. For a representative sampling, see the Works Cited section of this book, which also includes full bibliographic details for the works mentioned above.

NOTES

F ULL REFERENCES for all works cited in short form in the
Notes can be found in the Works Cited section of this book.

PREFACE

xiii "Leonardo, the complete man": Betty Burroughs, "Editorial Notes on
Leonardo," in Vasari, *Vasari's Lives,* 197.

OPENING EPIGRAPH

xvii "Man is a model": Jean Paul Richter, *The Notebooks* 2, no. 1162, 291.
Translation slightly modified.

PROLOGUE: 1490

1 an inn called Il Saracino: Beltrami, *Documenti* no. 50, 32.
2 "The building supervisors": Schofield, Shell, and Sironi, *Giovanni An-
tonio Amadeo* no. 209, 183. Unpublished English translation supplied
to me by Richard Schofield, professor of architectural history, Istituto
Universitario di Architettura di Venezia.
2 "Master Leonardo the Florentine": Ibid., 183.
3 contributed more to the development: Vasari, "The Life of Francesco di
Giorgio Martini," in Vasari, *Lives.*
3 his illustrated treatises were copied: Scaglia, *Francesco di Giorgio,* 16.

3 "He was very attractive": Nicholl, *Leonardo,* 11, citing an anonymous source known as the Anonimo Gaddiano. For the full text, see Anonimo Gaddiano, "Leonardo da Vinci," in Goldscheider, *Leonardo,* 32.

4 "by nature very courteous": Nicholl, *Leonardo,* 126, citing the artist Paolo Giovio.

4 "He was so pleasing": Vasari, *Vasari's Lives,* 188.

4 "It was asked of a painter": Jean Paul Richter, *The Notebooks* 2, no. 1285, 350.

4 "From the dawning of the day": Bramly, *Leonardo,* 258.

4 "As you go about": Jean Paul Richter, *The Notebooks* 1, no. 571, 287. Translation slightly modified, based on Irma A. Richter, *The Notebooks,* 220.

5 "The measurement of Milan": Jean Paul Richter, *The Notebooks* 2, no. 1448, 434. Translation primarily from Pedretti, *Leonardo: Architect,* 26, with modifications based on the excerpt that appears in Kemp, *Leonardo,* 84–85. All three sources provide glosses on Leonardo's list.

7 dates from the early 1480s: Martino, *Trattato* 2, xv. "The Opera Architectura," 133.

8 "Basilicas [have] the proportions": Kruft, *A History,* 56.

10 "Man, called a little world": Ibid., 57. Translation slightly modified.

10 "All the arts and all rules": Betts, "On the Chronology," 5.

10 "As far as we are concerned": Alberti, *On the Art of Building,* 154.

11 "Virturbius de architretis": Pellegrin, *La Bibliothèque des Visconti,* 254.

1: BODY OF EMPIRE

13 "I have gathered": Vitruvius, *De architectura* 7, prologue, 14. Translation mine.

14 "Little fame has resulted": Ibid., 6, prologue, 5. Translation mine.

15 "not adorned": Suetonius, "The Life of Augustus," 28.3, in *Suetonius* 1, 167.

15 Rome was a sprawling warren: The details in this paragraph derive largely from Everitt, *Augustus,* 164.

16 "disease-ridden body": Cassius Dio, *Roman History* 56.39, in Dio, *Roman History* 7, 87.

16 hotline to the heavens: The phrase comes from Indra Kagis McEwen, private e-mail, February 2, 2011.

16 "Roman, you will remain sullied": Horace, Ode 3.6, as translated in Zanker, *The Power of Images,* 102.

17 "the founder and restorer": Livy, *Ab urbe condita libri* 4.20.7, in Zanker, *The Power of Images,* 104.

17 "I built the Senate House": Augustus, *Res gestae* 4.19–21, 27–29.

18 "In cities old and new": Philo, *Legatio* 149–51, in Zanker, *The Power of Images,* 298.

18 "The whole of humanity": Nikolaos of Damascus, in Zanker, *The Power of Images,* 297.

18 "By his wisdom and skill": Florus, *Epitome* 2.14.5–6, in McEwen, *Vitruvius,* 276–77.

19 his perfect body—of empire: For fascinating detail on Augustus and the body of empire, from which much of this chapter derives, see "The Body of the King," in McEwen, *Vitruvius,* 225–98.

19 Small and lame: Suetonius, "The Life of Augustus," 79–80, in *Suetonius* 1, 245–47.

21 "He was interested in Greek studies": Ibid., 89, in *Suetonius* 1, 257–59.

22 Cicero described it as an exemplar: Cicero, *Brutus* 86.196.

22 "full of dignity and holiness": Quintilian, *Institutio Oratoria* 5.12.20–21, in Zanker, *The Power of Images,* 99.

22 "Polyclitus made a statue": Pliny, *Natural History* 34.55, in Pollitt, *The Art of Ancient Greece,* 75.

24 "Your spirit will spread": Seneca, *De clementia* 2.2.1, in McEwen, *Vitruvius,* 261.

24 a special fondness for style guides: Vitruvius, *Ten Books* (trans. Rowland), introduction, 1.

24 what Cicero had just done: Vitruvius, *De architectura* 9, prologue, 17.

25 The term *architectura* itself: The earliest known use of the word appears in Cicero, *De officiis* 1.151.

25 "bring the whole body": Vitruvius, *De architectura* 4, prologue, in McEwen, *Vitruvius,* 7.

25 "incomplete drafts": Ibid.

26 "He ought to be both naturally gifted and amenable": Vitruvius, *De architectura* 1.3, in *The Ten Books* (trans. Morgan), 5–6.

27 "the use of the rule": Ibid., 1.4, 6.

27 "a figure the most perfect:" Plato, *Timaeus* 33b, in *Plato's Cosmology,* 54.

27 "I can see nothing more beautiful": Cicero, *De natura deorum* 2.18, in Cicero, *The Treatises,* 61.

27–28 "have the property of absolute uniformity": Cicero, *De natura deorum* 2.45, in McEwen, *Vitruvius,* 160.

28 "the power of nature": Vitruvius, *De architectura* 9.1.2, in *Ten Books* (trans. Rowland), 109.

29 "not only an inhabitant": Cicero, *De natura deorum* 2.90, in McEwen, *Vitruvius,* 160.

30 "foursquare in hands and feet": Simonides, in Plato, *Protagoras* 339a, in McEwen, *Vitruvius,* 269.

30 the words *urbs* (city) and *orbis* (circle): Varro, *De lingua latina* 5.143, in *On the Latin Language* 1, 135.

30 Romulus had divided: Cicero, *De divinatione* 2, in Cicero, *The Treatises,* 142.

30 "the pivot of the universe": Frontinus, *De agrorum qualitate* 37, in Campbell, *The Writings,* 9.

30 "The augur, with his head veiled": Livy, *Ab urbe condita libri* 1.18, in Rykwert, *The Idea of a Town,* 45.

31 "These points are charged": Manilius, *Astronomica* 1.801–5, 147.

31 "its origin in the heavens": Hyginus (2)4, in Campbell, *The Writings,* 135.

32 "I assert emphatically": Vitruvius, *De architectura* 1.4.9, in *Ten Books* (trans. Rowland), 27.

33 "countless varieties of juices": Vitruvius, *De architectura* 8.3.26, in *The Ten Books* (trans. Morgan), 241.

33 Philo of Alexandria had taken the analogy: Philo, *On the Allegories of the Sacred Laws* 2.7, in *The Works of Philo Judaeus* 1, 86.

33 "in form, order, and number": Suetonius, "The Life of Augustus," 80, in *The Lives,* 247.

34 "Who can doubt": Manilius, *Astronomica* 4.888–93, 293.

35 "The people of Italy": Vitruvius, *De architectura* 6.1.11, in *On Architecture* (trans. Schofield), 169.

36 "The stonecutters who wrought the stone": Wilson Jones, "Doric Measure," 87.

37 "the proper proportion": Galen, *De placitis Hippocratis et Platonis* 5.448, in Stewart, "The Canon," 125.

38 *"Quis locus":* Ovid, *Tristia* 2.287, in McEwen, *Vitruvius,* 198.

38 "No temple can be put together": Vitruvius, *De architectura* 3.1, in McEwen, *Vitruvius,* 195.

39 "the famous painters": Vitruvius, *De architectura* 3.1.2, in *The Ten Books* (trans. Morgan), 72.

39 "Likewise, in sacred dwellings": Vitruvius, *De architectura* 3.1.3, in McEwen, *Vitruvius,* 156.

2: MICROCOSM

42 "Behold the human creature!": Hildegard of Bingen, *Causae et curae* 2, in Newman, *Voice of the Living Light,* 134.

42 "In the third year of my life": Hildegard of Bingen, *Vita,* in Dronke, *Women Writers,* 145.

43 "Poor little womanly creature": Letter from Hildegard of Bingen to grieving widow, in Dronke, *Women Writers,* 194.

43 "I grew amazed": Hildegard of Bingen, *Vita,* in Dronke, *Women Writers,* 145.

43 "I see them wide awake": Hildegard of Bingen, letter to Guibert of Gembloux, in Newman, *Voice of the Living Light,* 114.

43 "When I was twenty-four": Hildegard of Bingen, *Vita* 1.2, in Maddocks, *Hildegard of Bingen,* 55.

44 "Crowds of people": Hildegard of Bingen, *Vita* 2.4, ibid., 89.

44 "Who is this woman": Schipperges, *The World of Hildegard of Bingen,* 11.

45 standardizing the size of the water pipes: Vitruvius, *Ten Books* (trans. Rowland), 6, n. 41.

46 "In him all things hold together": Colossians 1.17–18.

46 "As regards the peoples": Lewis, *A Middle East Mosaic,* 30.

46 One recent inventory: Smith, untitled review of Schuler, *Vitruv im Mittelalter,* 790.

46 "Let me tell you": Dodwell, *The Pictorial Arts of the West,* 246–47.

47 the librarian of one German monastery: Meyer, *Medieval Allegory,* 15.

48 "We use whatever appropriate symbols we can": Dionysius the Pseudo-Areopagite, *De divines nominibus* 1.4, in Hiscock, *The Symbol,* 30.

48 "he might lift us": Dionysius the Pseudo-Areopagite, *De coelesti hierarchia* 1.3, ibid., 30.

48 "to approach the heavens": Zaitsev, "The Meaning of Early Medieval Geometry," 531.

49 "God, the fabricator of man": Firmicus, *Mathesis* 3, prologue, 2–3, in Stock, *Myth and Science in the Twelfth Century,* 205.

49 "All things are contained": Isidore, *Sententiae* 1.11.1a, in Brehaut, *An Encyclopedist,* 62.

49 "whom the wise call a *microcosm*": Bede, *De temporum ratione* 35, in Rykwert, *The Dancing Column,* 69.

50 "A wheel of marvelous appearance": Hildegard, *Hildegard of Bingen's Book of Divine Works*, 22–24.

51 "In the year 1163": Ibid., 5–6.

52 "the scholar away from theology": Tachau, "God's Compass," 27.

52 "the composition of the globe": Chenu, *Nature, Man, and Society*, 10.

53 "To slight the perfection": William of Conches, *Philosophia mundi* i.22, in Chenu, *Nature, Man, and Society*, 11.

53 "Ignorant themselves": Ibid., i.23.

54 "riding the magic carpet": White, *Medieval Religion*, 298.

55 "When man looks": Bober, "The Zodiacal Miniature," 13.

55 "I would have you survey": Bernardus, *The Cosmographia*, 92.

55 "From the very top of our cranium": Hildegard, *Hildegard of Bingen's Book of Divine Works*, 97–98.

56 "The firmament": Hildegard of Bingen, *Causae et curae*, in Dronke, *Women Writers*, 174.

58 "The body itself": *Risa'il* 3.9–12, in Nasr, *An Introduction*, 101. Translation slightly modified.

60 "Nature's lineaments": Alan of Lille, *De planctu naturae* 6.3, in Hiscock, *The Symbol*, 130.

60 quite possibly by Benedictine nuns: Hoogvliet, "The Mystery of the Makers," 18.

61 were produced in German monasteries: Schuler, *Vitruv in Mittelalter*, provides abundant evidence for this assertion.

61 "God created humanity": Hildegard, *Hildegard of Bingen's* Book of Divine Works, 121.

61 "It is the same distance": Ibid., 94.

61 "If we extend ": Ibid., 90.

3: MASTER LEONARDO

63 "I can carry out sculpture": Jean Paul Richter, *The Notebooks* 2, 398. Translation slightly modified.

63 "There was born to me a grandson": Nicholl, *Leonardo*, 20. The details that follow about Leonardo's baptism can also be found on this page.

65 "He would have been very proficient": Vasari, *Lives*, in Nicholl, *Leonardo*, 53–54. See also Vasari, *Vasari's Lives*, 187.

66 "One day, Ser Piero took some": Vasari, *Lives*, in Nicholl, *Leonardo*, 61. See also Vasari, *Vasari's Lives*, 187–88.

66 "every traveler arriving": Verino, *Description of the City of Florence,* in Baldassarri and Saiber, *Images of Quattrocento Florence,* 210.

67 "Nothing is superior": Ibid.

68 "meticulously maintained": Dei, *La cronica dall'anno 1400 all'anno 1500,* in Baldassarri and Saiber, *Images of Quattrocento Florence,* 86.

68 "The barons must sometimes give precedence": Salvemini, "Florence in the Time of Dante," 320–21.

69 "Venetian, Milanese, Genoese": Dei, *La cronica dall'anno 1400 all'anno 1500,* in Baldassarri and Saiber, *Images of Quattrocento Florence,* 87.

69 "How can I properly describe": Verino, *Description of the City of Florence,* in Baldassarri and Saiber, *Images of Quattrocento Florence,* 210.

70 According to one period inventory: Dei, *La cronica dall'anno 1400 all'anno 1500,* in Nicholl, *Leonardo,* 63–64.

70 "The streets round about": Nicholl, *Leonardo,* 65.

71 According to figures: Dei, *La cronica dall'anno 1400 all'anno 1500,* in Wackernagel, *The World of the Florentine Renaissance Artist,* 300–01.

71 it resembled the studios: Bramly, *Leonardo,* 65–66.

73 "First, take a little": Cennini, *The Craftsman's Handbook,* 4–5.

74 "system of the naked body": Nicholl, *Leonardo,* 77.

75 "for she does not have any set proportion": Cennini, *The Craftsman's Handbook,* 48–49.

75 "chagrined," as Vasari put it: Vasari, *Vasari's Lives,* 189.

76 involved plenty of revelry: Bramly, *Leonardo,* 112–13.

76 "Full of the most graceful vivacity": Vasari, *Vasari's Lives,* 187.

77 "If you want to make a fire": Jean Paul Richter, *The Notebooks* 1, no. 649, 325.

77 "I am happy": Bramly, *Leonardo,* 117.

78 "pursues many immoral activities": Nicholl, *Leonardo,* 114. The details of the case that appear here, along with information about homosexuality in Florence, derive from Nicholl, *Leonardo,* 114–23; and Bramly, *Leonardo,* 117–24.

78 The word *Florenzer:* Nicholl, *Leonardo,* 116.

78 "It has dealings": Bramly, *Leonardo,* 124–25.

79 more than a hundred: Nicholl, *Leonardo,* 117.

79 "As I have told you": Irma A. Richter, *The Notebooks,* 288.

80 "A stone of good size": Bramly, *Leonardo,* 137–38. See also Jean Paul Richter, *The Notebooks* 2, 339.

80 According to one of his earliest biographers: Anonimo Gaddiano, "Leonardo da Vinci," in Goldscheider, *Leonardo,* 30.

82 "Painting possesses a truly divine power": Alberti, *De pictura* 2.25, in Alberti, *On Painting and On Sculpture,* 61.

83 "The divine character of painting": Bramly, *Leonardo,* 274. See also Leonardo, *Treatise on Painting* 1, no. 280, 113.

83 "The painter is lord": Irma A. Richter, *The Notebooks,* 194–95.

85 "You have a god's capacity": Cicero, *The Dream of Scipio* 24, in *On the Good Life,* 353.

85 "possesses in itself": Ficino, *Platonic Theology* 3.2, in Gadol, *Leon Battista Alberti,* 232.

86 "I have placed you": Pico della Mirandola, "Oration on the Dignity of Man," in McIntire and Burns, *Speeches,* 116.

87 "chained to the reading of manuscripts": Alberti, *On the Advantages and Disadvantages of Letters,* in Grafton, *Leon Battista Alberti,* 32.

88 "So that the subject": Alberti, *De Statua* 11, in Alberti, *On Painting and On Sculpture,* 133–35.

89–90 He listed sixty-eight: Ibid., 135.

91 In one of his notebook sketches: *Codex Atlanticus,* 189v. See Marani, "Leonardo, *The Vitruvian Man,* and the *De statua* Treatise," in Radke, *Leonardo,* 83.

91 he set out some preliminary thoughts: *Manuscript A,* 43r. See Marani, "Leonardo," in Radke, *Leonardo,* 84.

91 "Let me tell you": Alberti, *Momus,* in Baxandall, *Words for Pictures,* 37.

4: MILAN

92 "The painter's mind": Irma A. Richter, *The Notebooks,* 205.

92 the job of painting the altarpiece: Nicholl, *Leonardo,* 133.

93 "Alas!": Vasari, *Vasari's Lives,* 196.

93 "In his imagination": Ibid., 189.

93 "the universal master": Jean Paul Richter, *The Notebooks* 1, no. 506, 253.

93 "Describe the tongue": Ibid., 2, no. 819, 119.

93 "Of the flight": Ibid., no. 820, 119.

94 "They will say": Irma A. Richter, *The Notebooks,* 2. See also Jean Paul Richter, *The Notebooks* 1, no. 10, 14.

94 "Tell me": Bramly, *Leonardo,* 154. See also Jean Paul Richter, *The Notebooks* 2, nos. 1360, 1365, 1366, 413–14.

94 he lists eight Florentines: See Kemp, *Leonardo,* 65–66, for a full translation of the passage and commentary.

100 an army of animals: Hollingsworth, *Patronage in Renaissance Italy,* 171.

100 "There now appeared disorders": Machiavelli, *Istorie fiorentine* 7.28, in Nicholl, *Leonardo,* 93–94.

101 "The well-dressed painter": Leonardo, *Treatise on Painting* 1, no. 51, 37.

102 "I take up the burden": Bramly, *Leonardo,* 198.

103 "the coarse speech": Ibid., 200.

103 Leonardo traveled to Milan: Nicholl, *Leonardo,* 189.

103 "a form calculated in order to render the tone": Vasari, *Vasari's Lives,* 191.

103 "He surpassed all the musicians": Ibid., 191.

104 about a hundred workshops: Welch, *Art and Authority in Renaissance Milan,* 251.

105 "trumpeters and reciters": Jean Paul Richter, *The Notebooks* 2. See also Jean Paul Richter, *The Notebooks* 1, no. 11, 15.

106 "quality, the beauty": Da Vinci, *Treatise on Painting* 1, no. 15, 8.

106 "in numbers and measurements": Irma A. Richter, *The Notebooks,* 202.

5: THE ARTIST-ENGINEER

108 "The work our hands do": Da Vinci, *Treatise on Painting* 1, no. 34, 23.

108 "Many flowers copied": Kemp, *Leonardo,* 22.

110 "What man, however hard of heart": Alberti, *On Painting,* 35.

111 "This work makes the spectator wonder": Chrysoloras, *Comparison of Old and New Rome,* in Smith, *Architecture,* 213.

116 "He from whom nothing is hidden": Rykwert, *The Dancing Column,* 86. Translation slightly modified.

117 "Make a book": Bolgar, *The Classical Heritage,* 273. Translation slightly modified.

118 "We should imitate bees": Seneca, *Epistulae morales* 84, in Moss, *Printed Commonplace-Books,* 12.

119 "Everything proceeds from everything": Jean Paul Richter, *The Notebooks* 2, no. 1473, 445.

119 "The earth is moved": MacCurdy, *The Notebooks* 1, 78.

119 "My concern now": Pedretti, *The Literary Works* 1, 102.

123 in about 1484: for this date, see Schofield, "Leonardo's Milanese Architecture," 111–15.

123 "an infinite variety": Bramly, *Leonardo,* 175, with slight modifications. For the whole letter, see also Jean Paul Richter, *The Notebooks* 2, no. 1340, 395–98.

6: MASTER BUILDERS

126 "I shall show": Irma A. Richter, *The Notebooks,* 302.

127 "completely worldly and depraved": Abelard, *Historia calamitatum,* in Radice, *The Letters,* no. 1, 19.

127 "I see myself dwelling": Panofsky, *Abbot Suger,* 65. Translation slightly modified.

127 "The foundation of the temple": Bede, *De templo* 4.1, in Meyer, *Medieval Allegory,* 1.

127 "a figure and image": Maximus the Confessor, *Mystagogia* 2, in Hiscock, *The Symbol,* 25–26.

128 "the elegant architect": Alan of Lille, *Liber de planctu naturae,* in Kruft, *A History,* 36. Translation mine.

129 "It shall come to pass": Isaiah 2:2.

130 "We come at last": Vasari, *On Technique,* 83–84.

132 "In the articulation": Durandus, *Rationale divinorum officiorum* 1.14, in Rykwert, *The Dancing Column,* 39. Translation slightly modified.

132 in remarkably similar terms: See, for example, the description (c. 1436) of the cathedral of Florence cited in Grafton, *Leon Battista Alberti,* 281: "I have decided that the wonderful edifice of this sacred basilica more or less takes the shape of a human body."

133 "seeking out architects": Hiscock, *The Wise Master Builder,* 164.

133 "Villard de Honnecourt greets you": Barnes, *The Portfolio of Villard de Honnecourt,* 35.

135 "imagined": Ibid., 95.

136 "ought to rise": Ackerman, *"Ars sine scientia nihil est,"* 91.

138 correspond to those of the Pantheon: Schofield, "Amadeo, Bramante, and Leonardo," postscript, 95.

138 "The Lord God is seated": Ackerman, *"Ars sine scientia nihil est,"* 100.

138 "in a fashion ": Ibid., 100.

139 "You have appointed": Welch, *Art and Authority in Renaissance Milan*, 108.

139 "by a prudent geometrician": Ibid.

139 "May God help me": Ibid.

140 "Because of the departure": Schofield, "Amadeo, Bramante, and Leonardo," 68, n. 4. Unpublished English translation supplied to me by Richard Schofield.

140 "When fortune comes": Bramly, *Leonardo,* 213. See also Jean Paul Richter, *The Notebooks* 2, no. 1177, 294.

141 "My lords, deputies, fathers": Irma A. Richter, *The Notebooks,* 300–02. Slightly modified, based on the partial translation in Nicholl, *Leonardo,* 223.

144 a stylized image of himself and Leonardo: Nicholl, *Leonardo,* 310–12.

146 "What he handed down": Alberti, *On the Art of Building* 6.1, 154.

147 "He made careful drawings": Vasari, *Vasari's Lives,* 72–73.

147 "My gods!": Alberti, *On the Art of Building* 6.1, 154. Translation slightly modified.

148 "prostrate and stripped": Poggio Bracciolini, *De varietate fortunae* 1, in Elmer, Webb, and Wood, *The Renaissance in Europe,* 7.

149 the Florentine Vitruvius: Gadol, *Leon Battista Alberti,* 99, n. 10.

149 "Let it be said": Alberti, *On the Art of Building,* prologue, 5.

149 Leonardo would even record: Reti, "The Two Unpublished Manuscripts," no. 19, 81.

150 "The harmony is such": Alberti, *On the Art of Building* 1.9, 23–24.

151 "works on architecture": Vespasiano, *Lives,* in Whitcomb, *Literary Source Book,* 77.

151 Francesco was a figure: The biographical highlights listed in this paragraph derive primarily from Betts, *The Architectural Theories,* 3–7; and Scaglia, *Francesco di Giorgio,* 13–17.

152 "Pictures are very apt": Pliny, *Natural History* 25.4–5, cited in Ivins, *Prints and Visual Communications,* 14.

153 "as many interpreters as readers": Martini, *Treatise,* 2.489, in Laurenza, "The *Vitruvian Man,*" 44.

153 He did so most memorably in his *Treatise*: Betts, "On the Chronology," 13–14.

154 "a well-composed": Ibid., 5.

155 "I will show you": Filarete, *Treatise* (trans. Spencer), 6r, 12.

156 "seems to outline": Dulcino, *Nuptiae illustrissimi ducis mediolani,* in Schofield, "Amadeo, Bramante, and Leonardo," 82.

7: BODY AND SOUL

159 "A good painter": Irma A. Richter, *The Notebooks,* 176.

161 "took an especial delight": Vasari, *Lives,* in Nicholl, *Leonardo,* 43. See also Vasari, *Vasari's Lives,* 188.

161 "He would not kill a flea": Nicholl, *Leonardo,* 43.

161 "do not feed on anything": Ibid., 478.

162 "The frog retains life": O'Malley and Saunders, *Leonardo,* 352.

162 "The frog immediately dies": Ibid., 350.

162 "Having placed": Mundinus, *Anathomia,* in Singer, *The Fasciculo di Medicina,* 59.

162 one of the earliest surviving references: Park, "The Criminal and the Saintly Body," 7.

163 "Sketch in the bones": Alberti, *On Painting and On Sculpture,* 75.

163 "It is necessary": Clayton, *Leonardo,* 12.

164 "The professor shall read": Ibid.

164 a medical miscellany that Leonardo himself owned: Reti, "The Two Unpublished Manuscripts," no. 2, 81.

164 "microcosm": Mundinus, *Anathomia,* in Singer, *The Fasciculo di Medicina,* 60.

166 "Having observed the guts": Ibid., 68.

167 "You see to the right": Ibid.

167 "In man, these lobes": Ibid., 71.

168 If you opened your eyes outside: Jean Paul Richter, *The Notebooks* 1, no. 68, 42.

168 "Down to my own time": Ibid., no. 21, 19.

171 he owned at least 45 books: For the contents of the list, see Jean Paul Richter, *The Notebooks* 2, 442–45. For the dating, see Pedretti, *The Literary Works* 2, 353–54.

171 he owned at least 116: For the contents and dating of the list, see Reti, "The Two Unpublished Manuscripts," 81–89; and Pedretti, *The Literary Works* 2, 355–68.

171 "Try to get Vitolone": Jean Paul Richter, *The Notebooks* 2, no. 1448, 435.

172 One high-ranking official: Vallentin, *Leonardo,* 149.

173 Here, under one roof: For the contents of the Visconti library, see Pellegrin, *La Bibliothèque des Visconti.*

177 "By the ancients": Kemp, *Leonardo,* 98–99. See also Jean Paul Richter, *The Notebooks* 2, no. 929, 179.

177 "tortuously ponderous": Letze and Buchsteiner, *Leonardo,* 18.

178 "This work should begin": Clayton, *Leonardo,* 25. See also Jean Paul Richter, *The Notebooks* 2, no. 797, 108–09.

179 other topics that he would have to cover: Jean Paul Richter, *The Notebooks* 2, no. 805, 114.

179 "Represent whence catarrh": O'Malley and Saunders, *Leonardo,* 31.

180 "You will have set before you": Jean Paul Richter, *The Notebooks* 2, no. 798, 111. Translation modified slightly, based on O'Malley and Saunders, *Leonardo,* 32.

182 some twenty different editions: Schaff, *St. Augustine's* City of God, xiii.

182 Leonardo himself owned a copy: Reti, "The Two Unpublished Manuscripts," no. 11, 81.

182 "This would be more apparent": Augustine, *City of God* 22.24, 1074.

183 "Driven by an ardent desire": Bramly, *Leonardo,* 86. See also Jean Paul Richter, *The Notebooks* 2, no. 1339, 395.

185 "The cavity of the orbit": O'Malley and Saunders, *Leonardo,* 44.

186 "The parts pertaining to sensation": Mundinus, *Anathomia,* in Singer, *The Fasciculo di Medicina,* 91.

186 "The soul seems to reside": Jean Paul Richter, *The Notebooks* 2, no. 838, 127.

188 "Now, cut carefully": Mundinus, *Anathomia,* in Singer, *The Fasciculo di Medicina,* 91.

189 "Where the line *am* intersects": O'Malley and Saunders, *Leonardo,* 52.

8: PORTRAIT OF THE ARTIST

190 "Painting is philosophy": Leonardo, *Treatise on Painting* 1, no. 8, 5.

190 "the universal measure of man": Jean Paul Richter, *The Notebooks* 1, editor's remarks, 167.

192 "From the top of the ear": Ibid., no. 317, 173.

192 "The distance from the top": Ibid., no. 310, 170.

192 "The smallest thickness": Ibid., no. 348, 185.

192 "The foot": Ibid., no. 325, 176.

192 "*yl* is the fleshy part": Ibid., no. 349, 186.

193 On May 10, 1490: Pedretti, *Leonardo: Architect,* 35.

193 some 136 structures: Betts, "On the Chronology," 14.

194 translating Vitruvius into Italian: Ibid., 13.

195 "The art of architecture": Ibid., 4.

195 "Item for 21 June": Beltrami, *Documenti,* no. 50, 32. Unpublished translation supplied to me by Richard Schofield, professor of architectural history, Istituto Universitario di Architettura, Venice.

196 "reconciling the sign": Betts, "On the Chronology," 4, 5.

196 he was also borrowing directly: Ibid., 5.

197 "all the arts": Ibid.

199 "Vitruvius says that the navel": Filarete, *Treatise* (trans. Spencer), 8.

199 "can be decreased": Millon, "The Architectural Theory," 261.

200 to help write a final report: Schofield, "Amadeo, Bramante, and Leonardo," 69.

200 time in Pavia for research: Nicholl, *Leonardo,* 269; and Bramly, *Leonardo,* 216.

200 he had dinner in the city: Jean Paul Richter, *The Notebooks* 2, no. 1458, 438.

201 "many very famous and wise men": Pacioli, preface to *De divina proportione,* in Taylor, *No Royal Road,* 256.

201 "There was also Giacomo Andrea": Ibid., 257.

201 they quartered his body and displayed its pieces: Müntz, *Leonardo,* 101.

202 "Messer Vincenzo Aliprando": Jean Paul Richter, *The Notebooks* 2, no. 1501, 452.

202 "imperfect work": Sgarbi, "A Newly Discovered Corpus," 32.

202–203 "The manuscript is the earliest": Ibid., 31.

206 He used a variety of implements: For interesting detail on the construction of the drawing, see Landrus, "Leonardo's Canons," 55–61.

207 "Vitruvius, the architect": Kemp, *Leonardo on Painting,* 309. See also Jean Paul Richter, *The Notebooks* 1, no. 343, 182–83.

208 Only ten of the twenty-two measurements: See, for example, Jean Paul Richter, *The Notebooks* 1, no. 340, 181, which includes several of the non-Vitruvian measurements that appear in the text that accompanies Leonardo's drawing of Vitruvian Man.

209 "You who think": Pedretti, *The Literary Works* 2, 91.

210 "an act of radical philology": Laurenza, "The *Vitruvian Man*," 44.

212 "I have all measure in me": Rykwert, *The Dancing Column,* 86. Translation slightly modified.

212 "Man, called a little world": Kruft, *A History,* 57. Translation slightly modified.

212 "the center of nature": Ficino, *Platonic Theology* 3.2, in Gadol, *Leon Battista Alberti,* 232.

212 "From the human body derive": Wittkower, *Architectural Principles,* 15.

212 "By the ancients": Kemp, *Leonardo,* 98–99. See also Jean Paul Richter, *The Notebooks* 2, no. 929, 179.

212 "Man is a model of the world": Jean Paul Richter, *The Notebooks* 2, no. 1162, 291. Translation slightly modified.

213 most notably Albrecht Dürer: See, for example, the studies of the leg that appear in Dürer's *Dresden Sketchbook* (1517). In 1507, Dürer himself also produced some studies of Vitruvian Man (London, British Library, MA Sloane 5230, fol. 2), but they are rendered very differently from Leonardo's.

213 "I beseech you": Clark, *The Drawings of Leonardo da Vinci,* no. 19007, 5.

213 "He then tabulated": Giovio, "The Life of Leonardo da Vinci," in Goldscheider, *Leonardo,* 29.

213 he envisaged it as the frontispiece: Mariani, "Leonardo," in Radke, *Leonardo,* 91.

214 "a key to define": Dragstra, "The Vitruvian Proportions," 83–84.

214 Luca Pacioli mentioned: Pacioli, *De divina proportione,* preface, in Taylor, *No Royal Road,* 257.

216 "Measure on yourself": Leonardo, *Treatise on Painting,* no. 438, 162.

216 "There is one nowadays": Kemp, "Leonardo da Vinci," 199, in Farago, *An Overview,* 433.

EPILOGUE: AFTERLIFE

219 a cursory description: The reference was made by the painter Giovanni Paolo Lomazzo, who, in surveying the contents of Leonardo's notebooks, described the picture simply as "a demonstration in a figure of all the proportions of the members of the human body." See Lomazzo, *Idea del tempio* 1, 47.

219 The first copy: According to Pedretti, *The Literary Works* 1, 244–45, the image was first printed in *Disegni di Leonardo da Vinci incisi e pubblicati* (1784) by Carlo Giuseppe Gerli.

224 "I cannot resist": Cellini, *Discorso dell'architettura,* in Nicholl, *Leonardo,* 487.

225 "With what words": Pedretti, *The Literary Works* 1, 84.

WORKS CITED

Ackerman, James S. *"Ars sine scientia nihil est:* Gothic Theory of Architecture at the Cathedral of Milan." *Art Bulletin* 31, no. 2 (June 1949), 84–111.

Alberti, Leon Battista. *On Painting.* Translated by Cecil Grayson. Introduction and notes by Martin Kemp. London and New York: Penguin Books, 2004.

———. *On Painting and On Sculpture.* Edited with translations, introduction, and notes by Cecil Grayson. London: Phaidon Press, 1972.

———. *On the Art of Building in Ten Books.* Translated by Joseph Rykwert, Neil Leach, and Robert Tavernor. Cambridge, Mass.: MIT Press, 1988.

Augustine, Saint, Bishop of Hippo. *Concerning the City of God Against the Pagans.* Translated by Henry Bettenson, with a new introduction by G. R. Evans. London and New York: Penguin Books, 2003.

Augustus, Emperor of Rome. *Res gestae divi Augusti.* Introduction and commentary by P. A. Brunt and J. M. Moore. London: Oxford University Press, 1967.

Baldassarri, Stefano Ugo, and Arielle Saiber, eds. *Images of Quattrocento Florence: Selected Writings in Literature, History, and Art.* New Haven, Conn., and London: Yale University Press, 2000.

Barnes, Carl F., Jr. *The Portfolio of Villard de Honnecourt (Paris, Bibliothèque Nationale de France, MS Fr 19093): A New Critical Edition and Color Facsimile.* Farnham, England, and Burlington, Vt.: Ashgate, 2009.

Baxandall, Michael. *Words for Pictures: Seven Papers on Renaissance Art and Criticism.* New Haven, Conn.: Yale University Press, 2003.

Beltrami, Luca, ed. *Documenti e memorie riguardanti la vita e le opere di Leonardo da Vinci: In ordine cronologico.* Milan: Fratelli Treves, 1919.

Bernardus Sylvestris. *The* Cosmographia *of Bernardus Sylvestris.* Translated by Winthrop Wetherbee. New York: Columbia University Press, 1990.

Betts, Richard Johnson. *The Architectural Theories of Francesco di Giorgio,* vol. 1. Ann Arbor, Mich.: University Microfilms, 1972.

———. "On the Chronology of Francesco di Giorgio's Treatises." *Journal of the Society of Architectural Historians* 36, no. 1 (March 1977): 3–14.

Bober, Harry. "The Zodiacal Miniature of the *Très Riches Heures:* Its Sources and Meaning." *Journal of the Warburg and Courtauld Institutes* 11 (1948): 1–34.

Bolgar, R. R. *The Classical Heritage and Its Beneficiaries.* London: Cambridge University Press, 1973.

Bramly, Serge. *Leonardo: Discovering the Life of Leonardo da Vinci.* Translated by Siân Reynolds. New York: Edward Burlingame Books, 1991.

Brehaut, Ernest. *An Encyclopedist of the Dark Ages: Isidore of Seville.* New York: Columbia University, 1912.

Campbell, J. B. *The Writings of the Roman Land Surveyors.* London: Society for the Promotion of Roman Studies, 2000.

Cassius Dio. *Roman History.* Translated by Earnest Cary on the basis of the version of Herbert Baldwin Foster. Loeb Classical Library: 2, 37, 63, 66, 82–83, 175–77. Cambridge, Mass.: Harvard University Press, 1954–61.

Cennini, Cennino. *The Craftsman's Handbook.* Translated by Daniel V. Thompson, Jr. New York: Dover Publications, 1933.

Chenu, Marie-Dominique. *Nature, Man, and Society in the Twelfth Century: Essays on New Theological Perspectives in the Latin West.* Selected, edited, and translated by Jerome Taylor and Lester K. Little. Chicago: University of Chicago Press, 1968.

Cicero. *On the Good Life: [Selected Writings of] Cicero.* Translated by Michael Grant. Harmondsworth, England: Penguin, 1971.

———. *The Treatises of M. T. Cicero.* Edited and translated by C. D. Yonge. London: H. G. Bohn, 1853.

Clark, Kenneth. *The Drawings of Leonardo da Vinci in the Collection of Her Majesty the Queen at Windsor Castle.* 3 vols. London: Phaidon, 1968.

Clayton, Martin. *Leonardo da Vinci: The Anatomy of Man: Drawings from the Collection of Her Majesty Queen Elizabeth II.* With commentaries on anatomy by Ron Philo. Houston: Museum of Fine Arts, and Boston: Bulfinch Press, 1992.

Dodwell, C. R. *The Pictorial Arts of the West, 800–1200.* New Haven, Conn.: Yale University Press, 1993.

Dragstra, Rolf. "The Vitruvian Proportions for Leonardo's Construction of the 'Last Supper.'" *Raccolta Vinciana* no. 27 (1997): 83–104.

Dronke, Peter. *Women Writers of the Middle Ages: A Critical Study of Texts from Perpetua (d. 203) to Marguerite Porete (d. 1310)*. Cambridge, England, and New York: Cambridge University Press, 1984.

Elmer, Peter, Nick Webb, and Roberta Wood. *The Renaissance in Europe: An Anthology*. New Haven, Conn.: Yale University Press in association with Open University, 2000.

Everitt, Anthony. *Augustus: The Life of Rome's First Emperor*. New York: Random House, 2006.

Farago, Claire, ed. *An Overview of Leonardo's Career and Projects until c. 1500*. New York: Garland, 1999.

Filarete. *Treatise on Architecture, Being the Treatise by Antonio di Piero Averlino, Known as Filarete*. Translated with an introduction and notes by John R. Spencer. New Haven, Conn.: Yale University Press, 1965.

Gadol, Joan. *Leon Battista Alberti: Universal Man of the Early Renaissance*. London and Chicago: University of Chicago Press, 1969.

Goldscheider, Ludwig. *Leonardo da Vinci: Life and Work, Paintings and Drawings, with the Leonardo Biography by Vasari*. London: Phaidon, 1959.

Grafton, Anthony. *Leon Battista Alberti: Master Builder of the Renaissance*. Cambridge, Mass.: Harvard University Press, 2002.

Hildegard, Saint. *Hildegard of Bingen's* Book of Divine Works, with Letters and Songs. Edited and introduced by Matthew Fox. Santa Fe, N.M.: Bear & Co., 1987.

Hiscock, Nigel. *The Symbol at Your Door: Number and Geometry in Religious Architecture of the Greek and Latin Middle Ages*. Aldershot, England, and Burlington, Vt.: Ashgate, 2007.

———. *The Wise Master Builder: Platonic Geometry in Plans of Medieval Abbeys and Cathedrals*. Aldershot, England, and Brookfield, Vt.: Ashgate, 2000.

Hollingsworth, Mary. *Patronage in Renaissance Italy, from 1400 to the Early Sixteenth Century*. London: John Murray, 1994.

Hoogvliet, Margriet. "The Mystery of the Makers: Did Nuns Make the Ebstorf Map?" *Mercator's World* 1, no. 6 (1996): 16–21.

Ivins, William M. *Prints and Visual Communication*, pbk. ed. Cambridge, Mass.: M.I.T. Press, 1969. Originally published in 1953 by Harvard University Press.

Kemp, Martin. "Leonardo da Vinci: Science and the Poetic Impulse." Lecture delivered to the Royal Society of Medicine on June 6, 1894. Re-

printed in *An Overview of Leonardo's Career and Projects Until c. 1500*, ed. Claire Farago. New York: Garland, 1999.

———. *Leonardo da Vinci: The Marvellous Works of Nature and Man*. Oxford and New York: Oxford University Press, 2007.

———, ed. *Leonardo on Painting: An Anthology of Writings by Leonardo da Vinci with a Selection of Documents Relating to His Career as an Artist*. Selected and translated by Martin Kemp and Margaret Walker. New Haven, Conn.: Yale University Press, 1989.

Kruft, Hanno-Walter. *A History of Architectural Theory from Vitruvius to the Present*. Translated by Ronald Taylor, Elsie Callander, and Antony Wood. London: Zwemmer, and New York: Princeton Architectural Press, 1994.

Landrus, Matthew. "Leonardo's Canons: Standards and Practices of Proportional Design in His Early Work." Thesis, University of Oxford, 2006.

Laurenza, Domenico. "The *Vitruvian Man* by Leonardo: Image and Text." *Quaderni d'Italianistica* 27, no. 2 (2006): 37–56.

Leonardo da Vinci. *Treatise on Painting: Codex urbinas latinus 1270*. 2 vols. Translated and annotated by A. Philip McMahon. With an introduction by Ludwig H. Heydenreich. Princeton, N.J.: Princeton University Press, 1956.

Letze, Otto, and Thomas Buchsteiner, eds. *Leonardo da Vinci: Scientist, Inventor, Artist*. Translation, Institut für Kulturaustausch Tübingen. Ostfildern-Ruit: G. Hatje, 1997.

Lewis, Bernard. *A Middle East Mosaic: Fragments of Life, Letters, and History*. New York: Random House, 2000.

Lomazzo, Giovan Paolo. *Idea del tempio della pittura*. 2 vols. Translated with notes by Robert Klein. Florence: Istituto Nazionale di Studi sul Rinascimento, 1974.

MacCurdy, Edward, ed. and trans. *The Notebooks of Leonardo da Vinci*. 2 vols. New York: Reynal & Hitchcock, 1938.

Maddocks, Fiona. *Hildegard of Bingen: The Woman of Her Age*. New York: Doubleday, 2001.

Manilius. *Astronomica*. Loeb Classical Library: 469. Cambridge, Mass.: Harvard University Press, 1977.

Martini, Francesco di Giorgio. *Trattato di architettura*. 3 vols. Firenze: Giunti Barbèra, 1979.

McEwen, Indra Kagis. *Vitruvius: Writing the Body of Architecture*. Cambridge, Mass.: MIT Press, 2003.

McIntire, Suzanne, and William Burns. *Speeches in World History*. Facts on File Library of World History. New York: Facts on File, 2009.

Meyer, Ann R. *Medieval Allegory and the Building of the New Jerusalem.* Cambridge, England, and Rochester, N.Y.: D. S. Brewer, 2003.

Millon, Henry. "The Architectural Theory of Francesco di Giorgio." *Art Bulletin* 40, no. 3 (September 1958): 257–61.

Moss, Ann. *Printed Commonplace-Books and the Structuring of Renaissance Thought.* Oxford and New York: Clarendon Press, 1996.

Müntz, Eugene. *Leonardo da Vinci: Artist, Thinker, and Man of Science.* Translated from the French. London: W. Heinemann, and New York: C. Scribner's Sons, 1898.

Nasr, Seyyed Hossein. *An Introduction to Islamic Cosmographical Doctrines: Conceptions of Nature and Methods Used for Its Study by the Ikhwān al-Safā', al-Bīrūnī, and Ibn Sina.* Rev. ed. Albany: State University of New York Press, 1993.

Newman, Barbara, ed. *Voice of the Living Light: Hildegard of Bingen and Her World.* Berkeley: University of California Press, 1998.

Nicholl, Charles. *Leonardo da Vinci: The Flights of the Mind.* New York: Penguin, 2005.

O'Malley, Charles D., and J. B. de C. M. Saunders. *Leonardo da Vinci on the Human Body: The Anatomical, Physiological, and Embryological Drawings of Leonardo da Vinci.* New York: Greenwich House, 1982.

Panofsky, Erwin, ed. and trans. *Abbot Suger on the Abbey Church of St.-Denis and Its Art Treasures.* 2nd ed. Princeton, N.J.: Princeton University Press, 1979.

Park, Katharine. "The Criminal and the Saintly Body: Autopsy and Dissection in Renaissance Italy." *Renaissance Quarterly* 47, no. 1 (Spring 1994): 1–33.

Pedretti, Carlo. *Leonardo: Architect.* Translated by Sue Brill. New York: Rizzoli, 1985.

——, ed. *The Literary Works of Leonardo da Vinci.* 2 vols. Oxford: Phaidon, 1977.

——, Giovanna Nepi Sciré, and Annalisa Perissa Torrini. *I disegni di Leonardo da Vinci e della sua cerchia nel Gabinetto dei Disegni e Stampe delle Gallerie dell'Accademia di Venezia.* Florence: Giunti, 2003.

Pellegrin, Elisabeth. *La Bibliothèque des Visconti et des Forza, ducs de Milan, au XVe siècle.* Paris: Vente au Service des Publications du C. N. R. S., 1955.

Philo. *The Works of Philo Judaeus: The Contemporary of Josephus.* Translated from the Greek by C. D. Yonge. London: Henry G. Bohn, 1854–55.

Plato. *Plato's Cosmology: The Timaeus.* Translated with a running com-

mentary by Francis Macdonald Cornford. New York: Humanities Press, 1952.

Pollitt, J. J. *The Art of Ancient Greece: Sources and Documents.* Cambridge, England, and New York: Cambridge University Press, 1990.

Prager, Frank D., and Gustina Scaglia. *Brunelleschi: Studies of His Technology and Inventions.* Cambridge, Mass.: MIT Press, 1970.

———. *Mariano Taccola and His Book* De Ingeneis. Cambridge, Mass.: MIT Press, 1972.

Radice, Betty, ed. and trans. *The Letters of Abelard and Heloise.* Translation revised by M. T. Clanchy. London: Penguin, 2003.

Radke, Gary M., ed. *Leonardo da Vinci and The Art of Sculpture.* Atlanta: High Museum of Art, and New Haven, Conn.: Yale University Press, 2009.

Reti, Ladislao. "The Two Unpublished Manuscripts of Leonardo da Vinci in the Biblioteca Nacional of Madrid—II." *Burlington Magazine* 110, no. 779 (February 1968): 81–91.

Richter, Irma A., ed. *The Notebooks of Leonardo da Vinci.* World's Classics. Oxford and New York: Oxford University Press, 1980.

Richter, Jean Paul, ed. and trans. *The Notebooks of Leonardo, Compiled and Edited from the Original Manuscripts.* 2 vols. New York: Dover Publications, 1970. Originally published in 1883 by Sampson Low, Marston, Searle & Rivington as *The Literary Works of Leonardo da Vinci.*

Rykwert, Joseph. *The Dancing Column: On Order in Architecture.* Cambridge, Mass.: MIT Press, 1996.

———. *The Idea of a Town: The Anthropology of Urban Form in Rome, Italy, and the Ancient World.* Princeton, N.J.: Princeton University Press, 1976.

Salvemini, Gaetano. "Florence in the Time of Dante." *Speculum* 11, no. 3 (July 1936): 317–26.

Scaglia, Gustina. *Francesco di Giorgio: Checklist and History of Manuscripts and Drawings in Autographs and Copies from ca. 1470 to 1687 and Renewed Copies (1764–1839).* Bethlehem, Pa.: Lehigh University Press, and London: Associated University Presses, 1992.

Schaff, Philip. *St. Augustine's City of God and Christian Doctrine,* vol. 2. Select Library of the Nicene and Post-Nicene Fathers of the Christian Church. 14 vols. Grand Rapids, Mich.: W. B. Eerdmans, 1977–86. Originally published: New York: Christian Literature Co., 1886–90.

Schipperges, Heinrich. *The World of Hildegard of Bingen: Her Life, Times, and Visions.* Translated by John Cumming. Collegeville, Minn.: Liturgical Press, 1998.

Schofield, Richard. "Amadeo, Bramante, and Leonardo, and the *Tiburio* of Milan Cathedral," *Achademia Leonardi Vinci* 4 (1989): 68–95.

———. "Leonardo's Milanese Architecture: Career, Sources, and Graphic Techniques." *Achademia Leonardi Vinci* 4 (1991): 111–15.

———, Janice Shell, and Grazioso Sironi, eds. *Giovanni Antonio Amadeo: Documents*. Como: New Press, 1989.

Schuler, Stefan. *Vitruv im Mittelalter: Die Rezeption von "De architectura" von der Antike bis in die frühe Neuzeit*. Cologne: Böhlau, 1999.

Schultz, Bernard. *Art and Anatomy in Renaissance Italy*. Ann Arbor, Mich.: UMI Research Press, 1985.

Sgarbi, Claudio. "A Newly Discovered Corpus of Vitruvian Images." *RES: Anthropology and Aesthetics* 23 (Spring 1993): 31–51.

Singer, Charles, ed. *The Fasciculo di Medicina, Venice, 1493*. 2 vols. Monumenta Medica, under the general editorship of H. E. Sigerist. Florence: R. Lier & Co., 1925.

Smith, Christine. *Architecture in the Culture of Early Humanism: Ethics, Aesthetics, and Eloquence, 1400–1470*. New York: Oxford University Press, 1992.

———. Untitled review of Schuler, *Vitruv im Mittelalter*. *Speculum* 76, no. 3 (July 2001), 790–91.

Stewart, Andrew. "The Canon of Polykleitos: A Question of Evidence," *Journal of Hellenic Studies* 98 (1978): 122–31.

Stock, Brian. *Myth and Science in the Twelfth Century: A Study of Bernard Silvester*. Princeton, N.J.: Princeton University Press, 1972.

Suetonius. *Suetonius*. 2 vols. Loeb Classical Library. Translated by J. C. Rolfe. London: W. Heinemann, and New York: Macmillan, 1914.

Tachau, Katherine H. "God's Compass and *Vana Curiositas:* Scientific Study in the Old French *Bible Moralisée*." *Art Bulletin* 80, no. 1 (March 1998): 7–33.

Taylor, R. Emmett. *No Royal Road: Luca Pacioli and His Times*. Chapel Hill: University of North Carolina Press, 1942.

Torrini, Annalisa Perissa. *Leonardo: L'uomo vitruviano fra arte e scienza*. Venice: Marsilio, 2009.

Vallentin, Antonina. *Leonardo da Vinci: The Tragic Pursuit of Perfection*. Translated by E. W. Dickes. New York: Viking Press, 1938.

Varro. *On the Latin Language*. Translated by Roland G. Kent. 2 vols. Loeb Classical Library. Cambridge, Mass.: Harvard University Press, 1977.

Vasari, Giorgio. *Lives of the Most Eminent Painters, Sculptors & Architects*. Translated by Gaston du C. de Vere. 10 vols. London: Macmillan and the Medici Society, 1912–15.

———. *On Technique*. Translated by Louisa S. Maclehose. Edited with introduction and notes by G. Baldwin Brown. London: J. M. Dent, 1907.

———. *Vasari's Lives of the Artists*. Abridged and edited with commentary by Betty Burroughs. New York: Simon & Schuster, 1946.

Vitruvius. *On Architecture*. Translated by Richard Schofield. London and New York: Penguin Books, 2009.

———. *Ten Books on Architecture*. Translated by Ingrid D. Rowland. Commentary and illustrations by Thomas Noble Howe; with additional commentary by Ingrid D. Rowland and Michael J. Dewar. New York: Cambridge University Press, 1999.

———. *The Ten Books on Architecture*. Translated by Morris Hicky Morgan. New York: Dover Publications, 1960. Originally published in 1914 by Harvard University Press.

Wackernagel, Martin. *The World of the Florentine Renaissance Artist: Projects and Patrons, Workshop and Art Market*. Translated by Alison Luchs. Princeton, N.J.: Princeton University Press, 1981.

Welch, Evelyn S. *Art and Authority in Renaissance Milan*. New Haven, Conn.: Yale University Press, 1995.

Whitcomb, Merrick. *A Literary Source Book of the Renaissance*. 2nd ed. Folcroft, Pa.: Folcroft Library Editions, 1973 [c. 1903].

White, Lynn Townsend. *Medieval Religion and Technology: Collected Essays*. Berkeley: University of California Press, 1978.

Wilson Jones, Mark. "Doric Measure and Architectural Design 1: The Evidence of the Relief from Salamis." *American Journal of Archaeology* 104, no. 1 (January 2000): 73–93.

Wittkower, Rudolf. *Architectural Principles in the Age of Humanism*. 4th ed. London: Academy, and New York: St. Martin's Press, 1988.

Zaitsev, Evgeny A. "The Meaning of Early Medieval Geometry: From Euclid and Surveyors' Manuals to Christian Philosophy." *Isis* 90, no. 3 (September 1999): 522–53.

Zanker, Paul. *The Power of Images in the Age of Augustus*. Translated by Alan Shapiro. Ann Arbor: University of Michigan Press, 1988.

Zöllner, Frank. *Vitruvs Proportionsfigur: Quellenkritische Studien zur Kunstliteratur im 15. und 16. Jahrhundert*. Worms: Wernersche Verlagsgesellschaft, 1987.

———, and Johannes Nathan. *Leonardo da Vinci, 1452–1519: The Complete Paintings and Drawings*. Translated by Karen Williams. Köln and Los Angeles: Taschen, c. 2003.

ACKNOWLEDGMENTS

L EONARDO TIRELESSLY SOUGHT to learn from others as he pursued his own investigations, and in writing this book I tried to follow suit.

I'm very grateful to Dr. Annalisa Perissa Torrini, the director of the Office of Drawings and Prints at the Gallerie dell'Accademia in Venice, for allowing me an unforgettable private viewing of Vitruvian Man and for sharing with me her expert technical understanding of the drawing. Thanks also to Martin Clayton, the deputy curator of the Print Room at the Royal Library in Windsor, England, for giving me the chance to inspect firsthand some thirty of Leonardo's original anatomical and proportional studies, a number of which are reproduced in this book. Speaking of illustrations: without the translation help so ably and amiably offered to me by Valentina Zanca, the publicist at Profile Books, the British publisher of this book, I would not have been able to negotiate the bureaucratic demands and idiosyncrasies of the many Italian libraries from which I acquired images for this book.

I owe a special debt to three scholars without whose private counsel, published writings, and spirit of generosity this book would have been much diminished. Indra Kagis McEwen—an adjunct professor of art history at Concordia University, in Montreal, and the author of the remarkable study *Vitruvius: Writing the Body of Architecture,* from which much of my first chapter derives—opened my eyes to the richness of the world described and inhabited by Vitruvius, and then did her best to keep me honest as I distilled her ideas into dramatically reduced form. Richard Schofield, a professor of architectural history at the Istituto Universitario di Architettura, in Venice, provided all sorts of help: by offering expert perspective on the architectural environment in which Leonardo worked in the 1480s and 1490s; by translating several original fifteenth-century documents for me from Latin and Italian into English; by reading and commenting on a full early draft of this book; and, perhaps most important, by plying me with Chianti, pizza, and an evidently bottomless supply of sardonic wit during the two research visits I made to Venice. Finally, the architect Claudio Sgarbi introduced me to the remarkable drawing of Vitruvian Man that he discovered in Ferrara, shared with me his new findings about the drawing's origins, and selflessly located and translated rare documents for me in the Biblioteca Comunale dell'Archiginnasio, in Bologna—all while already fully occupied teaching architectural history and theory to Carleton University students in Ottawa and Bologna.

I'm also grateful to the following people, many of whom I approached out of the blue, for their advice and assistance: Carl Barnes, Yelitza Claypoole, Susan Dackerman, Claire Farago, Gregory Guzman, Christine Johnson, Martin Kemp, Matthew

Landrus, Domenico Laurenza, An Mertens, Rebecca Price, Jasper van Putten, Christine Smith, Ted Widmer, Mark Wilson Jones, Frank Zöllner, and Robert Zwijnenberg. Thanks especially to Daniel Crewe, Alison Lester, Valerie Lester, Cullen Murphy, and Steven Schlozman, each of whom read part or all of this book in early form and provided valuable comments and criticism. Robb Menzi, Bill Pistner, and Chris Stone, for their part, continued to provide critical periods of subzero perspective. Any errors of fact or judgment that remain in this book, of course, are entirely my own.

In writing this book I worked with the same publisher, Free Press, that I worked with in writing my previous book, *The Fourth Part of the World.* I can't imagine a more professional and collegial publishing team than the one at Free Press, and I owe special thanks to many of its members: to Hilary Redmon, my terrific editor, whose critical eye and supportive nature have helped improve both of my books immeasurably; to Sydney Tanigawa, for so ably standing in for Hilary during her absence, and for shepherding this book through production; to Dominick Anfuso and Martha Levin, for their continuing interest in my work; to Ellen Sasahara for her wonderfully sensitive touch as a designer; and to Jocelyn Kalmus, for her help with publicity and her unflagging good cheer in confronting the not insubstantial challenges of promoting a book about really old pictures and ideas. Thanks also to Lynn Anderson, this book's copy editor, for her thoughtful and meticulous attention to so many tiny details.

My literary agent, Rafe Sagalyn, helped me develop and shape the idea for this book, and then provided judiciously timed dollops of encouragement, perspective, and advice while

I was working on it. The same goes for Valerie Lester, Alison Lester, and Jane Lester, who all lived through a lot with me during the period I was writing the book. My daughters, Emma, Kate, and Sage, increasingly busy with their own lives, kept me grounded at home and did their best to ensure I wouldn't finish this book too quickly. And then there's my wife, Catherine Claypoole—who, while raising our girls with me and holding down a demanding day job that never stops expanding, also lived through the writing of this book with me day by day and helped me with it in more ways than I can possibly express. All I can say is this: more than fifteen years in, I still feel like the luckiest man alive for having found her.

Finally, a cosmic shout-out to my father, Jim Lester, who died while I was writing this book. He was, and will always be, my favorite Renaissance Man.

PERMISSIONS AND CREDITS

CREDITS—COLOR PLATES

Plate 1: Microcosm. From *De natura rerum*, by Isidore of Seville. The Bodleian Library, University of Oxford (MS. Auct. F. 2. 20).

Plate 2: Microcosm. Also known as Byrhtferth's diagram. By permission of the President and Fellows of St John's College, Oxford (MS Oxford St John's College 17, 7*v*).

Plate 3: Microcosmic Man. ÖNB/Wien (MSS VI 12600, fol 29*r*).

Plate 4: The Ebstorf mappamundi. Courtesy of Kloster Ebstorf. Map image courtesy of Martin Warnke, Leuphana University of Lüneburg, Institute for Culture and Aethetics of Digital Media (www.leuphana.de/ebskart).

Plate 5: Microcosmic Man (Hildegard). Lucca, Biblioteca Statale, with permission of the Ministry of Cultural Heritage (Lucca MS fol. 9*r*).

Plate 6: God as architect. ÖNB/Wien (Codex Vindobonensis 2554).

Plate 7: Microcosmic Man (Taccola). Department of Prints and Early Manuscripts, Munich Staatsbibliothek (Lat 197, I, 36*v*).

Plate 8: Two skulls (Leonardo). The Royal Collection © 2011, Her Majesty Queen Elizabeth II (RL 19057*r*).

Plate 9: Vitruvian Man (Leonardo). Gallerie dell'Accademia, Venice. Courtesy of the Ministry for the Public Good and Cultural Activities.

CREDITS—BLACK-AND-WHITE IMAGES

Figure 1: The Lambeth Palace world map. From Nennius, *Historia brittonum.* Courtesy of the Lambeth Palace Library (MS 371, fol. 9*v*).

Figures 2 and 3: Biblioteca Medicea Laurenziana, Florence (MS 282, Ashburnham 361, fols. 10*v* and 21*r*). Courtesy of the Ministry for the Public Good and Cultural Activities. All further reproduction is prohibited. Photos: Donato Pineider.

Figure 4: Octavius coin. Numismatica Ars Classica NAC AG, Auction 46, Lot 466.

Figure 5: Augustus coin. Numismatica Ars Classica NAC AG, Auction 45, Lot 61.

Figure 6: The Spear Bearer. Minneapolis Institute of Arts, The John R. Van Derlip Fund and Gift of funds from Bruce B. Dayton, an anonymous donor, Mr. and Mrs. Kenneth Dayton, Mr. and Mrs. W. John Driscoll, Mr. and Mrs. Alfred Harrison, Mr. and Mrs. John Andrus, Mr. and Mrs. Judson Dayton, Mr. and Mrs. Stephen Keating, Mr. and Mrs. Pierce McNally, Mr. and Mrs. Donald Dayton, Mr. and Mrs. Wayne MacFarlane, and many other generous friends of the Institute.

Figure 7: The Prima Porta statue. Courtesy of the Vatican Museums (Inv. 2290).

Figure 8: Spherical cosmos. Herzog August Bibliothek Wolfenbüttel (Cod. Guelf. 36.23 Aug. 2°, fol. 51*v*).

Figure 9: Cardinal directions. Herzog August Bibliothek Wolfenbüttel (Cod. Guelf. 36.23 Aug. 2°, fol. 42*v*).

Figure 10: Roman colony. Herzog August Bibliothek Wolfenbüttel (Cod. Guelf. 105 Gud. lat., fol. 51*v*).

Figure 11: Oxford metrological relief. Ashmolean Museum, University of Oxford (AN Michaelis 83).

Figure 12: Christ as a microcosm. Department of Prints and Early Manuscripts, Munich Staatsbibliothek (Mu CLM 13002, fol. 7*v*).

Figure 13: Early anatomical illustrations. Department of Prints and Early Manuscripts, Munich Staatsbibliothek (Mu CLM 13002, fol. 3*r*).

Figure 14: Tuscan landscape (Leonardo). Uffizi Gallery (GDSU, cat. P, 8; Inv. fot. 543513). Photo: Alinari Archive.

Figure 15: Florence. From Hartmann Schedel's *Nuremburg Chronicle.* Wikimedia Commons.

Figure 16: David (Verrocchio). Gabinetto Fotografico, S.S.P.S.A.E e per il Polo Museale della città di Firenze (B/N 579606).

Figure 17: Perspectograph (Leonardo). Copyright Biblioteca Ambrosiana, Milan (CA 5*r*): VB 548/11.

Figure 18: Armillary sphere and Christ. From *Annotationi sopra la lettione della Spera del Sacro Bosco* (1550), by Fra Mauro. Courtesy of the Rare Books and Special Collections Division, Library of Congress (QB41.S4 M3).

Figure 19: Man and the cosmos. From *Margarita philosophica* (1503), by Gregor Reisch. Courtesy of the Rare Books and Special Collections Division, Library of Congress (Rosenwald 595 Rosenwald Coll).

Figure 20: Alberti's "definer." From *On Sculpture*, by Leon Battista Alberti, in *A Parallel of the Antient Architecture with the Modern* (1707), by Roland Fréart. Courtesy of the Rare Books and Special Collections Division, Library of Congress (NA2812 .F8 1707 Pre-1801 Collection).

Figure 21: Proportions of the ideal human form. From *De statua*, by Leon Battista Alberti. The Bodleian Library, University of Oxford (MS. Canon. Misc. 172, fol 232*v*).

Figure 22: Domes and study for the head of St. James (Leonardo). The Royal Collection © 2011, Her Majesty Queen Elizabeth II (RL 12552).

Figure 23: A machine of Brunelleschi's. Biblioteca Nazionale Centrale, Florence (Palatino 776, 10*r*). Reproduced by kind permission of the Ministry of Cultural Heritage. No further reproduction allowed without express permission of the Biblioteca Nazionale Centrale.

Figure 24: Siege engine. From *De re militari*, by Roberto Valturio. Courtesy of the Rare Books and Special Collections Division, Library of Congress (Incun. 1472 .V21 Rosenwald Coll).

Figure 25: Gun and mortar studies (Leonardo). The Royal Collection © 2011, Her Majesty Queen Elizabeth II (RL 12652*r*).

Figure 26: Madonna and child (Villard de Honnecourt). Bibliothèque Nationale de France (BNF, MS Fr 19093, 10*v*).

Figure 27: Wrestlers and church choir. Drawing by Rebecca Price, and reprinted with her permission. Originally published in Carl F. Barnes, *The Portfolio of Villard de Honnecourt* (2009), 21, Figure 11.

Figure 28: Geometrical drawings (Villard de Honnecourt). Bibliothèque Nationale de France (BNF, MS Fr 19093, 18*v*).

Figure 29: Domes (Leonardo). Copyright Biblioteca Ambrosiana, Milan (CA 719*r*): VB 548/11.

Figure 30: Heraclitus and Democritus (Bramante). Pinacoteca di Brera, Milan. Photo: Alinari Archives, Florence.

Figure 31: Grain mill (Martini). Biblioteca Medicea Laurenziana, Florence (MS 282, Ashburnham 361, fol. 33*v*). Courtesy of the Ministry for the Public Good and Cultural Activities. All further reproduction is prohibited. Photo: Donato Pineider.

Figures 32 and 33: Head in capital (Martini) and *Body in column (Martini).* Biblioteca Medicea Laurenziana, Florence (MS 282, Ashburnham 361, fols. 20*v* and 13*v*). Courtesy of the Ministry for the Public Good and Cultural Activities. All further reproduction is prohibited. Photos: Donato Pineider.

Figure 34: Skull and pillars (Leonardo). The Royal Collection © 2011, Her Majesty Queen Elizabeth II (RL 12608*r*).

Figure 35: Public dissection. From *Fasciculus medicinae*, by Johannes Ketham. Courtesy of the Rare Books and Special Collections Division, Library of Congress (Rosenwald 263).

Figures 36 and 37: Zodiac Man and *Bloodletting Man.* From an encyclopedic manuscript containing allegorical and medical drawings. Courtesy of the Rare Books and Special Collections Division, Library of Congress (Rosenwald Collection ms. no. 3).

Figure 38: Wound Man. Wellcome Library, London (WMS 290, 53*v*).

Figures 39 and 40: Human head (Leonardo) and *Human skull (Leonardo).* The Royal Collection ©2011, Her Majesty Queen Elizabeth II (RL 19018*r* and RL 19058*v*).

Figure 41: Brain ventricles. From *Philosophiae naturalis compendium*, by K. Peyligk (Leipzig, 1489), as reproduced in *Studies in the History and Method of Science* (1917), by Charles Singer, 116 (manuscript source not attributed).

Figure 42: Brain ventricles. From *Margarita philosophica* (1503), by Gregor Reisch (Rosenwald 595 Rosenwald Coll). Courtesy of the Rare Books and Special Collections Division, Library of Congress.

Figure 43: Brain ventricles (Leonardo). The Royal Collection © 2011, Her Majesty Queen Elizabeth II (RL W12603*r*).

Figure 44: Proportions of the human body (Leonardo). The Royal Collection © 2011, Her Majesty Queen Elizabeth II (19133*r*).

Figure 45: Vitruvian Man (Martini). Biblioteca Medicea Laurenziana, Florence (MS 282, Ashburnham 361, fol. 5*r*). Courtesy of the Ministry for the Public

Good and Cultural Activities. All further reproduction is prohibited. Photo: Donato Pineider.

Figure 46: Vitruvian Man (Ferrara). Biblioteca Ariostea, Ferrara (Cart. Sec. XVI, fol. Figurato, Classe II, n. 176, fol 78*v*).

Figure 47: Superimposed Vitruvian Men. © Toby Lester.

Figure 48: Proportions of the human body and foot (Martini). Biblioteca Medicea Laurenziana, Florence (MS 282, Ashburnham 361, fol. 15*v*). Courtesy of the Ministry for the Public Good and Cultural Activities. All further reproduction is prohibited. Photo: Donato Pineider.

Figure 49: Motion study (after Leonardo?). The Pierpoint Morgan Library (MA 1139, fol. 6).

Figure 50: Skylab II logo. Wikimedia Commons.

Figure 51: Italian euro. Wikimedia Commons.

Figure 52: Parodies of Vitruvian Man. Google Images search.

Figure 53: Hands and foot of Vitruvian Man. Gallerie dell'Accademia, Venice. Courtesy of the Ministry for the Public Good and Cultural Activities. All further reproduction is prohibited.

INDEX

Page numbers in *italics* refer to illustrations.

Abélard, Peter, 126–127
Adam, 50, 116, 167, 191
Aether, 33
Agrippa, Marcus, 45
Alan of Lille, 60, 128, 173
Alberti, Leon Battista, 10–11, 95,
 152–156, 158, 170, 173, 196,
 216
 body mapping and, 87–91, *89, 90*
 on Brunelleschi, 109–110
 influence on Leonardo of, 81,
 83, 85, 86, 91, 149–150
 On Painting by, 81–83, 110, 150,
 163
 On Sculpture by, 88–91, 150,
 191, 209
 *On the Art of Building, in Ten
 Books* by, 145–151, 153, 194
 Ptolemy's influence on, 87
Albertus Magnus (Albert the
 Great), 105, 173
Albumasar, 173
Alcabitius, 173

Aliprando, Vincenzo, 202
Amadeo, Giovanni Antonio, 2
Anatomy. *See* Human anatomy
Anatomy (Mundinus), 162–164,
 166, 167, 179, 186
Anaxagoras, 119
Ancient Monuments (Francesco di
 Giorgio Martini), 194
Annunciation (Leonardo da Vinci),
 97
Anthropometry, 190–193, 200,
 208–209
Antonio da Vinci, 63
Apollo (god), 24
Arabs, 46, 58, 105, 166, 167, 170,
 173, 175, 186
Archimedes of Syracuse, 114
Architecture. *See Ten Books on
 Architecture* (*De architectura
 libri decem*) (Vitruvius)
Argyropoulos, Joannes, 95
Aristotle, 28, 52, 53, 95, 105,
 166–167, 173, 180, 182, 188

Armillary sphere, 83–84, *84*
Arno River, Italy, 67
Arnolfo di Cambio, 110
Artery Man, 58
Assiolo (Pagolino Scarpellino), 6
Augury, 30, 32
Augustus, Emperor, xiii, 143, 146,
 223
 Augustus of Prima Porta statue
 of, *22,* 22–24,
 coins depicting, *20,* 20–21, 23
 dedication of *Ten Books* to, 25,
 29, 41
 empire building by, 17–18
 name of, 14–15
 obsession with order, 15, 27, 41
 physical appearance of, 19–20,
 33
 rebuilding of Rome by, 14–17,
 25, 38
 Vitruvian Man and, 48
 Vitruvius and, 45
Augustus of Prima Porta, 22, 22–24
Averroes, 173
Avicenna, 188

Baptism of Christ (Verrocchio), 75
Basilica of St. Peter, Rome, 143
Beauvais cathedral, France, 138
Benci, Ginevra de', 97
Benedetto Dei, 68, 69
Benedetto of the Abacus, 95
Benedictine nuns, 60
Berneri, Giovanni Agostino, 1, 195
Bible, the, 33, 49, 94, 127
Biblioteca Comunale Ariostea of
 Ferrara, 202
Bloodletting Man, 175, *176*
Boccaccio, Giovanni, 170
Body mapping, 88–91, *89, 90*
Bone Man, 58, *59,* 175

Book of Divine Works (Hildegard of
 Bingen), 50–51, 55–56, 61
Book of Isaiah, 129
Bossi, Giuseppe, 219
Botticelli, Sandro, 97
Brain, 185–188, *187*
Bramante, Donato, 143–145, 149,
 156, 215, 223
Brunelleschi, Filippo, 3, 82, 95,
 134, 153
 Alberti on, 109–110
 Florence cathedral and, xiv, 67,
 70, 109–112, 114, 115, 125,
 140–141
 as role model for Leonardo, 109,
 112, 121
 study of ruins of ancient Rome
 by, 146–147
Butterfly effect, 119
Byzantines, 46

Caesar, Julius, 13, 14, 20, 27, 143
Canon (Polykleitos), 21, 22, *22,* 190
Cardano, Fazio, 172
Cardinal directions, 31, *32*
Cardo maximus, 31–32
Caterina (mother of Leonardo), 63,
 66
Cathedrals, xiv, 128–129, 136
 construction of, 132–133
 in Florence, xiv, 67–68, 70, 98,
 109–112, 114, 115, 125, 130,
 132, 140–141
 Gothic, 130
 as microcosmic body, 131–132
 in Milan (the *tiburio*), 2, 7,
 98–99, 125, 132, 136, 138–
 142, 145, 156, 193, 196, 200
 in Pavia, 2, 195, 196
Causes and Cures (Hildegard of
 Bingen), 55, 56

Cell doctrine, 185–187, *187*
Cennini, Cennino, 73
Ceolfrith, 45, 46
Chaos theorists, 119
Charlemagne, 126
Christ, 45–46, 48, 50, 116
 as microcosm, 56–58, *57,* 60–61
Christian scholars and theologians,
 46–49, 51–55, 58, 95, 127,
 130, 158, 174, 223
Chrysoloras, Manuel, 111–112
Church-body analogy, 8–9, *9*
Cicero, 22, 24–25, 27–29, 62, 85,
 104, 173
Circle and square, 32, 136, 138
 cardinal directions and, 31, *32*
 cathedral construction and,
 132–133
 as complement to each other,
 29–30
 in Ferrara manuscript, 203–205,
 210
 in Francesco's sketch, 198, *198*
 importance of, xii, 25
 in Leonardo's drawing, 206–207,
 209–211
 spherical cosmos and, 28–29,
 29, 31
 symbolic powers attributed to,
 27
 in Taccola's drawing, 216, 217
 in Vitruvius's description, xi,
 39–40
City of God, The (St. Augustine),
 181–183, 190
Clark, Kenneth, 220
Climates, 34–35
Codex Huygens, 214
Coins, Roman, 20–21, *22, 23*
Colonia Augusta (Roman colony), *32*
Columbus, Christopher, 96

Commonplace books, 117–118
Compagnia di San Luca, 76
Constantine the Great, Emperor, 49
Coordinate-based mapping, 87–88
Corinthian architecture, 26
Corsali, Andrea, 161
Cosmos
 contemplation of, 38–39
 design of, 28–29
Craftsman's Handbook, The (*Il libro
 dell'arte*) (Cennini), 73–76, 82
Crossbow, construction of, 121,
 123, 169
Cutaway views, 153–154, 184, 186,
 189

Da Vinci, Leonardo. *See* Leonardo
 da Vinci
Da Vinci Code, The (Brown), ix
Dante, Aligheri, 170, 173
David (Verrocchio), 72, *72,* 215
De juvamentis stomachi (Galen),
 166
De ponderibus, 171
De Predis brothers, 104, 120
Decumanus maximus, 31–32
Democritus, 144–145
Diana (goddess), 24
Dispositio regalis (Haly Abbas), 166
Doric architecture, 26
Dream of Scipio (Cicero), 85
Durandus, William, Bishop of
 Mende, 131–132
Dürer, Albrecht, 213

Ebstorf mappamundi, 60–61
Elements of Geometry (Euclid), 173
Epistles of the Brethren of Purity,
 58–60
Etruscans, 16, 32
Euclid, 173

Eugenius III, Pope, 44
Eve, 167
Evolution, 49
Eye, nature of the, 167–168

Fasciculus medicinae (Ketham), 165
Federico da Montefeltro, Duke of
 Urbino, 151–153, 193
Ferrara, Giacomo Andrea da,
 201–203, 206, 210, 216, 223
Ficino, Marsilio, 85–86, 95, 212
Filarete (Antonio di Pietro Aver-
 lino), 154–156, 158, 173, 196,
 199, 209
Finitorium, 88, 191
Florence, Italy, 62, 66–81, *67,* 87
 beauty of, 66–67
 cathedral in, xiv, 67–68, 70, 98,
 109–112, 114, 115, 125, 130,
 132, 140–141
 guilds in, 68, 69
 homosexuality in, 78
 humanists in, 81, 95, 96
 Leonardo goes to, 66, 70–71
 Machiavelli's history of, 100–101
 Milan and, 98–102
 Neoplatonism in, 85, 91, 95
 population of, 67
 public dissections in, 164
 streets of, 69–70
Florus, 18
Fourth Part of the World, The
 (Lester), x
Francesco di Giorgio Martini, 5,
 123, 134, 156, 158, 209
 Ancient Monuments by, 194
 birth of, 151
 church-body analogy of, 8–9, *9*
 Duke Federico and, 151–152
 education of, 152

Leonardo and, 6–8, 121,
 195–197, 223
 Milan cathedral (the *tiburio*)
 and, 2, 7, 193, 196, 200
 Pavia cathedral and, 195, 196
 reputation of, 3
 sketch of Vitruvian Man by,
 197–199, 203, 216
 Ten Books on Architecture by
 Vitruvius and, 152, 196–199
 translation of *Ten Books* by,
 194–196
 travel to Pavia with Leonardo,
 1–4, 6–8, 121, 172, 195
 *Treatise on Architecture, Engi-
 neering, and the Art of War*
 by, 7–10, 121, 153–155, *154,
 155,* 193, 196–199, 202, 211,
 211, 212
François I, King of France, 224
Franks, 130, 148
French style, 129
Frog, dissection of, 159–162, 181,
 188
Frontinus, 62

Galen, 37, 166, 173, 188
Gallerie dell'Accademia, Venice,
 xiv-xv, 218, 219
Genoa, Italy, 68
Geography, 35–36, 54, 60
Geography (Ptolemy), 87, 89, 180
Geography I, 48
Geometrical shapes and theories,
 48, 132–138, *137 See also*
 Circle and square
Germanic tribes, 46
Ghiberti, Lorenzo, 163
Ghirlandaio, Domenico, 97

Ginevra de' Benci (Leonardo da Vinci), 97
Giovio, Paolo, 213
Goths, 97, 130, 148
Greece (ancient), 16, 21, 25, 26, 30, 33, 34, 36–38, 119, 129–130, 158, 166, 170, 174, 182, 190, 223
Greek language, 47
Guilds, Florentine, 68–69
Gutenberg, Johannes, 20

Hagia Sophia, Constantinople, 111
Haly Abbas, 166
Héloïse, 127
Heraclitus, 144–145
Heribert of Cologne, 133
Hildegard of Bingen, xiv, 42–44, 50–51, 55–57, 60, 61, 116, 128, 191
Holy Spirit, 50
Homosexuality, 78–79
Honorius, 173
Horace, 16
Hugh of St. Victor, 105, 173
Human analogy, 33–34, 85–86, 155, 156, 173–175, 177
Human anatomy, 36–38, 56, 58–60, 177–185, 209, 213
Human proportions, study by Leonardo of, 190–193, 200, 208–209
Humanists, xiv, 10, 62, 81, 87, 95, 96, 148, 150, 170, 174

Ionic architecture, 26
Isidore of Seville, 49–50, 105, 173, 174
Islamic scholars, xiv, 54, 58, 174
Italian Renaissance, 62, 81, 82, 129

Jupiter (planet), 35

Ketham, Johannes, drawing of public dissection, *165*

Lake Como, 97
Lambeth Palace world map, x, *xi*
Last Supper, The (Leonardo da Vinci), 123, 214, 224
Latin language, 145, 170, 174
Latitude and longitude, 87, 88
Leo X, Pope, 93
Leonardo da Vinci
 Alberti's influence on, 81, 83, 85, 86, 91, 149–150
 animal anatomy and, 159–162, 181, 188
 Annunciation by, 97
 as apprentice to Verrocchio, 66, 71–76, 91, 100, 108, 120, 163, 223
 approach to natural philosophy of, 94, 96
 baptism of, 63–64
 birth of, 63
 books owned by, 7, 9, 154, 171, 182, 193, 196, 198
 Bramante, friendship with, 143–145, 149, 156, 223
 Brunelleschi as role model for, 109, 112, 121
 cell doctrine and, 186, 187, *187*
 character and personality of, 4, 76, 77
 childhood of, 64
 crossbow, construction of, 121, 123, 169
 deadlines, trouble with, 92–93, 96
 death of, 219

Leonardo da Vinci (*continued*)
dissections and, 159–162,
163–167, 181, 183–185, 188
earliest surviving drawing by,
64, *65*
early life of, 65–66
education of, 64, 65, 117,
169–171
emergence of artistic talents of,
66
eulogy for, 224
Ferrara, friendship with, 201–
202, 223
finances of, 92
first encounter with Vitruvian
Man, 74–75
first recorded commission of, 92
freeing of caged birds by, 123,
161
frog dissection by, 159–162, 181,
188
Ginevra de' Benci by, 97
goes to Florence, 66, 70–71
handwriting of, 64, 144, 207
homosexuality and, 78
human anatomy and, 156–158,
157, 175, 177–185, 209, 213,
215
On the Human Body by, 178–
180, 208, 213
illegitimacy of, 63
independent studio of, 80
information-gathering mode of,
5–6
investigations and inventions
of, 10, 93–96, 96, 105–107,
118–121, 159–161, 160,
168–169, 169
jokes and humor and, 4, 76–77,
160
The Last Supper by, 123, 214, 224

Latin language and, 145, 170,
174
legacy as anatomist, 213
Ludovico Sforza and, 103–105,
120, 121, 123, 140, 143
Medici family and, 80–81, 97
as member of the Compagnia di
San Luca, 76
in Milan, 97, 101, 103–108, 120,
145, 200–201
Milan cathedral and, 99, 132,
140–142, *141,* 156, 159, 193,
196
military engineering and,
120–125, *124,* 143
mirror script of, 64, 144, 207
as model for Verrocchio's *David,*
72, 215
Mona Lisa by, 122, 224
musical talents of, 76, 101, 103,
120
nature of eye and, 167–168
notebooks of, 4–5, 83, 91,
107–109, 112, 114, 117–120,
123, 140–142, 150, 156, 159,
160, 169, 171, 172, 190, 191,
202, 209, 212, 218, 223, 224
partnership with Verrocchio, 75,
77, 80, 81, 97
physical appearance of, 3–4, 72,
77, 214
in *Portrait of Heraclitus and
Democritus* by Bramante,
144–145, *144,* 215
possible self-portrait of, 83, *84*
as producer of special effects, 77
questions of others by, 94–96
quoted, 63, 92, 108, 126, 159,
190
rumination on penis by, 78–79
Saltarelli affair and, 77–80, 96

On Sculpture by, 91, 214
self-education program of,
169–171, 183
Sforza horse by, 160, 224
skull studies by, 184–189, 185,
187
soul and, 180–181, 186, 188,
189, 193
stringed instruments, construc-
tion of, 121
Study for the Head of St. James
by, 112, 113
study of human proportions by,
190–193, 191, 200, 208–209
Taccola's manuscripts and illus-
trations and, 116, 121
Ten Books of Vitruvius and, 62,
142–143, 145, 197, 207, 208
travel to Pavia with Francesco,
1–4, 6–8, 121, 172, 195
Verrocchio's Baptism of Christ
and, 75
Virgin of the Rocks by, 104, 120
in Visconti library, 172–173, 200
as visual thinker, 174–175
Vitruvian Man drawing by, ix-xv,
117, 199–201, 198, 203,
205–225, 205
Libro architettonico (Filarete), 154
Linear perspective, 82, 109, 153
Livy, 17, 30
Lombard Plain, Italy, 1, 172, 195
Lombardy, 120
Louis XII, King of France, 201
Lucretius, 62

Machiavelli, Niccolò, 100, 151
Macrocosm, 48–49
Madonna and Child (Villard de
Honnecourt), 135
Manilius, Marcus, 31, 34, 62

Manuscripts, copying of, 46, 47,
223
Margarita philosophica (Reisch), 86
Mark Antony, 14
Marmocchi, Carlo, 94–95
Mars (planet), 35
Masini, Tommaso, 161
Master builders, 128–130, 133, 134,
136, 146, 158
Maternus, Julius Firmicus, 49
Maximus, 127
Medici, Lorenzo de', 80–81, 85, 97,
99, 100, 101, 103, 150
Medicine, 34, 54, 141–142, 175,
181
Melzi, Francesco, 219, 223
Metrological relief, 37, 37, 190, 223
Microcosm, theory of the, xii, xiv,
44, 49, 55, 91, 116, 131, 174,
175, 189, 216
Christ as, 56–58, 57, 60–61
Mignot, Jean, 136, 138–139
Milan, Italy, xiv, 68
cathedral in (the tiburio), 2,
7, 98–99, 125, 132, 136,
138–142, 141, 145, 156, 193,
196, 200
Florence and, 98–102
history of, 97–98
Leonardo in, 97, 101, 103–108,
120, 145, 200–201
public dissections in, 164
urban renewal and beautification
in, 98, 103, 125, 140
Military engineering, 120–125, 122,
124, 143
Minor mundus, 34
Mirror of Nature (Speculum natu-
rale) (Vincent of Beauvais),
106
Momus (Alberti), 91

Mona Lisa (Leonardo da Vinci), 122, 224
Moorish Spain, 54
Mundinus (Raimondo de'Luzzi), 162–167, 173, 179, 186, 188
Muscle Man, 58, *59,* 175

Naples, Italy, 68
Natural History (Pliny the Elder), 173
Natural philosophy, 53–54, 93–95
Neoplatonism, 85, 91, 95, 116, 147
Nero, Emperor, 24
Nerve Man, 58, *59,* 175
Nicholas V, Pope, 148, 150
Notebooks of Leonardo da Vinci, 4–5, 83, 91, 107–109, 112, 114, 117–120, 123, 140–142, 150, 156, 159, 160, 169, 171, 172, 190, 191, 202, 209, 212, 218, 223, 224
Nude, The: A Study in Ideal Form (Clark), 220

Octavius Thurinus, Gaius (*see* Augustus, Emperor)
Officers of the Night and Monasteries, Florence, 77
On Divine Proportion (Pacioli), 201, 212, 214
On Engines (Taccola), 114–116
On Machines (Taccola), 115, *115*
On Military Matters (Valturio), 121, 122
On Painting (Alberti), 81–83, 110, 150, 163
On Rhetoric (Cicero), 25
On Sculpture (Alberti), 88–91, 150, 191, 209
On Sculpture (Leonardo da Vinci), 91, 214

On the Art of Building, in Ten Books (Alberti), 145–151, 153, 194
On the Human Body (Leonardo da Vinci), 178–180, 208, 213
On the Latin Language (Varro), 25
Oration on the Dignity of Man (Pico della Mirandola), 86
Ovid, 173
Oxford metrological relief, 37

Pacioli, Luca, 201, 212, 214
Pagave, Venanzio de, 219, 222–223
Palazzo Vecchio, Florence, 92
Pantheon, Rome, 138
Parthians, 24
Pavia, Italy, 200
 cathedral in, 2, 195, 196
 Leonardo's travels to, 1–4, 6–8, 195
 public dissections in, 164
 Visconti library in, 11, 171–173
Perissa Torrini, Annalisa, xv, 218, 221
Persia, 36
Perspectograph, 83–84, *84*
Petrarch, 170, 172, 173
Philo of Alexandria, 33, 56
Pico della Mirandola, Giovanni, 86
Piero (father of Leonardo da Vinci), 63, 66
Plague, 123
Plato, 27, 28, 33, 52, 53, 78, 173, 180
Platonic Theology (Ficino), 85–86, 212
Pliny the Elder, 22, 105, 152, 173
Pneuma, 33
Po Valley, Italy, 97
Poggio Bracciolini, Gian Francesco, 62, 148

Pollio, Marcus Vitruvius (*see* Vitruvius)
Polykleitos, 21–22, *22,* 23, 37–39, 190
Ponte Vecchio, Florence, 67
Portinari, Benedetto, 6
Portrait of Heraclitus and Democritus (Bramante), 144–145, *144*
Prince, The (Machiavelli), 151
Printing, invention of, 170
Priscian, 62
Ptolemy, Claudius, 87–89, 105, 173, 180, 298

Quadrant, The (Marmocchi), 94–95
Quintilian, 22, 62, 104

Race-based ideology, 35
Reims cathedral (Villard de Honnecourt), *135*
Reisch, Gregor, 86
Renaissance man, 26
Rome, Italy, 35, 130, 158, 170, 174
 See also Augustus, Emperor
 founding of, 30
 layout of, 30–32
 rebuilding of, 14–17, 25, 38
 ruins of ancient, 147, 148, 150, 194
 Stoics in, 33, 34
Romulus, 20, 30, 32

Sacrobosco, 173
St. Augustine, 52, 105, 173, 181–183, 190
St. Disibod's monastery, 44
St. Gall monastery, 62
St. Paul, 45–46
St. Rupert's monastery, 44, 128
St. Thomas Aquinas, 105, 173
Saint-Denis, Paris, 126, 127
Saltarelli, Jacopo, 78

Saltarelli affair, 77–80, 96
Santa Maria Maggiore, Milan, 99
Santo Stefano, Milan, 102
Saturn (planet), 35
Scholastics, 94, 95, 102, 169
Seneca, 24, 118
Sensus communis (Common Sense), 185–188
Sforza, Galeazzo Maria, 99, 102
Sforza, Giangaleazzo, 102
Sforza, Ludovico, 1–2, 97, 102–105, 120, 121, 123, 140, 143, 145, 160, 201, 223
Sforza family, 98, 172
Sforza horse (Leonardo da Vinci), 160, 224
Sgarbi, Claudio, 202–203, 206, 210
Siena, Italy, 151, 153, 193, 194
Simpsons, The (television show), ix
Sistine Chapel, Rome, 97
Site selection, 32
Sixtus IV, Pope, 97
Skull studies by Leonardo da Vinci, 184–189, *185, 187*
Song of Songs, 44
Soul, the, 180–181, 186, 188, 189, 191, 193
Spear Bearer (Polykleitos), *22,* 21–24, 190
Square. *See* Circle and square
Stoics, 33, 34
Study for the Head of St. James (Leonardo da Vinci), 112, *113*
Suetonius, 15, 21, 33
Suger, Abbot, 126–129
Sylvestris, Bernardus, 55

Taccola "the Crow" (Mariano di Jacopo), 114–116, 121, 134, 153, 158, 212, 216, 217

Taverna, Giovanni, 6
Technological revolution, 51–52
Temple construction, 38
Templum, 30
*Ten Books on Architecture (De
 architectura libri decem)*
 (Vitruvius), 10–11, 13, 33, 36,
 85, 114, 148, 173, 190, 213
 See also Vitruvian Man
 basic principles in, 27
 on climates, 34–35
 copying of, 46, 47, 223
 on cosmos, 28
 dedication of, 25, 41
 earliest excerpts and summaries
 of, 47–48
 Ferrara manuscript, 202–205,
 210
 Francesco and, 152, 196–199
 illustrations of, 218
 Leonardo and, 62, 142–143, 145,
 197, 207, 209
 obscurity of, 10–11, 146
 on site selection, 32
 surviving copies of, 45, 61, 62
 translation of, 194–196
Timaeus (Plato), 27, 53
Toscanelli, Paolo dal Pozzo, 95–96
*Treatise on Architecture, Engineer-
 ing, and the Art of War* (Fran-
 cesco di Giorgio Martini),
 7–10, 121, 153–155, 193,
 196–199, 202, 211, 212
Triangles, 136, 138
 cathedral construction and,
 132–133
Trinity, the, 133

University of Tübingen, 164
Urbino, 151–152, 193

Valturio, Roberto, 121–123
Varro, 25
Vasari, Giorgio, 65, 66, 75, 76,
 92–93, 103, 123, 130, 147,
 161
Vatican Library, 150, 151
Vein Man, 58
Venerable Bede, 49–50, 105, 127,
 173, 174
Venice, Italy, 68, 120, 123
Ventricles, 186, 188
Verino, Ugolino, 66, 67, 69–70
Verrocchio, Andrea del, 95, 100
 David by, 72, *72,* 215
 Leonardo as apprentice to, 66,
 71–76, 91, 100, 108, 120, 163,
 223
 partnership with Leonardo, 75,
 77, 80, 81, 97
Villard de Honnecourt, 133–137,
 135, 137, 156
Vincent of Beauvais, 105, 106
Vinci, Italy, 63–64, 66, 80, 117
Virgil, 173
Virgin of the Rocks (Leonardo da
 Vinci), 104, 120
Visconti, Gaspare, 216
Visconti, Giangaleazzo, 98
Visconti Castle, Pavia, 200
Visconti family, 98, 172
Visconti library, Pavia, 11, 171–173,
 200
Vitolone, 6, 171
Vitruvian Man *See also Ten Books
 on Architecture (De architec-
 tura libri decem)* (Vitruvius)
 context of birth of, 38–41
 earliest excerpts and summaries
 of *Ten Books,* 47–48

Ferrara manuscript, 202–205, 204, 205, 210, 216
Francesco's sketch of, 197–199, 198, 203, 216
at Gallerie dell'Accademia, Venice, xiv-xv, 218, 219, 221
Hildegard of Bingen's visions and, 44, 50–51, 61
as Leonardo self-portrait, 214–215
Leonardo's drawing of, ix-xv, 117, 199–201, 203, 205–225
Leonardo's first encounter with, 74–75
in modern world, ix-x, 219–220, 220–221
original of Leonardo's drawing, xiv-xv, 218, 219, 221–223

resemblance of Lambeth Palace world map to, x, xi
resemblance to Christ, 47
Taccola's illustration and, 116
Vitruvius's description of, 38–41, 198, 199, 208–210
as worldwide icon, ix-x
Vitruvius, ix, xi, xii, xiii, 105, 132, 136, 150, 154, 156, 174 See also Ten Books on Architecture (De architectura libri decem)

William of Conches, 53–55, 173
Witelo, 171, 173, 200
Wound Man, 175, 176
Wrestlers and church choir (Villard de Honnecourt), 135

Zodiac Man, 175, 176

ABOUT THE AUTHOR

TOBY LESTER is a contributing editor to and has written extensively for *The Atlantic*. A former Peace Corps volunteer and United Nations observer, he lives in the Boston area with his wife and three daughters. His previous book, *The Fourth Part of the World* (2009), about the map that gave America its name, was a finalist for the Barnes & Noble Discover New Writers Award and was picked as a Book of the Year by *The Washington Post*, *The Wall Street Journal*, and several other publications. His work has also been featured on the radio program *This American Life*.